Sustainable Living

Dominique Gauzin-Müller

Sustainable Living

25 international examples

Birkhäuser – Publishers for Architecture
Basel · Berlin · Boston

To our children, Florence and Thibaut,
who cheerfully accept that ecology
forms an important part of our family life.

To everyone involved in ecological architecture,
whose dedication and commitment I greatly admire.

I wish to thank everyone at Editions du Moniteur for their steadfast support over the past 20 years – particularly Frédéric Lenne (Director), and Valérie Thouard for her professionalism, constructive criticism and warm working relationship. Producing this book with Valérie – the fourth we have worked on together – was once again a great pleasure.

My thanks go to the designers of the houses presented in this publication, as well as to their colleagues, for their friendly advice and patience they showed when answering my innumerable questions.
Many thanks as well to Suzanne Déoux, who kindly agreed that our discussion on housing and health could be published in this work.
My thanks to Françoise Fromonot for her help in describing Glenn Murcutt and Wendy Lewin's house in Sydney, and for authorising the reproduction of images from her book.
Thank you to Emmanuel Caille, editor-in-chief of the *D'Architectures* review, who kindly made Glenn Murcutt's drawings available to us.
Thank you as well to Marco Moro and Sergio Sabbadini for their help with drafting the text on Pietro Carmine's house.
My thanks go to Marika Frenette for her advice on the town house in Montreal and the residence on Orcas Island.
Many thanks to Bruno Peuportier for authorising us to use his drawings on transparent thermal insulation.
I would like to thank Michael Faulhaber from the sun-trieb consulting firm for his explanations regarding the technical fittings for the house in Giessen.
My thanks also to the Swiss engineer Konrad Merz and the Brazilian engineer Helio Olga, who introduced me to several of the timber houses published in this book.

My heartfelt thanks to Michelle and Raoul Gauzin for their invaluable advice and encouragement.
And lastly, many thanks to Serge Sidoroff, Philippe Madec, Daniel Fauré, Christian Charignon, Guy Archambault and the other members of the informal network of "cultural creatives of the building world" for the information they generously shared with me and the friendly messages that brightened up my mail box.

Graphic Design
Isabel Gautray
Christine Dodos-Ungerer

Cover Design
Alexandra Zöller

Translation from French
Sarah Parsons

Editing
Christian Rochow

Lithography
FAP

Printing
Chirat

This book is also available in a German language edition.
(ISBN 13: 978-3-7643-7466-2, ISBN 10: 3-7643-7466-7)

A CIP catalogue record for this book is available from the Library of Congress, Washington D.C., USA

Bibliographic information published by Die Deutsche Bibliothek
Die Deutsche Bibliothek lists this publication in the Deutsche Nationalbibliografie; detailed bibliographic data is available in the Internet at <http://dnb.ddb.de>.

© 2006 Birkhäuser – Publishers for Architecture,
P.O. Box 133, CH-4010 Basel, Switzerland
Part of Springer Science+Business Media
© 2005, Groupe Moniteur, Editions du Moniteur, Paris,
for the original edition
Printed on acid-free paper produced from chlorine-free pulp.
TCF ∞

Printed in France

ISBN 13: 978-3-7643-7467-9
ISBN 10: 3-7643-7467-5

9 8 7 6 5 4 3 2 1
http://www.birkhauser.ch

The French edition of this book was published under the title "25 maisons écologiques" by Editions du Moniteur, 17, rue d'Uzès, 75108 Paris Cedex 02, France.

Contents

Housing and ecology

Housing and ecology: international trends

In the first half of the 20th century, the flowering of the Modern Movement on most continents led to the emergence of an international style that abandoned, amongst other legacies, the traditional deference to the constraints of local climate and regional peculiarities. At the time, only a few architects warned of the dangers of this radical departure from nature and tradition, advocating instead the merits of the *genius loci* – in the case of Frank Lloyd Wright and Christian Norberg-Schulz – or respect for the "little people" so dear to Alvar Aalto. Their undeniably "modern" houses, often made of stone and wood, seemed to rise up out of the ground with the self-evident appropriateness of a native element of the place.

Bioclimatic principles

During the period that followed World War II, economic expansion in industrialised countries gradually ensured that all buildings were fitted with technical systems to keep the occupants comfortable in the winter and summer. But beginning in the 1960s, a few professionals, such as David Wright, argued in favour of organic housing that would draw upon solar gains. After the oil shocks of the 1970s, the rising cost of natural gas and fuel oil began to generate awareness of the finite nature of natural resources and of the dangers of pollution. Some architects were determined to move away from the wasteful use of fossil fuels and raw materials. They analysed the responses of vernacular housing to the specific features of sites and climates. These studies led them to define bioclimatic principles that could reduce energy requirements in housing whilst guaranteeing comfort through the use of passive sources, by way of appropriate choices in siting, orientation, shape of the building structure and extensions toward the exterior, as well as materials and vegetation planted nearby.

Example of a 1970s solar house design: David Wright's solar glasshouse.

From an intuitive approach to evaluation grids

The bioclimatic approach, which relies on site observation and on lessons drawn from vernacular housing, is fairly intuitive. In the early 1990s, the first environmental evaluation grids, designed to assess on an "objective" basis the environmental properties of buildings, were produced. These were the Green Building Tool in North America, the Building Research Establishment Environmental Assessment Method (BREEAM) in the United Kingdom, and the HQE® method in France, amongst others. These multicriteria analysis grids, inspired by the ISO 14001 standard, were generally linked to an environmental management process. They were often designed for public facilities and office buildings, but were also applied to collective housing or even to single-family dwellings. The design of Sarah Wigglesworth's home and combined architectural practice in London (see page 118) was on the contrary deliberately undertaken in an empirical manner, without an analytical grid or complex calculations. Her choice of a low-cost and easily replaceable membrane cladding illustrates an approach based on breaking down the building into several functions provided by clearly distinct components over variable lengths of time: long term for the structural frame, and shorter term for the interior and exterior facings. The holistic approach applied by the Italian architect Pietro Carmine when building his combined home and practice (see page 114) is also not based upon any grid, but is driven by a converse principle, since it emphasizes "noble" materials, designed to carry out a number of functions over the long term.

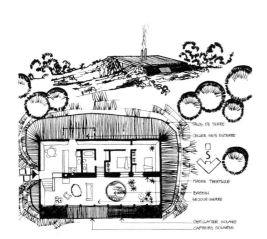

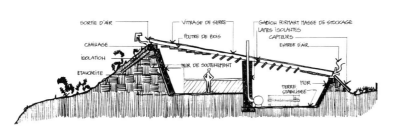

HOUSING AND ECOLOGY

Reason-based architecture – between low-tech and high-tech

Avenues for research have gradually diversified. Depending on each architect's sensibility and experience, more or less emphasis may be placed on the ecological, social, cultural or economic aspects of the environmental approach. Three major trends are currently emerging simultaneously: the low-tech approach, its high-tech competitor and a reason-based architecture that seeks a happy medium between the two. Driven by industrial research, the high-tech approach essentially focuses on optimising energy efficiency through sophisticated technical systems (see inset on page 13). Low-tech practitioners such as Antonius Lanzinger (see page 124), however, advocate economy of resources and the use of traditional know-how. They are often motivated by a strong social conscience and seek the well-being of occupants, working on designing healthy homes and self-construction. A third way between the two movements is gradually surfacing – one that is less militant and more pragmatic, and which does not hesitate to make use of innovative systems in addition to bioclimatic measures. It makes human needs the centrepiece of its approach. It is in the small federal state of Vorarlberg, at the western tip of Austria, that the most compelling examples of this reason-based architecture have been developed since the 1980s. The *Baukünstler* (from *Baukunst*, "the art of building") who have designed these structures are unquestionably "cultural creatives", as these movers of societal change have been called by Paul Ray and Sherry Anderson[1]. The houses of Wolfgang Ritsch (see page 68) and Dietrich and Untertrifaller (see page 52) reflect a critically aware regionalism, striking a balance between tradition and modernity.

Combining passive measures and technical systems to conserve energy

After the 1992 Earth Summit in Rio de Janeiro, the governments of many countries undertook commitments to sustainable development. This sped up the process of mainstreaming an environmental approach in all economic sectors, and particularly the building industry. In European industrialised countries which have a continental climate (Germany, Austria, Switzerland) or Nordic weather conditions (Scandinavia, Finland), measures for strengthening insulation of the building envelope are always combined with optimised technical systems. Industrial and political choices drive this emphasis on reducing energy consumption and developing technology for renewable energy sources. Companies taking such a bet on the future hope their technological edge will prove a source of windfall profits when the inevitable takeoff of the environmental market materialises – which many expect to happen very soon. The United States and European countries with milder climates, such as Spain, France or Italy, are starting to take steps to catch up, emphasising summertime comfort and natural air conditioning.

Houses for "inhabiting the landscape"

In Australia, a continent with very low population density that includes areas of tropical and desert climate, the challenges are very different. Research has focused on minimising the impact of housing in an unspoilt natural environment. As vast distances between buildings make it impractical to systematically connect houses to water, wastewater and energy networks, architects focus on providing autonomy in water and energy, and on efficient waste disposal, as in the house by Peter Stutchbury (see page 102). Australia is amongst the countries

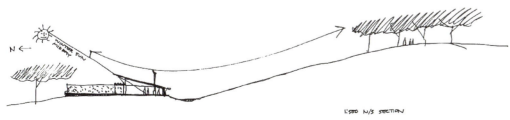

1:500 N/S SECTION

[1] The Cultural Creatives: How 50 Million People Are Changing the World, Paul H. Ray, Sherry Ruth Anderson, Harmony Books, 2000

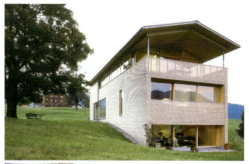

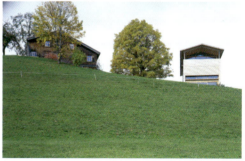

Between tradition and modernity – reason-based architecture in the Vorarlberg: house in Schwarzenberg, Austria, 1999; architects: Helmut Dietrich and Much Untertrifaller.

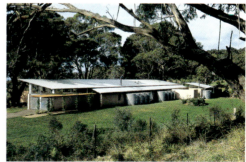

One of Glenn Murcutt's "houses for inhabiting the landscape": Meagher house in Bowral, New South Wales, Australia, 1992.

most richly endowed with examples of green houses, and it owes this largely to Glenn Murcutt, who for the past 40 years has provided convincing solutions for the four aspects of sustainable development – the ecological, social, economic and cultural dimensions. In his country and far beyond, he has influenced several generations of architects by imparting, with each of the buildings he has designed, his respect for the landscape. As he has explained, in nature, form depends on the place where it is found: why not in architecture? Economy is another of his leitmotifs, as when he declares that wastefulness is immoral.[2] The recognition accorded to his work with the Pritzker Prize in 2002 was an encouragement to all those who advocate an "authentic" architecture, freed from the concern with image.

[2] Based on an article by Françoise Fromonot, published in *D'Architectures*, No. 132, October 2003.

Collective involvement and social integration

In developing countries, ecological housing often goes hand in hand with the promotion of collective involvement and social integration. Many non-governmental organisations in Asia and South America teach the local population to produce compressed earth bricks, which initially allows them to build their own home in a way that matches their lifestyle; after that, they can build for others and start their own business. Using bags of earth stabilised with lime or cement, the Californian institute Cal Earth helps families build "eco-domes" that can withstand earthquakes. In countries that often experience scorching weather and where drinking water is a precious commodity, the collection of rainwater for domestic uses is a vital necessity. It is also important to ensure that domestic wastewater is filtered through a biological self-cleaning system. In India, several projects launched by architects combine control over the water cycle with the use of photovoltaic solar panels that generate the electricity required for lighting and the cooking of food. Examples include Bunker Roy's Barefoot College in the Rajasthan desert or Chitra Vishwanath's houses in Bangalore (see page 144). China has some of the best practices, but also plenty of the worst: for every person who, like Yung Ho Chang, warns of the dangers of excessive urbanisation and of the identity loss it entails, how many more opportunists, both local and foreign, have given unsatisfactory answers due to their being unfamiliar with the local context (see inset on page 42)?

Increasing housing density and combining work and living space

Even though the majority of the population dreams of owning a detached home (80% of the French population, according to a poll in *Le Monde* in 2005), it is justified to ask whether this type of housing is sustainable, especially in densely populated areas. In Europe, 75% of the population lives in cities, and worldwide the number of metropolises with over 10 million inhabitants is constantly rising. Both industrialised and developing countries on all continents face the same problems. To limit urban sprawl, high-density regions have already developed alternatives, made necessary by soaring land costs. These include semi-detached or terraced housing, individual houses grouped side by side or vertically, the restructuring or enlarging of existing houses whilst optimising their energy efficiency, and filling gaps in town centres. These models of densified housing on a human scale preserve occupants' privacy whilst

Houses made of plastic bottles.
In Honduras, the Eco-tec association (www.eco-tecnologia.com) has developed a technique for making houses and rainwater tanks out of plastic bottles filled by the future occupants with earth mixed with sawdust and sand recovered from construction sites. Initiated by Andreas Froese, this participative approach focuses on directly recycling waste.

The first house built by the association is topped by a planted roof.

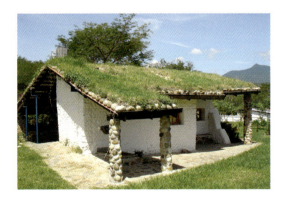

reducing the environmental footprint. This book discusses them by way of several projects: energy-efficient town housing in Switzerland (see page 74), restructuring and extending a colonial house in Sydney (see page 26) and building a town house in Montreal (see page 36). When the occupant's profession allows it, combining work and living space in one and the same building offers an alternative to the stress and pollution caused by commuting. Nine of the examples shown in this book offer this combination of housing with an office, a design practice or an artisan's studio.

Architectural minimalism – a consequence of user-friendly downsizing

Reasoned architecture respects natural sites and aims to conserve raw materials and energy. As such, it offers a pragmatic response to a worrisome situation. Most industrialised countries are experiencing economic stagnation, in a reversal of the general trend that characterised Europe's Thirty Glorious Years of postwar reconstruction – a period of rapid growth and euphoric consumption. On an ever more densely populated planet that is threatened by pollution and the depletion of natural resources, it is becoming urgent that we accept a more balanced sharing of wealth. It is therefore fair to ask whether making one's family home far larger than what is actually required, or owning a holiday home, are environmentally acceptable practices. Some examples shown in this book reflect such an awareness: "Sustainable development requires not only changes in our habits, but a revolution in our ways of thinking and acting."[3] A more balanced sharing of resources includes cutting back on needs that have often been created artificially by a consumer society under the influence of the media. This user-friendly downsizing can be expressed in architecture by voluntary sobriety – a formal minimalism and the use of salvaged components, giving priority to recyclable or recycled materials.

[3] Philippe Madec, architect, urban planner and writer. Director of the Master's programme in "Architecture and sustainable and equitable development", at the school of architecture in Lyon.

11

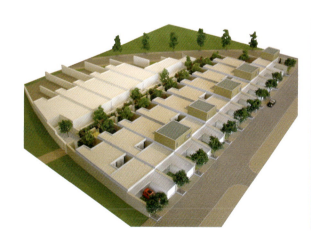

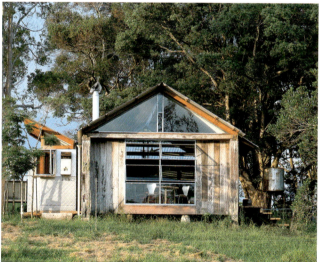

Terraced housing – an alternative to urban sprawl. This form of housing has long been used in English-speaking countries with high population levels, and is beginning to take off in France under the pressure of soaring land prices. Set between stone party walls and timber-framed end walls, Cusy and Maraval's "Vanilla Villas" in Montpellier offer 150 m² of habitable space on a 250 m² plot.

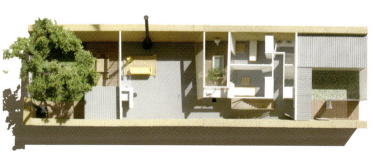

Detached house in Australia, 1992: Glenn Murcutt converted a tractor shed, recycling the wood from the demolished parts. The largely glazed openings were inserted into the old façade.

The many faces of ecological housing

The image of ecological architecture changes dramatically according to relief, climate, regional resources, local culture, the social strata of occupants and the political choices of the people governing them. The fact that there are so many different responses is nothing new: studying vernacular housing reveals the wide range of solutions that have been developed in order to provide occupants with the comfort they desire, whilst respecting the integrity of the local territory. Without being backward-looking, there seems to be a need today to find a balance between traditional and modern approaches, and to develop "reason-based" housing that is functional, comfortable, economical in its use of raw materials and environmentally sound in the broadest possible sense of the term.

From vernacular architecture to bioclimatic housing

Vernacular architecture is the expression of know-how acquired through centuries-old experience, passed on and enhanced from generation to generation. We need to reflect on what it teaches, perpetuate it, but also expand and extend it. Vernacular housing is "concrete science". Its shapes, materials and processes were dictated by the local microclimate and the natural resources that could typically be found in the region. This produced wood structures in forested regions; rammed earth or brick walls and tiled roofs in regions with clay soil; slate or lauze (thick schist slabs) roofing in schist-rich areas; and masonry made of limestone, sandstone or granite according to the nature of the substratum. Thanks to experience handed down over the years, traditional architecture also factored in risks and hazards related to relief and climate, taking into account floodplains, avalanche corridors and more. Bioclimatic housing does not imitate vernacular architecture – that would only produce a ridiculous pseudo-authenticity – but draws inspiration from its practice of blending smoothly into the landscape, matching traditional usage with functionality and using each material in accordance with its inherent nature. Authentic architecture can only exist within a living tradition.

What is an ecological home?

Whether it is a holiday home or the main residence, an ecological home is first and foremost a building that meets the wishes and current needs of its users, and which anticipates the future, taking into account

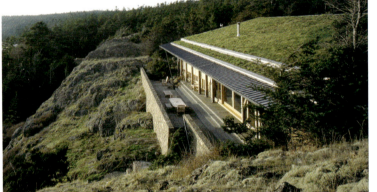

Blending smoothly into an unspoilt landscape:
Reeve residence on Orcas Island, Washington State, the United States, 2003; architects: Cutler Anderson.

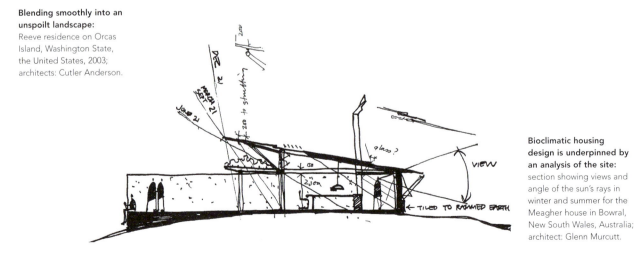

Bioclimatic housing design is underpinned by an analysis of the site: section showing views and angle of the sun's rays in winter and summer for the Meagher house in Bowral, New South Wales, Australia; architect: Glenn Murcutt.

changes in the family unit and the use of the home in different ages of life (see inset on page 84). Other, more subjective criteria vary according to the local environment, urban or natural, to the geographic and sociological context and to the financial means of clients. Analytical grids generally include visual and acoustic comfort as well as control of waste disposal and of the water cycle (see page 17). However, most professionals would agree that the three main focuses of an environmentally sound approach are ensuring that the structure blends with the site, providing thermal comfort in both winter and summer and adopting a reasoned approach when deciding on materials. Whether derived from an intuitive or analytical process, the examples presented in this book all offer interesting solutions covering at least two of these focuses.

Blending structures with the site

The highly subjective concept of blending a structure with its site can be interpreted in a variety of ways. Some take it to mean a contemporary update of vernacular architecture, as in the case of the Mediterranean villa in the Balearic Islands (see page 46), in other cases it may lead up to the point of camouflage: clad in wood with silver-grey tones, Kristian Gullichsen's cottage seems to melt into its background of rocks and pine trees (see page 22). Homes can also be cave dwellings or partially buried, like the house on the Gramat limestone plateau (see page 32). But the need for environmentally sound buildings is not limited to construction on land with a fragile ecosystem and in a natural landscape, such as the holiday home on Orcas Island (see page 56). Environmental sensitivity is just as crucial when adding buildings in a historic area, where the integrity of the urban fabric must be preserved. The designers of town houses in Montreal (see page 36) and Sydney (see page 26) smoothly integrated contemporary projects into historic neighbourhoods. Whether in cities or in the countryside, designing an ecological home always begins with an analysis of the land and of its immediate environment, including topography, access routes, views, view blocking features, existing vegetation, sunshine and dominant wind currents. But this analysis must then be broadened to a survey of the resources offered by the territory, such as local vegetation, materials available nearby and regional know-how. The *genius loci* has always been the wellspring for architectural projects.

Thermal comfort in winter and summer

Analysing the microclimate and applying bioclimatic principles are mandatory steps towards ensuring thermal comfort. In warm regions, passive measures are often enough to retain cool air and help create natural ventilation to offset midsummer heat. The beach house in Brazil (see page 86) and the house at Cap Ferret (see page 96) are apt illustrations of this type of bioclimatic design applied to the building structure and its extensions in the form of pergolas, overhangs, verandahs, low walls and foliage. In continental areas, where the weather varies

Housing that qualifies for the Minergie label; design principle diagram.
1 solar collectors for domestic hot water
2 dual-flow ventilation system with a heat exchanger that recovers a high proportion of calories from the used air
3 water-saving bathroom appliances
4 low-energy electric and household appliances
5 planted rooftop with water recovery

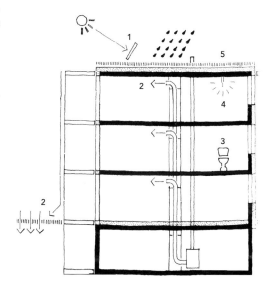

PASSIVE HOUSING LABEL

It was in Hesse, a federal state in Germany extremely pro active in promoting ecology, that the Passive Housing label was launched in 1989 by Wolfgang Feist, director of the Passivhaus Institut (www.ig-passivhaus.de). Qualifying for this label requires consuming less than 15 kWh per m^2 per year in heating energy, i.e. about six times less than provided for by French thermal regulations (RT 2000) and four times less than German regulations (Energiesparverordnung 2004). Thanks to the combination of optimised technical systems and passive measures related to the building envelope (reinforced insulation and perfect air tightness), energy requirements become so low that there is no need for a traditional boiler. Fresh air becomes a vector for heating and cooling, by means of a dual-flow mechanical ventilation system fitted with a heat exchanger that recovers a high proportion of calories (up to 90%) from the extracted air. In 2005, about 7,000 housing units had already been built according to these design principles in Germanic countries. This development is due, amongst other factors, to the work conducted by the Passivhaus Institut in conjunction with industrialists in order to create new building components. These include triple-glazing with rare gas infill frames featuring reinforced insulation (U coefficient = 0.6 W/m^2K). Houses designed according to the Passive Housing label are gradually being adopted in other European countries, and a study is underway in search of specific solutions for the Mediterranean climate.

sharply from one season to another, high-performance systems must be coupled with specific construction measures adopted for the building envelope, such as reinforced thermal insulation of solid walls and glazed openings or air tightness. The energy-flow concepts for Swiss, German and Austrian houses presented here always combine passive and active processes (see inset on page 78). European thermal regulations are becoming increasingly strict, and several countries have introduced very demanding standards for new and existing housing, such as the Passive Housing standard in Germany and Austria and the Minergie standard in Switzerland. To qualify as a Passive House, buildings must use less than 15 kWh per m^2 per year for heating and cooling. One particularly successful, albeit very costly, example is the house in Giessen (see page 90), which requires only 10 kWh per m^2 per year to guarantee a pleasant temperature in all seasons. These Germanic countries have also developed the concept of the zero-energy house, illustrated here by Werner Sobek's home (see page 64), and are even working on "positive energy houses" that produce more energy than they consume.

Making health a priority

People aspire to living in a healthy indoor climate with a naturally regulated rate of humidity. This is understandable after several public health scandals due to unhealthy buildings, ranging from lung diseases caused by asbestos, to lead poisoning or legionnaires' disease. Both designers and users need to be aware of these requirements when they choose the materials for the building structure, the technical systems, wall facings and floor coverings; and they also need to consider the products that will be used for finishing the various surfaces and for their ongoing upkeep. Many researchers are active in the field of healthy housing, and consumer groups are increasingly watchful on this point (see the interview with Dr. Suzanne Déoux, page 18/19). More and more clients are attracted to the idea of houses that they can assemble themselves from "raw" materials – e.g. bales of straw, stacked logs, bags of sand or earth, etc. The outcome is undoubtedly healthy housing, but is it architecture? It can be, as proved by Sarah Wigglesworth with her home and combined architectural practice in London (see page 118). On the other hand, does a log cabin imported from Finland or Canada have its place in a housing estate in a Belgian or French town? Is it ecologically sound to ship it there, knowing that European forests are under-exploited?

"Positive energy" terraced housing.
The last phase of the Solar Siedlung project by the German architect Rolf Disch was completed in 2005 near the Vauban district in Freiburg im Breisgau. The housing units clad in photovoltaic panels generate more energy than the users consume.

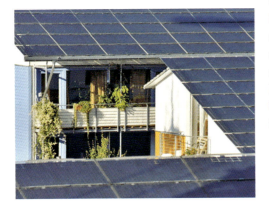

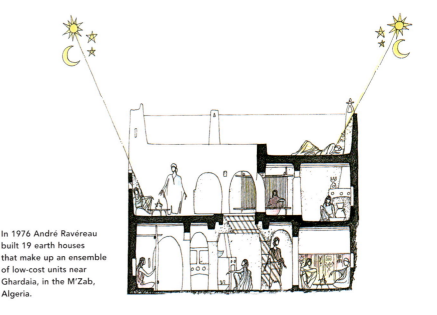

In 1976 André Ravéreau built 19 earth houses that make up an ensemble of low-cost units near Ghardaia, in the M'Zab, Algeria.

A reasoned choice of materials

Out of wood, stone, earth, concrete, aluminium or steel, which is the most ecologically correct material? The examples in this book demonstrate that, once again, the answer depends on local conditions. Wood may be the only renewable structural material, but it only seems appropriate to use it in regions where it is available in sufficient quantities and provided that it comes from sustainably managed forests. The two Brazilian houses in this book, both of which had Helio Olga as their engineer and builder, showcase the high quality of tropical wood (see pages 86 and 138). In Asia and North Africa, where wood is rare, building with rammed earth or earth bricks is far more sustainable, since the raw materials are available locally, and the very simple process requires little energy input and is suitable for building one's own home. Using just the right amount of the right material in the right place and combining several materials to leverage the benefits of each (see inset on page 54) is a solution that is both cost-effective and environmentally wise. The use of recycled materials is another appropriate choice. Australian architects, for example, often make use of wood recovered from dismantled former warehouses (see inset on page 130).

Are natural materials necessarily environmentally sound?

Obtaining the answer to this question will probably be much easier in the coming years, thanks to the full traceability of materials and the mainstreaming of labels describing all the components of a product, in line with regulations currently being prepared in several countries.

Ensuring summer comfort in a tropical zone: Valentim house in Brazil; architects: UNA Arquitetos.

BUILDING WITH RAW EARTH

As a building material, raw earth offers economic, social and ecological advantages: it is available on site and easy to apply, transport is negligible, and there is minimal waste. There are two types of techniques – rammed earth (a sort of concrete made of earth) and pre-fabricated earth bricks or blocks. In rammed-earth structures, the soil is compacted layer by layer between formwork using a rammer. The walls, which are about 50 cm thick, have high thermal mass. This ancient method spans the globe. The first traces of rammed-earth buildings were discovered in Pakistan, in the Indus valley, and remains have also been found dating from ancient Greek and Roman times, as well as in several sections of the Great Wall of China. A number of European countries likewise have examples of vernacular housing made of rammed earth. As it is a technique that requires an enormous amount of labour, and due to industrialised processes taking over from community methods of working, rammed-earth

construction was gradually sidelined, even in regions where workers are paid very little. However, it is currently being revived across the world, with variants – for example the guest house in China (see page 40) was built with raw earth without anything added, whereas for the house in Arizona (see page 148) described on page 148 the earth was stabilised with a 5% mix of Portland cement. In the second type of raw earth construction technique, pre-fabricated blocks are crafted out of adobe, clay and straw mortar, and compressed earth bricks. For adobe, a mix of clay, water and fibres (straw, woodwool or sawdust, hemp or even animal fur) is poured into wooden moulds that are removed after several days and the bricks are then left out to dry for two weeks in the sun. With compressed earth bricks, a mix of clay, silt and sand (often stabilised by chalk or cement) is compacted into manual or motorised presses. The most ancient remains of this technique, which have been found in Iraq, date from

about 7,000 years ago. Adobe vernacular housing can be seen in a wide array of countries, however, ranging from Peru to Togo, and from France to China. Yet the most spectacular examples are in Yemen, where most of the 500 five- to seven-storey housing blocks of Shibam date from the 16th century. The revival of earth construction over the past few decades owes much to the Egyptian architect Hassan Fathy, who used adobe to build the village of Gourna in the Valley of the Kings during the 1950s, as well as to André Ravéreau's work in the M'Zab, in Algeria. The Pinto house built out of compressed earth bricks (see page 144) is one of the 400 buildings constructed by the Indian architect Chitra Vishwanath in line with environmental design principles.

Yet it is not enough that a material be healthy or natural to make it environmentally sound. One must also check the amount of energy used to extract it, produce it, ship it and recycle it at the end of its life cycle. It takes 1 kilojoule to produce 1 kilogramme of wood (sawn and cut), but 42 kilojoules for 1 kilogramme of steel and 142 kilojoules for 1 kilogramme of aluminium. However, these figures must be balanced by the fact that aluminium is infinitely reusable and inexpensive to recycle, which explains why Glenn Murcutt has no qualms about using it. Quantitative data and objective answers can be produced by analysing the life cycle of materials, but the choices of designers and their clients also involve subjective factors, such as a desire to use wood cut in one's own forest or a type of stone that evokes childhood memories. Each place is unique and so is each family. The design of the house must take this into account to make the living environment suitable for all its occupants.

Architects serving users

The key challenge of sustainable development is how to make a shift to a more equitable and friendly society. Our future and that of our planet will depend upon the quality of human relations that we are able to establish and our ability to give to one another. This applies particularly to architects, who build structures in which men and women will spend most of their time. An architectural work is designed to serve, as Hassan Fathy explained in 1970 in *Architecture for the Poor*. The *Baukünstler* also see themselves as "service providers", and the cultural difference that characterises the Vorarlberg region (see pages 52 and 68) can be attributed as much to exchanges based on trust as on the population's sense of civic duty and pragmatism. The work of professionals in that region rests on moral values, a fondness for dialogue and a personal modesty that lead them to pool their capabilities. Going from the Austrian Alps to the Brazilian coast, from an intuitive approach to the systematic application of analytical grids, from wood to earth and from low-tech to high-tech, ecological architecture has many faces. The aim of this book is both to bear witness to this diversity and to highlight what these 25 remarkable achievements share, namely a common-sense approach tailored to local idiosyncrasies and the generous-hearted motivation of their designers.

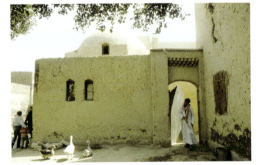

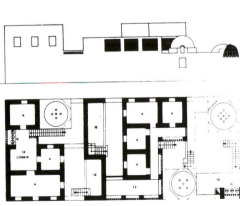

One of the houses in the village of Gourna in Egypt, built in the 1950s by the architect Hassan Fathy.

Energy efficient house in Pirmasens, Germany, 1998; architect: Bürling Schindler; energy consultant: Transsolar.
The house has two faces: a solid and opaque façade in the north-east (street side), and, in the south-west, a curtain wall that opens out to the forest, with two sliding sunscreens fitted with Douglas fir slats.

The ecological home: a few recommendations

Blending structures with the site

– Begin the design phase by surveying the site's idiosyncratic features, in terms of geography, geology, local culture and traditions, as well as vernacular architecture.

– Take into account landform, views and climate features: direction of dominant winds, maximum and minimum angles of sunlight according to the seasons, possible view blocking caused by relief and vegetation.

– Take into account any disamenities, such as the presence of a noisy road or railway, or of industrial operations producing unpleasant smells.

– Analyse what resources are available locally – e.g. forests, quarries, brick production, etc. and give priority to these products to limit the shipping of materials, a source of pollution.

– Tailor the structure to the terrain, by building as closely as possible to the natural slope of the land; limit excavation work and retaining walls, protect soils that have a fragile ecosystem.

– Preserve as much as possible the existing vegetation and opt for native species in selecting new plants.

Controlling the water cycle

– Select plumbing fixtures that save on water.

– Collect rainwater for watering the garden and possibly for use in flush toilets, or even to supply the washing machine.

– Naturally process waste water from kitchens and bathrooms through eco-pond systems based on filtration gardens planted with specific plants, such as irises or reeds.

– Plant the rooftop – either extensively, with a thin layer of substratum and sedum, or intensively, with topsoil and bushes.

A reasoned choice of materials

– Opt for materials that are renewable (e.g. wood), recycled or recyclable, or that do not require much energy to produce.

– Use materials recognised to be non-hazardous for human health – carefully screen surface treatment and finishing products.

– In choosing amongst products of similar quality, select materials produced locally to limit transport, a source of pollution, and to support the local economy.

Reduce waste and control its disposal

– Design and produce elements to the specific dimensions required to minimise offcuts.

– Opt for dry construction processes and workshop prefabrication.

– Set up a green construction site by sorting waste and limiting disamenities for neighbours.

Controlling energy needs for thermal comfort – heating, hot water and cooling

• "Passive" measures in relation to the building envelope, which are generally free or can be amortised in less than five years:

– optimise siting based on climate patterns;

– adapt the shape of the structure, making it compact in regions that have cold winters to minimise heat loss;

– size openings based on the amount of sunlight;

– in regions that have cold winters, use double-glazing, or even triple-glazing, with low-emission and high-transmission properties;

– set up optimised vertical and horizontal sunscreens to provide protection against sunlight in the summertime and let it into the house in winter;

– choose elements that draw on the benefits of certain materials with high thermal mass;

– strengthen the insulation of the building envelope;

– eliminate heat channels;

– check air tightness with the Blower Door system.

• Measures requiring additional investment, which can generally be amortised over a five- to 20-year period:

– a heat pump, if possible a reversible model that can cool the home in the summer;

– thermal solar collectors for domestic hot water;

– solar underfloor heating;

– dual-flow ventilation with a high-performance heat exchanger (mandatory to obtain certification under the Passive Housing label);

– masonry wood-burning stove, which delivers better heating performance than an open fire;

– an earth energy system (underground pipe system) that pre-heats incoming air in the winter and cools it in the summer;

– energy-efficient appliances (A-rated).

Control of energy needs for visual comfort: natural and artificial lighting

• "Passive" measures related to the building envelope, which are generally free or inexpensive:

– appropriate positioning and size of the openings;

– high-quality glass;

– fixed and mobile sunscreens to avoid glare.

• "Active" measures that can be amortised quickly through savings on energy consumption:

– energy-efficient appliances (A-rated);

– using low-consumption lightbulbs.

Towards a healthy home: Interview with Suzanne Déoux

Suzanne Déoux, M.D. and Ear, Nose & Throat specialist, has made the relationship between housing and health the core of her work since 1986. She is an expert consultant to manufacturers for health assessments of building industry products and equipment, and is a frequent lecturer in training sessions for building industry and health professionals.

What is the impact of housing on the health of the population?
The home is the primary human environment: in industrialised countries today, people spend nearly 60% of their time inside their homes. It is also the environment that can most easily be improved by taking a proactive approach to risk prevention. Alongside genetic makeup, individual lifestyle and the quality of medical care, it is one of the four key factors that determine the health of a population, according to the World Health Organization (WHO).

What are the risks that occupants can face from the environment within their buildings?
First, buildings are meant to protect occupants from outside threats, so they must clearly not become sources of indoor harm! But, secondly, you have to distinguish the concepts of hazard and risk, because the presence within the building of a hazardous substance does not necessarily imply a risk. There may be, within the building structure, chemicals or physical or biological agents that are inherently toxic, and therefore hazardous. However, there will be no risk if these toxic agents cannot migrate to the indoor environment, to the air or to the water, and if there is no possibility of respiratory, digestive or skin-level exposure. Risk is therefore determined by the probability of exposure to a hazard, but also to the sensitivity of the persons potentially exposed – which may be higher for children and elderly or ill persons.

As an example, the drive to curb energy consumption from homes has led to the use of thermal insulation materials, some of which include mineral or organic fibres. In 1998, France's national institute of health and medical research (Inserm) issued a report on the health effects of asbestos-substitute fibres, in which it concluded that "any new fibre marketed as a substitute for asbestos, or for any other use, must be suspected, until proven otherwise, of being pathogenic." Hazards related to fibres depend on their shape, their size, their chemical makeup and their persistence within the lungs. But risks remain practically nil if the fibre-based insulating material is hermetically sealed between two panels and cannot contaminate the indoor air, so that there is no possibility that the residents will be exposed. As an example, France's agency in charge of monitoring air quality recorded no difference between the outdoor and indoor concentrations of artificial mineral fibres in homes in the course of a 2001 survey of 90 homes.

What rules should be complied with in order to design and build healthy housing?
A healthy home depends first and foremost on its environment. In siting buildings, we cannot ignore obvious factors such as exposure to winds, which carry many pollutants, but also pollens from allergy-causing plant essences that may be located nearby. The nature of the soil and subsoil can also have a significant impact on the health of occupants, if suitable measures are not taken during the building of the home. In granite-rich regions, as an example, ensuring suitable airtightness of the connection between the ground and the building structure can prevent the seeping in of radon, an odourless radioactive gas that has a carcinogenic effect on the lungs. Sound factors must absolutely be taken into account, and not only for reasons of comfort.

Noise is a disamenity that one household out of three complains about by day and one out of five by night, according to the Housing 2002 survey conducted by France's national institute of statistics and economic studies (Insee). Exposure to excessive noise raises secretions of the stress hormones (noradrenalin, adrenalin and cortisol), which have a well-established connection to cardiovascular risks. Further, noise alters the structure of sleep and prevents the body from obtaining the physical and psychological recuperation it needs; it can never adapt to this type of sensory pollution. Having a power line nearby or a transformer within a building can alter the electromagnetic environment and expose residents to 50-hertz magnetic fields of an intensity of over 0.4 microTesla, which for children has been correlated with an increase in the risk of leukaemia.

How can you improve the feeling of well-being in housing?
You need both a certain degree of comfort and satisfactory health conditions. Well-being is the common denominator between comfort, known as "all that contributes to well-being," and health, understood, in the WHO's definition, as "a complete state of physical, mental and social well-being." Discomfort, whether caused by humidity, temperature, noise, visual factors or smells, can become pathogenic.
Various factors play a major role in the physiological and psychological balance of residents. First, spatial comfort is often neglected by those who describe housing units in terms of square metres rather than cubic metres, which would take into account the idea of a minimum volume of air per person. The height of ceilings is often lowered for economical reasons. Very often, the underlying design of housing units does not provide for direct entry of outside air and natural light in bathrooms and toilets. Under such condi-

tions, it is only through excellent operation of extractor fans that water vapour and odours can be removed from these rooms, to avoid the development of mould. "Air fresheners" are also used, which are a source of volatile organic compounds.

Based on what criteria should you choose building materials?
To create a healthy indoor environment, you need to use construction materials that do not undermine air quality inside the home. The health-related features of all products, natural or artificial, should be assessed and made known to the people involved in recommending, choosing and using building materials. For all materials, one needs to know the levels of volatile organic compounds and aldehydes, as well as the extent to which they promote the growth of microorganisms, particularly moulds. Measurements of natural radioactivity are only needed for materials extracted from the Earth's crust or derived from industrial by-products. As for fibrous insulating materials, whether of mineral, plant or animal origin, information needs to be provided on the size of the fibres and their biopersistence in the lungs, as well as on the chemical composition of bonding agents and additives.

Energy efficiency in housing is essential, but should not be achieved at the expense of suitable air renewal. The gradual deterioration in the quality of indoor air through lack of proper ventilation has an economic and human cost – the increase in health problems attributable to excessive confinement. But because healthcare costs are harder to quantify than energy bills, they are often overlooked when the approach to building design is not all-encompassing.

What can users do?
Occupants can act directly on the sanitary quality of their home and need to become managers of their own quality home health.[1] They should be aware that their behaviour can undermine or even cancel out the beneficial effects of a well designed home. A human presence in an enclosed space is itself a source of bio-effluent, water vapour and carbon dioxide (CO_2). When there is not enough air renewal, concentrations of humidity and CO_2 rise – and high carbon dioxide is an indicator of excessive confinement. Some activities can also affect indoor air quality, with the main pollutant being tobacco smoke: this complex mix of gasses and fine particles includes about 4,000 identified compounds, of which over 43 are carcinogenic. It is also unfortunate that domestic needs as basic as drying laundry, which raises humidity levels significantly within the home, are often forgotten in the design of homes, with no dedicated rooms being planned. The health of residents can also be negatively impacted by poor maintenance on technical equipment, especially boilers; by the use of cleaning products that may produce harmful emissions; and by the spraying of insecticides or of air fresheners – which add substances that mask odours but do not neutralise the molecules causing them.

How can we promote the mainstreaming of healthy homes?
We need buildings that protect both the environment and the health of their occupants. This can only be achieved if the buildings are planned, designed and constructed to ensure that residents can enjoy healthy and pleasant living conditions within functional spaces, whilst seeking to conserve energy and natural resources. But even the greenest buildings need to be used and maintained appropriately to remain beneficial. That is why living in healthy homes requires the commitment of all involved.

19

[1] See Drs Suzanne and Pierre Déoux, *Habitat Qualité Santé*, Medieco, Andorra, 1997.

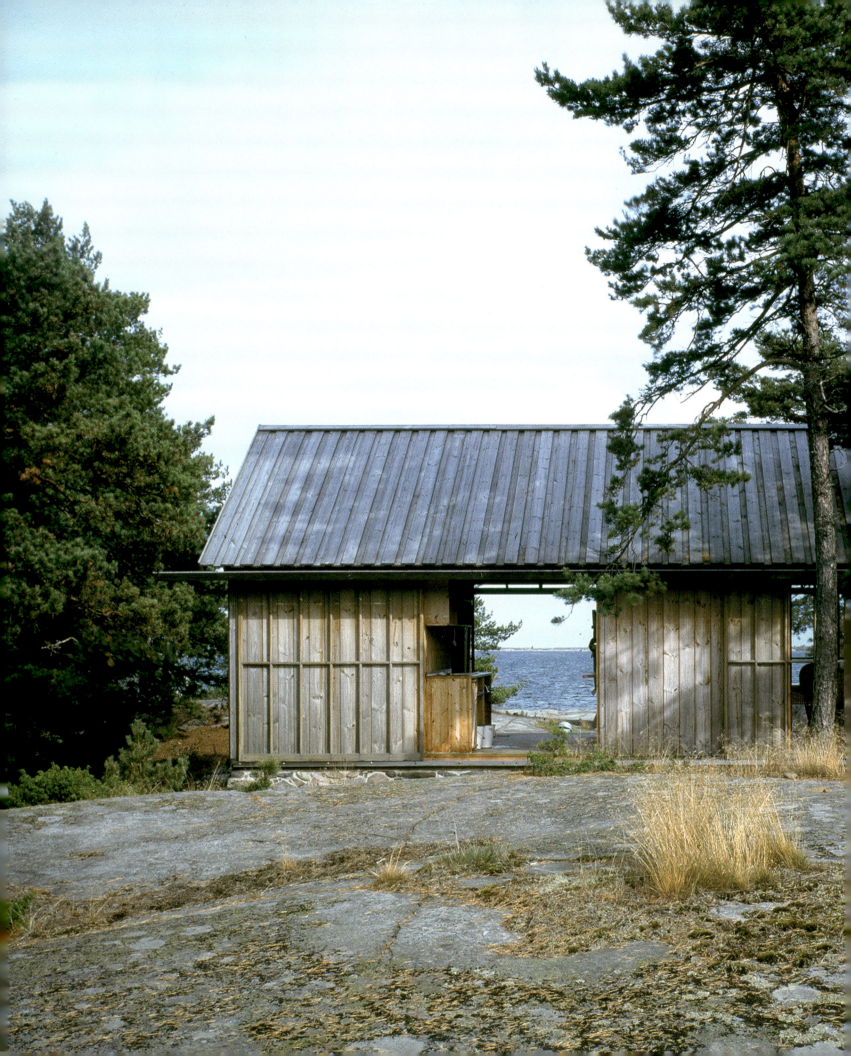

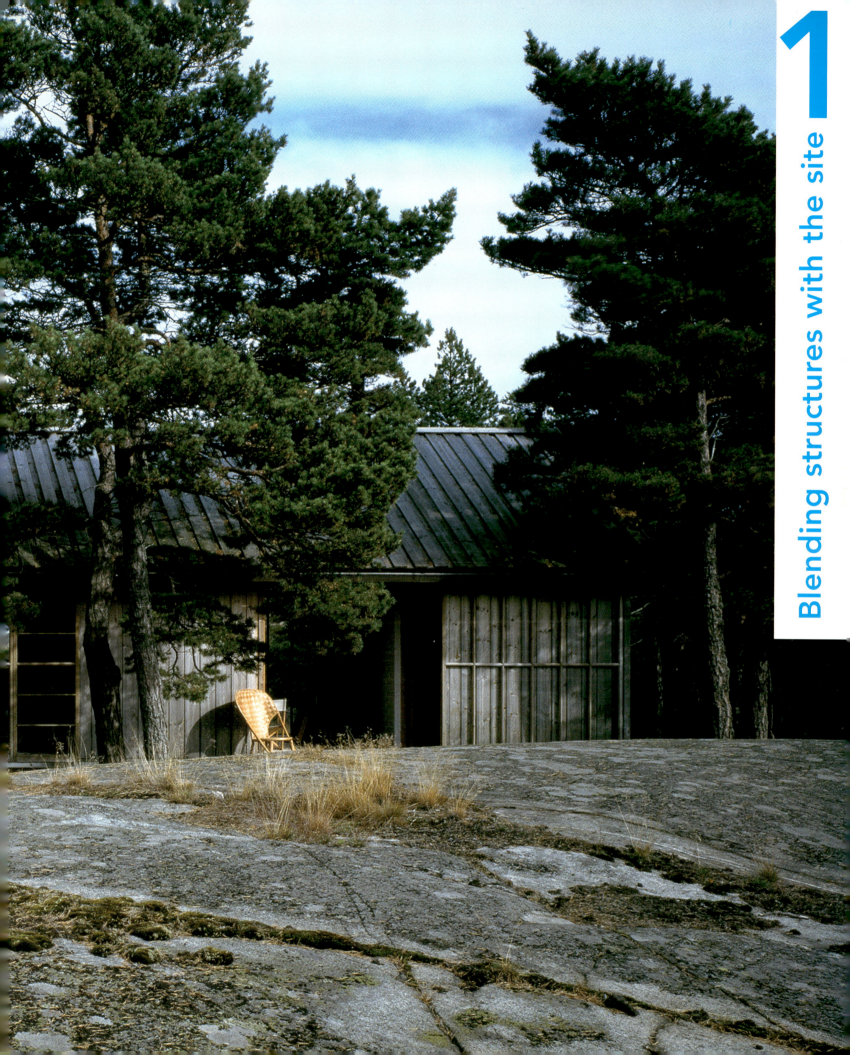

Log cabin in the Hiittinen archipelago, Finland
Kristian Gullichsen

The very essence of the Finns' national psyche lies in their ambiguous relationship with nature, which can be described as a combination of love, respect and fear. This rapport is clearly illustrated in the architecture of Finland – a country with a low population level and still steeped in pagan traditions. The propensity to build log cabins deliberately stripped of modern comforts is underpinned by a desire to rediscover the slow pace and movements of rural life, whilst making the most of the well-being generated by sunshine, light and warmth during Finland's all-too-short summers.

Together with his family and friends, the architect Kristian Gullichsen constructed this modest holiday home on a seven-hectare island in the archipelago stretching between Helsinki and Porvoo. Perched on a cluster of rocks by the sea, the cabin hugs the curves of the landform. The lightness of wood not only makes it easier to self-build but also allows for the structures to be assembled on sites that are difficult to approach whilst preserving fragile natural habitats.

The cabin's design is grounded both in Hiittinen's traditional architecture and in the Moduli, a low-cost, lightweight modular holiday house constructed out of wood, designed in 1974 by Kristian Gullichsen and Juhani Palasmaa. Set on a tight layout grid, the cabin stretches along a north-south axis, topped by a pitched roof. There is an alternation of solid and transparent components, based on a 2.10 metre-pattern. There is one bay for the bedroom, four for the living room and dining room, one for the covered terrace and another – at the far northern end – for the cloakroom and sauna. Two opposite-facing sliding glass doors are incorporated into the east and west façades. These extend the living room out to east- and west-facing natural terraces formed by the outcrop of granite rocks, and which respectively enjoy the morning and afternoon sun.

A low base made of stones collected on site was used to level out the uneven rocky ground. The lightweight conifer frame is clad in panelling laid vertically on the outside and in a horizontal, grooved arrangement on the inside. The exterior boards are unjointed, in tune with traditional design solutions whereby the upper layer of boards protects the joints of the lower layer. The gutters were hollowed out of tree trunks, and the roof is supported by exposed triangulated trusses, with the principal rafters (which also serve as the spars) bracing the tie-beams. The wooden floor and plain furnishings are likewise made of local evergreen.

The dwelling does not have any running water. Fresh water is drawn from a nearby spring, and the sauna is used as a bathroom. When the light fades at the end of the day, candles are lit. A cast-iron wood-burning stove stands in front of a brick wall that separates the bedroom from the living room, warming the air when the evenings grow chill. Once the autumnal storms begin, the cottage is closed up until the following summer, and blends into its natural surroundings.

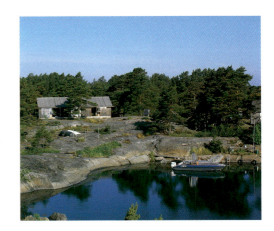

site: island in the Hiittinen archipelago, Finland — programme: single-storey summer house comprising living room/dining room, bedroom, verandah, cloakroom and sauna — client: Gullichsen family — architect: Kristian Gullichsen — habitable surface area: 63 m² — schedule: self-built project spanning several years, completed in 1993 — materials and construction system: wall structure, interior and exterior cladding, structural frame, roof, wood floor, furnishings and sliding door frames in local conifer — environmental measures: minimum impact on the site and environment in general (no running water or electricity, and heating by wood-burning stove); use of untreated local timber and stones collected in situ.

Many Finns dream of having a log cabin with a sauna, set in the midst of trees. Most of them build their cabins with their own hands, on the shore of a lake or the Baltic sea.

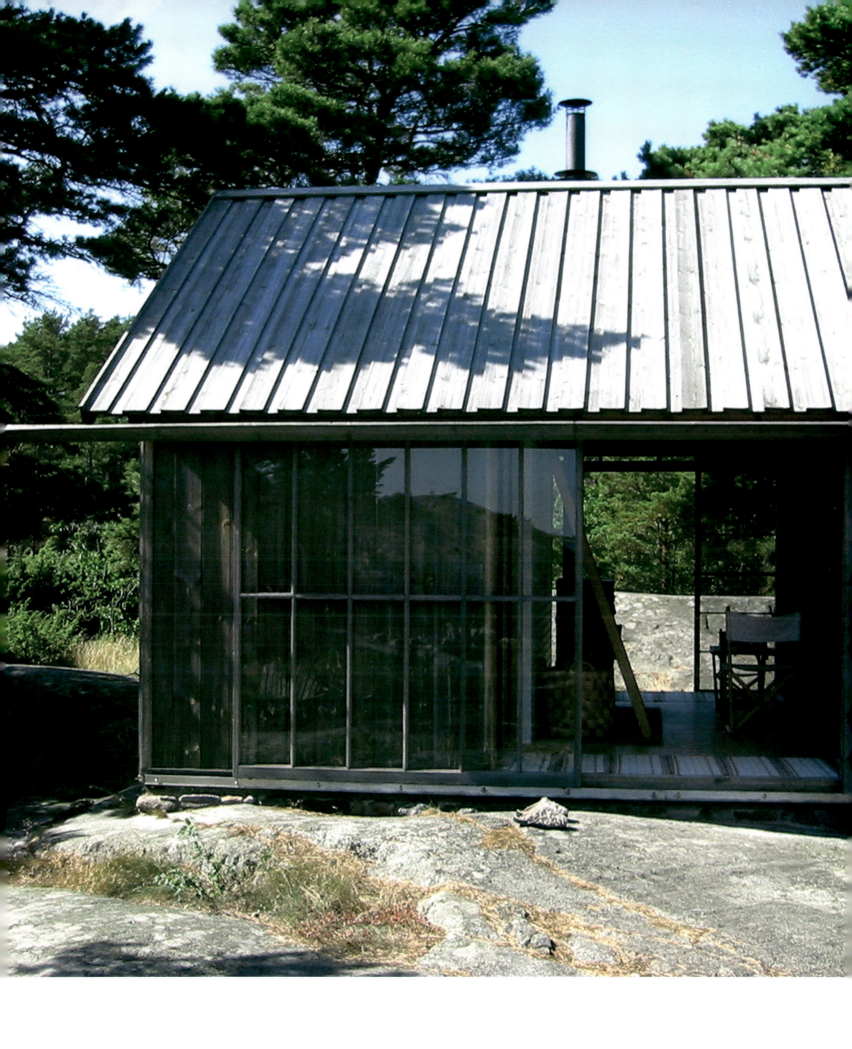

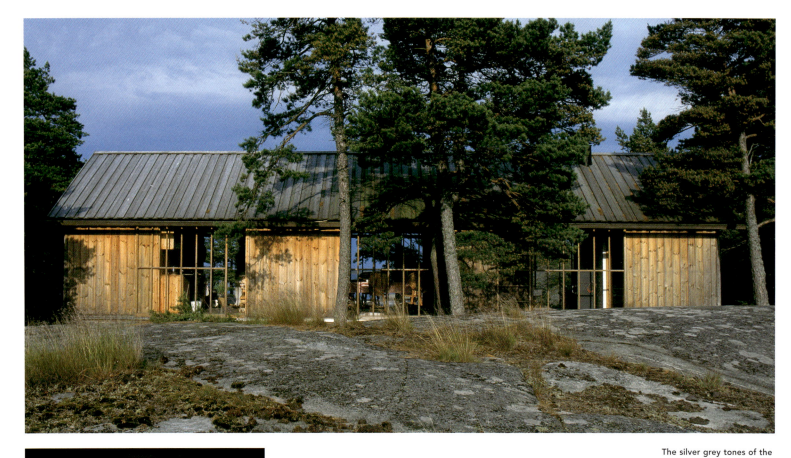

The silver grey tones of the timber cladding and roof change hue according to the weather.

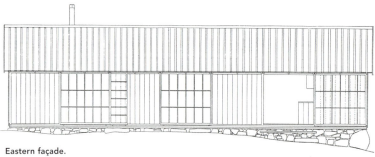

Eastern façade.

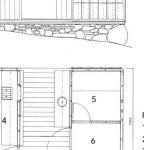

Plan.
1 bedroom
2 living room
3 dining room
4 kitchen
5 sauna
6 cloakroom-storage area

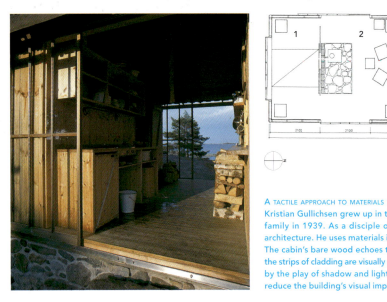

A TACTILE APPROACH TO MATERIALS

Kristian Gullichsen grew up in the Mairea villa in Noormakku designed by Alvar Aalto for his family in 1939. As a disciple of the Finnish master, he has adopted a tactile approach to architecture. He uses materials in a highly sculptural way, showcasing their texture and colour. The cabin's bare wood echoes the colour of the rocks and pine trunks. The bands created by the strips of cladding are visually extended by the boards of the roof, which form ribs underscored by the play of shadow and light. These striations breathe life into the structure's surface and reduce the building's visual impact on the environment.

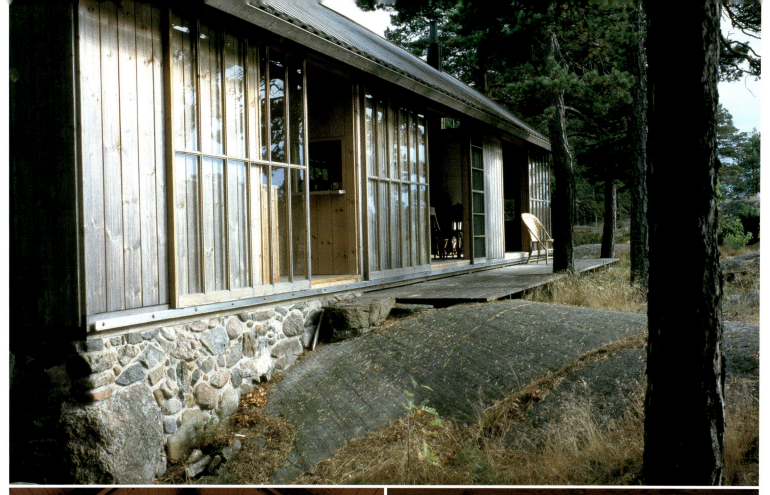

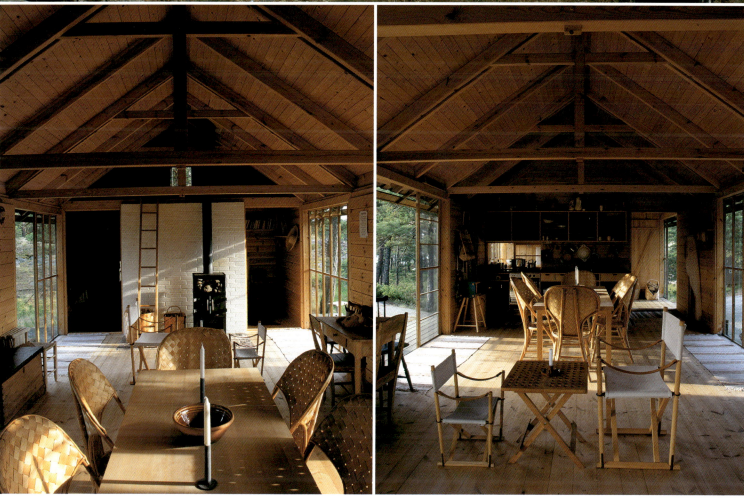

Reconstruction of a house in Sydney, Australia

Glenn Murcutt and Wendy Lewin

Glenn Murcutt is convinced that a person acting alone can change the course of events – a belief that is borne out in the international impact of this Australian architect's works and teachings. His winning of the prestigious Pritzker Prize in 2002 testifies to the profession's growing interest in ecology as well as to its respect for Glenn Murcutt's architectural craftsmanship. As an admirer of the "genius of nature" he fights against wasting energy and raw materials, fashioning skilfully simple structures. Since he founded his practice in 1969, his testing ground has been residential design. To date, he has built almost 500 "houses for inhabiting the landscape". His corrugated-iron "shed houses" that lightly touch the earth in the Outback have attained worldwide renown. However, he also works on renovating and extending ordinary urban dwellings – modest projects that he designs by hand with as much care as his more spectacular buildings. Together with his wife Wendy Lewin (a former student of his at Sydney University), Glenn Murcutt has recently restructured the place in which he has lived and worked as a sole practitioner for the past 40 years – a house of small, long and narrow proportions, located in one of Sydney's suburban residential districts built some one hundred years ago. Made of exposed bricks and topped by a tiled roof, it sits on a 6.55 metre-wide plot that slopes north-west. By means of roof projections and digging out half of the space underneath the house on the garden side the habitable surface area was doubled without flouting local building codes. Despite extremely strict constraints, the wager paid off. A colonial dwelling with dark, tight rooms has been metamorphosed into a large, airy and light-filled space.

There are three levels altogether, each of varying heights, which slot precisely into one another. The architectural practice is located on the garden level, the main residential part is on the ground floor, and there is a second bedroom with storage space under the eaves. The volume of this bedroom was almost doubled via two strips of glazed rooflights in the north-east that capture both the morning sun and cool sea breezes. Adjustable exterior metal-slat blinds enable the occupants to regulate the intensity of light and solar gains.

As the house is located in a listed historical area, the front wall had to be kept in its original form. However, the north-west end wall, which in the southern hemisphere soaks up the sun's dying rays, was converted into a wall of steel and glass. Fixed and mobile devices are attached to this geometrically variable "skin", so that it can be adapted to seasonal weather conditions. Most of the pre-existing flora – which was meticulously noted in the plans – has been preserved, and the views out from the glazed wall are channelled towards a small garden, where an old mimosa tree reigns in glory.

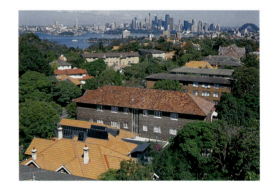

site: Sydney, Australia — programme: renovating and extending a semi-detached town house with associated architectural practice; basement – cellar and technical equipment room; garden level – office and archive space; ground floor – entrance, bedroom, bathroom, kitchen, dining room, living room; under the eaves – bedroom with bathroom, attic — clients: Glenn Murcutt and Wendy Lewin — architects: Glenn Murcutt and Wendy Lewin, Sydney — surface areas: plot – 257 m²; residence – around 120 m² (habitable); architectural practice – 31 m² (useable) — schedule: design period – 1999; construction period – 2004 — materials and construction system: exposed brick walls; timber floor structure and structural frame; north-west end wall in laminated glass set in a lacquered steel frame with hardened glass openings; wood flooring in the practice and living room; timber sunscreen in the practice; tiled roof — environmental measures: combining work and living space; enhancing the architectural heritage of a listed suburban area; preserving pre-existing vegetation; using construction techniques that help create natural light and ventilation; converting the north-west wall into a glazed wall that can adapt to weather conditions by means of fixed and mobile devices.

Glenn Murcutt has metamorphosed the small colonial house where he has lived and worked for the past 40 years.

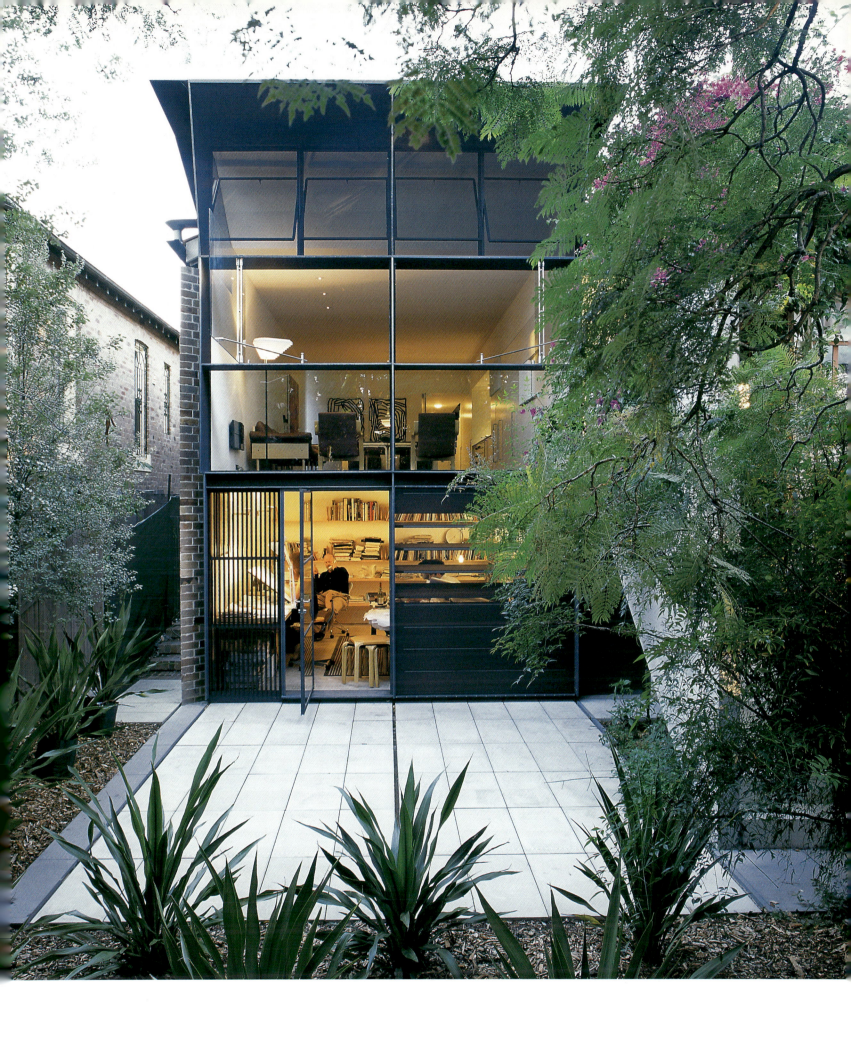

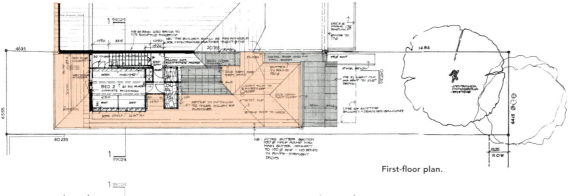

First-floor plan.

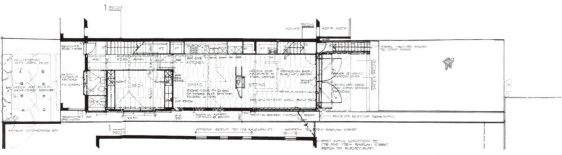

Ground-floor plan.

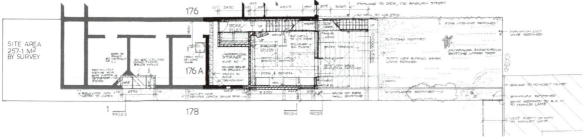

Garden-level plan.

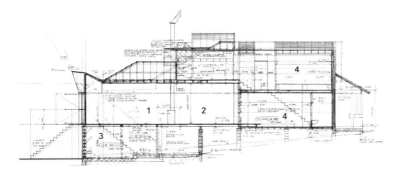

Longitudinal section.
1 living room
2 dining room
3 practice
4 bedroom

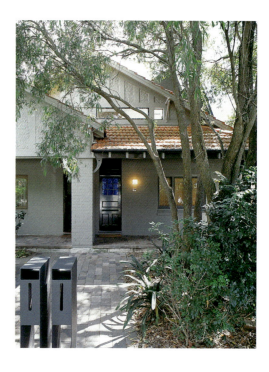

28

BLENDING STRUCTURES WITH THE SITE

GLENN MURCUTT, CRAFTSMAN OF ECOLOGICAL SINGLE-FAMILY HOUSES

Glenn Murcutt's love of nature and the Australian landscape goes back to his childhood. His first sources of inspiration were drawn from Mies van der Rohe's plain designs as well as from Aboriginal culture and the vernacular architecture of the many countries he has visited. His highly characteristic style also bears the traits of Alvar Aalto's Nordic modernism, and his craftsman's handling of industrial products, which he often employs in ways other than for which they were originally intended, can assuredly be traced back to Pierre Charreau's Glass House. Very early on, Glenn Murcutt, who refuses to build outside Australia, chose to do "extremely ordinary things extraordinarily well" and to do them on his own. This method of carrying out all of the project phases himself reflects his underlying philosophy. The essence of his schemes lies in his careful analysis of each site and the dialogue he strikes up with his clients, as well as with his engineers and craftsmen who have become his friends. Having worked out an initial design solution and its variants, he draws up the plan and sections, with the façade following on naturally. In the final phase, he eliminates everything that seems superfluous to him. Glenn Murcutt's clients, who are mostly from Sydney's intellectual middle-class, book him three to five years in advance due to his busy schedule that has resulted from his success and renown.

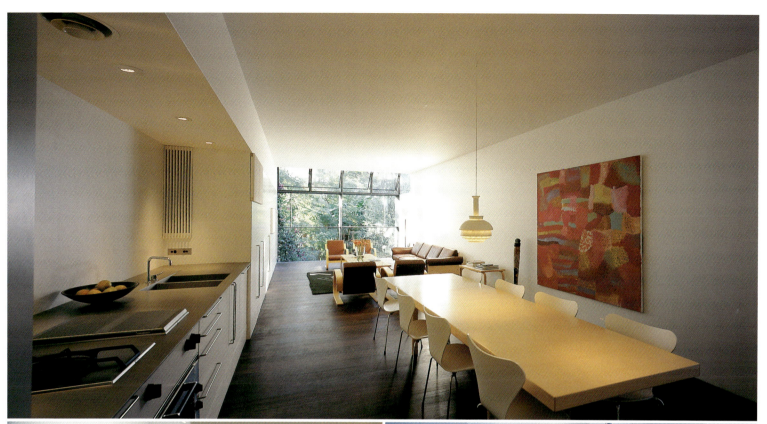

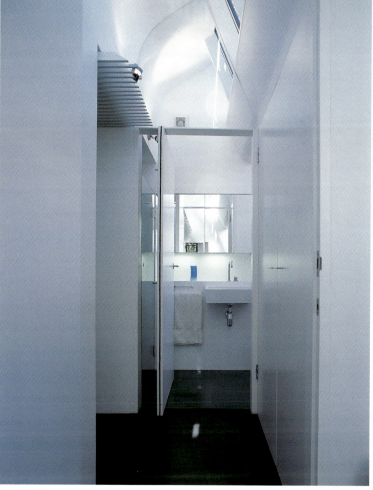

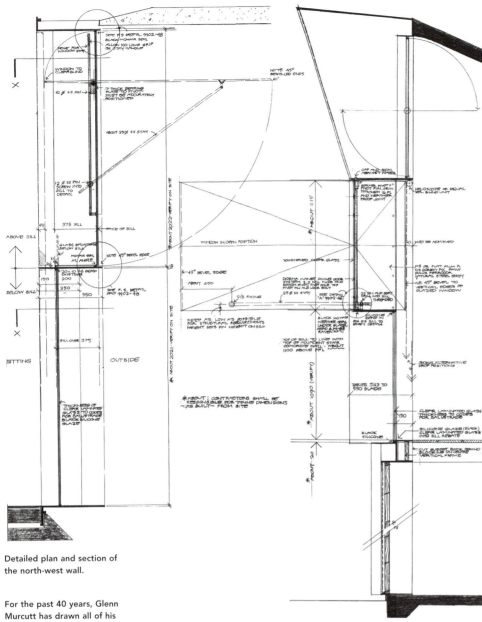

Detailed plan and section of
the north-west wall.

For the past 40 years, Glenn
Murcutt has drawn all of his
designs by pencil or ink on
tracing paper. His sketches,
plans, sections and construction
detail drawings always feature
hand-written comments.

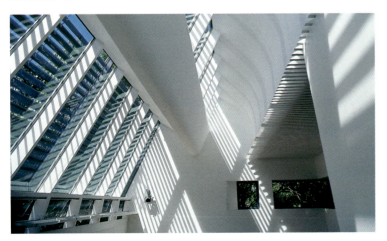

A GLAZED END WALL THAT CAN BE ADAPTED TO WEATHER CONDITIONS

The new north-west end wall stands between the party wall and the exposed brick façade. Made of glass and wood and set in a steel frame, it was designed to passively provide its occupants with thermal comfort and views out to the exterior in every season. On the upper part, an overhang and metal sections shelter the wall from rain and halt the sun's rays in summer. Swivelling imposts, protected from insects by a retractable fly screen, help evacuate hot air. In front of the living room, two large frameless glass openings are set on vertical pivots above a high, deep glazed spandrel, and can be swung open out to the garden. Fronting the office on the lower level, wooden slats filter the light and the sun's rays, through fine vertical strips near the door, and through wide horizontal strips that can be manually oriented, behind the window. The garden's thick greenery creates a preliminary natural curtain and slightly cools the air.

NB. Some of the references to Glenn Murcutt's projects are based on articles by Françoise Fromonot featured in *D'Architectures* review and in her book entitled *Glenn Murcutt* published by Gallimard, Paris, in 2003.
The layout and graphic design of the sections and plans were kindly authorised by the *D'Architectures* review.

Partially buried house at Causse de Gramat, France

Gouwy Grima Rames

The Causse de Gramat is a limestone plateau covered in a fine layer of arable soil. Sheep and goats braying amidst the dry stone are the only animals that can graze on the perfumed tufts of grass sprouting on the gravelly ground beneath juniper trees and young oaks, around which truffles can sometimes be found. This unwelcoming environment with a hot microclimate is scarcely populated and has a fragile ecosystem. Any building that is constructed in such a harsh, isolated spot must not only respect, but also be protected from, its natural surroundings.

The architecture of this single-storey house located in Séniergues, in the heart of 40 hectares of grounds, is based on a rural, rational and common-sense design concept that followed an in-depth analysis of the site's landform, access, views and vegetation. The choice of the structure's raw material sprang from the site's *genius loci*, and the initial ideas were conceived on site.

The house sits at the top of an arid hill. Mirroring the local architecture that can be found in the Causses du Quercy, its walls are made of local limestone blocks assembled without using mortar – except for several load-bearing components on the south façade, which are made from white concrete blocks. Only the chimney and a small stone wall emerge from the upper part of the site. The decision to bury the north façade was made on several counts: to shut out the noise and sight of the A20 motorway that gashes the hill facing the house; to provide protection from the northerly winds; to ensure a continuum with the pre-existing landscape; and to gently introduce a contemporary form of architecture into an unspoilt site. Fortunately, the owner – a retired waterproofing entrepreneur – was not against the idea of a home devoid of a traditional gable roof.

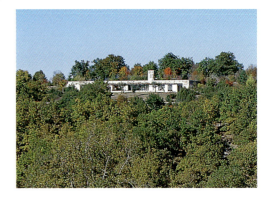

Skilled at adopting a pragmatic environmental approach, Gouwy, Grima and Rames concentrated on the architect's primordial role, namely meeting the requirements of the building's users and fulfilling their current and future needs. This private house was first and foremost designed for young and older people to live in on a daily basis. Its architecture is plain, stripped of superfluous elements. Its rigorous volumetric design showcases the tactile aspect of bare stone, whose colour and texture is set off by the natural light. Stone not only boasts aesthetic qualities and a deep-rooted relationship with traditional techniques and craftsmanship, it also enjoys a number of technical advantages. It has high thermal mass, is long-lasting and easy to upkeep, and weathers handsomely over time.

The living room and bedrooms open out onto a few square metres of lawn – an oasis of green girded by low stone walls and shielded from the sun by the shade of a vine arbour. At the end of the construction phase, local species of foliage were re-planted, including the surface of the roof, in order to restore the site's covering of loose stones and vegetation that existed before the building work.

site: Séniergues, Lot, France — programme: single-storey main residence, with open-plan living room and kitchen with eating area, bedroom with large bathroom, bedroom with smaller bathroom, interior courtyard on the north side, large terrace on the south side, study with independent access — client: private — architects: Laurent Gouwy, Alain Grima, Jean-Luc Rames, Toulouse — surface areas: plot – 40 ha; house – 156 m² (habitable); garage and ancillary buildings – 45 m² — schedule: design period – 1998; construction period – October 1999 to July 2000 — construction cost: EUR 198,200 incl. VAT — materials and construction system: 20 cm cement block walls with 9 cm-thick mineral wool on the inside and exposed 25 cm stone for the exterior facing; white concrete block load-bearing components (19 x 19 x 39 cm) on the south façade; metal I-beams forming a lintel above the glazed openings, supported where necessary by round steel posts; aluminium joinery with double glazing; fired-clay 20 x 20 cm interior floor tiles; polished concrete terraces; rooftop planted with greenery on a hollow-block concrete deck insulated with 10 cm-thick polyurethane foam and featuring a bitumen felt multi-layer waterproofing system; galvanised steel wire supporting the vine arbour and stretched over metal posts; granite-like "black forge" paint (Oxiron Titan) used for surfacing all the steel frames — environmental measures: house partially buried into the ground so that it fades into the landscape and benefits from the high thermal mass of earth; use of local limestone based on a traditional dry-stone technique; flat roof planted with local vegetation; exterior slatted aluminium blinds and vine arbours on the south façade to minimise overheating in summer — specific equipment and fittings: open fire in the living room; underfloor heating using water-filled coils heated by a fuel-oil boiler.

Drawing on critical regionalism, Gouwy, Grima and Rames combine a range of traditional references with contemporary minimalism.

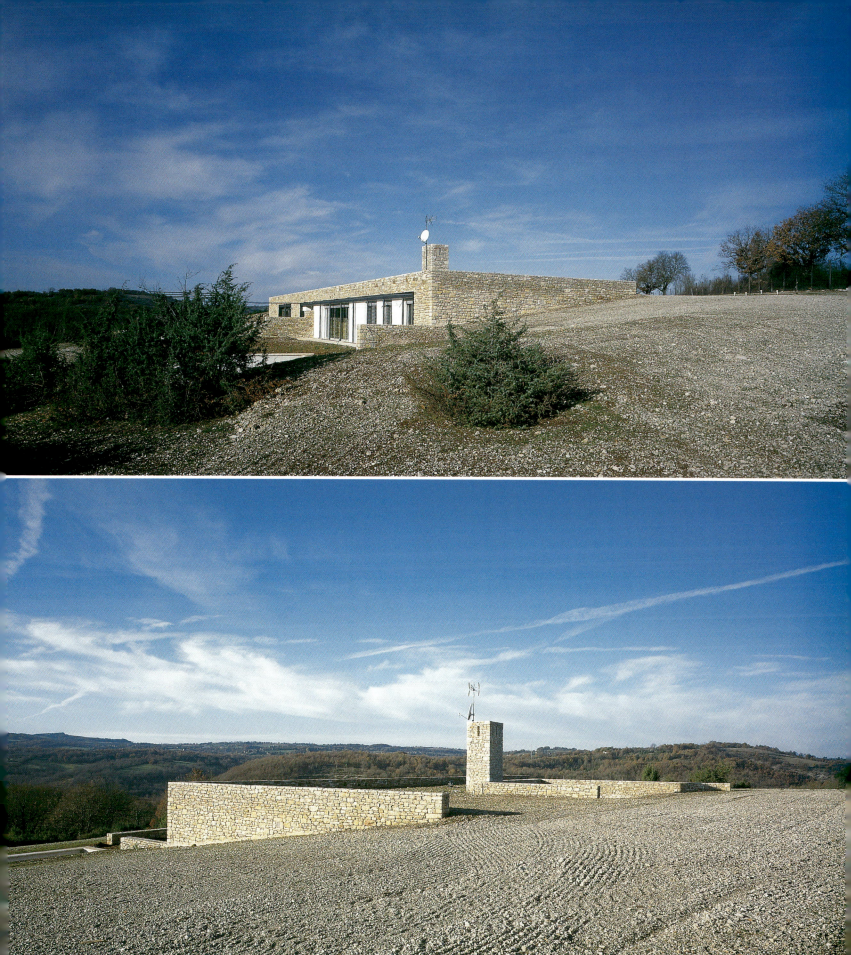

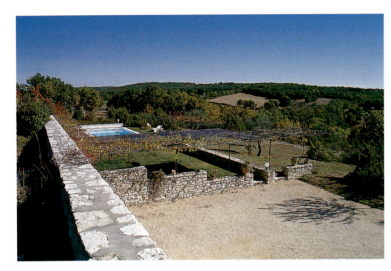

Section of the external wall.
1 local limestone (25 cm)
2 cement blocks (20 cm)
3 air gap
4 thermal insulation using rockwool (90 mm)
5 plasterboard (13 mm)
6 polished concrete terrace
7 reinforced concrete slab
8 cement screed with integrated underfloor heating and fired-clay flooring
9 plaster rendering
10 hollow-block deck
11 vapour barrier
12 polyurethane foam insulation (90 mm)
13 multi-layer waterproofing
14 anti-root protection
15 topsoil

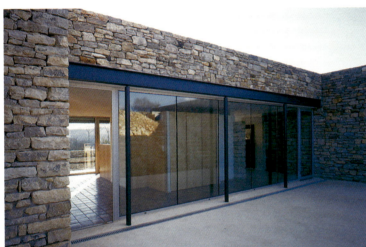

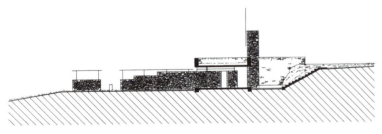

Cross section.

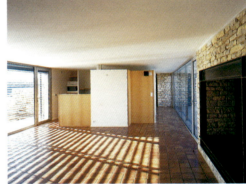

The concept of extending the house out to the exterior is drawn from vernacular housing and creates a transition between unbuilt and built areas, between public and private space, and between past and present.

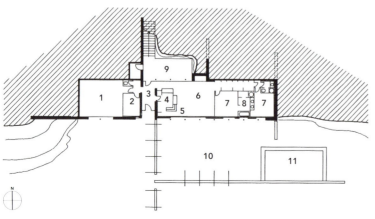

Plan.
1 garage
2 study
3 entrance
4 kitchen
5 eating area
6 living room
7 bedroom
8 bathroom
9 interior courtyard
10 terrace
11 swimming pool

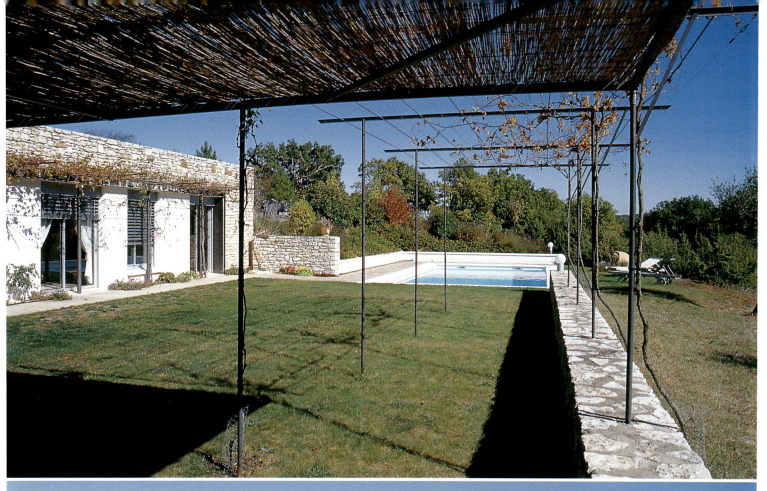

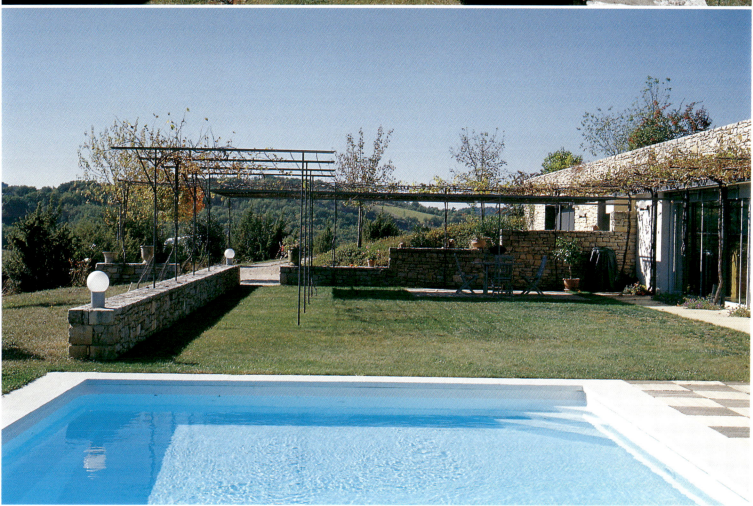

Town house and studio in Montreal, Canada

Scheme/Marc Blouin with François Courville

36

BLENDING STRUCTURES WITH THE SITE

In order to ensure sustainable development of our planet we need to begin by logically managing ground use, particularly in large towns and cities. Montreal is a city that encourages the construction of houses with party walls, as well as the conversion of former industrial sites and even religious buildings into semi-collective housing, with a view to increasing the density of urban and suburban areas. This town house and graphic design studio by the Scheme architectural practice demonstrates that we can slow urban sprawl and offer families highly salubrious and luminous accommodation in the city centre, in dwellings that fall midway between individual and collective housing. The house itself stands in the 1920s working-class district of Villeray, where two- to three-storey terraced buildings line the streets, with direct access on each level. Integrating a new building into an existing fabric always raises a number of questions, such as how it should be positioned within the urban framework, what design should be adopted, and what it should be used for – all determining factors for a district's daily life. The scheme offers continuity, both in terms of alignment and the use of brick for the structure's façade, whilst at the same time breaks with the surrounding volumetric design and architectural vocabulary. It makes optimal use of a deep, narrow plot measuring 6 m by 26 m. The front and rear façades were positioned on the edge of the developable zone, so as to create a central patio around which each functional component of the plan is structured. Set along an east-west axis, the house features a long, narrow layout grid for circulation and service areas (kitchen, bathroom and technical equipment room), with a wider block for the main rooms that open out both onto the façades and the patio. The graphic design studio, living room and bedroom face the street (rue de Gaspé), whilst the dining room and small bedroom above the kitchen overlook the courtyard. Untreated wood was used for the flooring of the ground level (both in the rooms themselves and in the patio), reinforcing the sensation of uniformity.

The studio is partially buried into the ground. It can be accessed from the street and is separated from the private ground-floor areas. It is double height, thanks to an opening in the living room floor structure, and receives natural light from the street-facing façade. This astute interweaving of space means that clients can visit the studio without entering the private living quarters. There are two interior staircases (the steps leading to the first floor being positioned opposite the patio), which also facilitates the division of living and working space. The layout of the windows and doors capitalises on natural ventilation, cutting out the need for air conditioning. By playing on the split levels, partially hollowing out the built structure, and reducing the height of the wider grid on the courtyard side, the architects managed to draw daylight into each room and energise volumes by alternating between interior and exterior space. As a result, the whole site has been transformed into habitable space.

site: 7770, rue de Gaspé, Montreal, province of Quebec, Canada — programme: town house with combined work space; basement – studio and ancillary areas; ground floor – living room, dining room, kitchen and patio; first floor – two bedrooms and bathroom — clients: François Courville and Andrée Lauzon — architects: Scheme/Marc Blouin, Montreal; landscape designer: François Courville; other project team member: Philippe Lupien — structural engineer: Génivar group — prime contractor: RSP Construction, Normand Belair — surface areas: plot – 156 m²; house: 250 m² (habitable), including 23 m² studio — schedule: start of design period – 1999; construction period – May to September 2000 — construction cost: EUR 110,000 incl. VAT (materials and work) — materials and construction system: brick party walls; timber-framed façades with ventilated 4-cm cavity and brick facing; exposed interior frame in glued-laminated pine; unexposed structural frame made of spruce (Canadian conifer); joinery, steps of the interior staircase and patio floor made of rough-sawn hemlock (Canadian conifer); sanded and varnished walnut wood floor; plasterboard interior cladding; two retractable, garage-like glazed doors to close off the patio — environmental measures: increasing the density of city-centre housing, blending the structure into a historic quarter, combining work and living space, creating a central patio to let in daylight and natural ventilation into a deep and narrow grid, using renewable and recyclable local materials (Quebec wood and fired-clay bricks made in Montreal), partly planted rooftop, forced-air heating powered by an individual boiler that runs on natural gas.

When the two glazed retractable doors are raised, the patio becomes another room in itself.

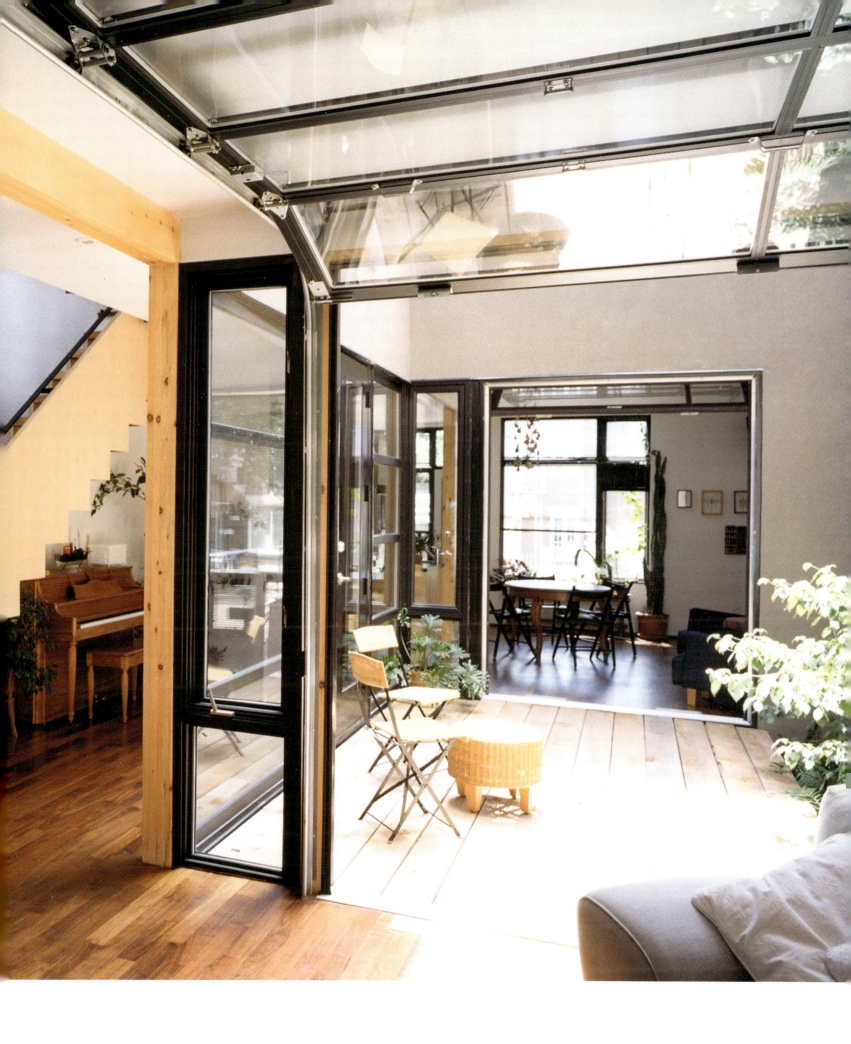

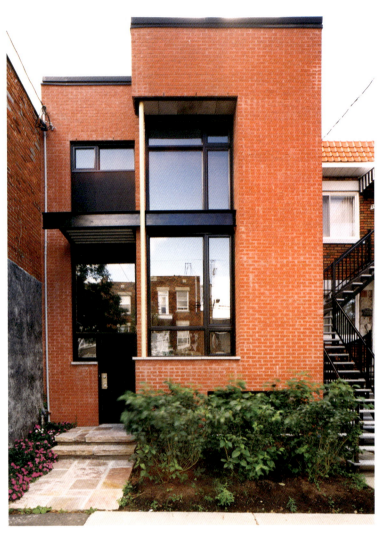

The large bay windows overlooking rue de Gaspé light the living room and studio.

INCREASING HOUSING DENSITY TO COMBAT URBAN SPRAWL

Rural exodus and high population levels in towns and cities whose boundaries are being pushed further and further out are two major issues that face today's society. 50% of the world's population live in urbanised areas. Every continent is affected, whether it be in industrialised countries where people are drawn to towns in search of work, or developing regions, where demographic levels are rising sharply. Urban sprawl has disastrous consequences for both nature and mankind. It increases travel time, noise and pollution; it leads to a breakdown in social relations; and it destroys the landscape. In the Canadian province of Quebec, as in many other countries, design schemes have been drawn up for single-family housing in town and city centres, offering an alternative to the typical detached suburban dwelling, in terms of plot size, design type and functional uses.

Longitudinal section.

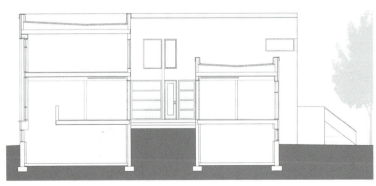

The stairs leading to the two bedrooms on the first floor are made of solid rough-sawn hemlock, and the guard rail is Douglas fir plywood.

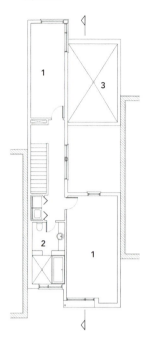

First-floor plan.
1 bedroom
2 bathroom
3 planted rooftop

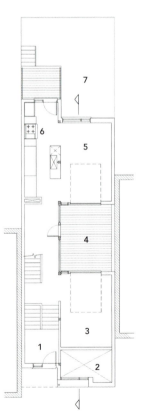

Ground-floor plan.
1 street-facing entrance
2 void over the studio
3 living room
4 patio
5 dining room
6 kitchen
7 courtyard

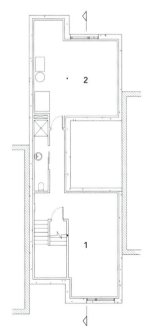

Basement plan.
1 studio
2 storage area

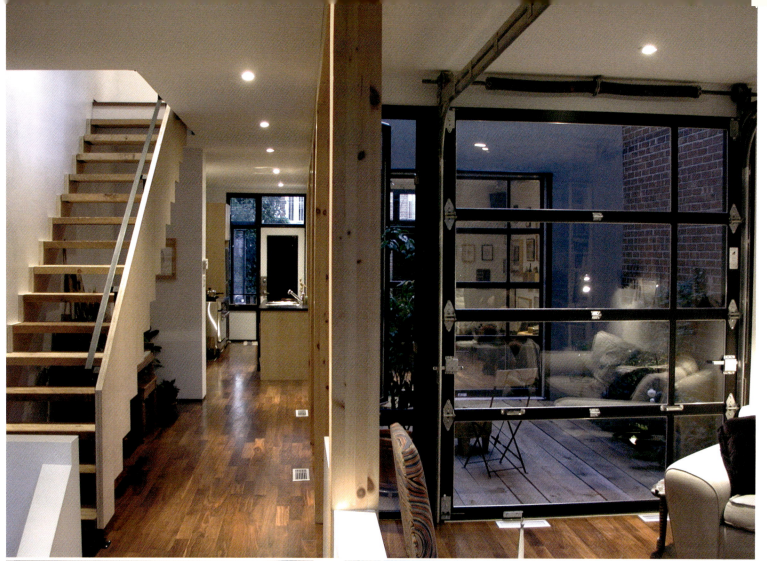

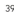

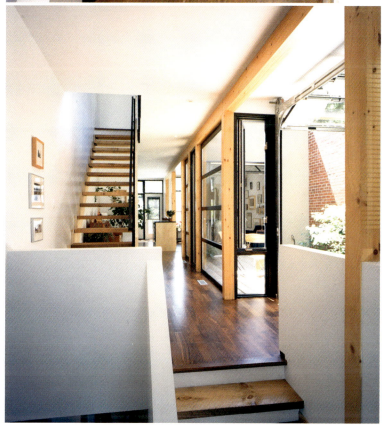

Rammed earth house near the Great Wall of China

Yung Ho Chang

Yung Ho Chang is a Chinese pioneer of bioclimatic architecture who draws on critical regionalism. In view of the standardised building approach adopted from the West, his strategy is to focus on the four basic issues of architecture, namely site, programme, space and tectonics. He holds firm against "the tendency of losing the quality of architecture or even architecture itself in China's great craze of rushing ahead". His slogans are mini instead of mega, quality instead of quantity, slowness (unhurried reflection) instead of speed, and order instead of chaos.

The Split House is located north of Beijing, near the Great Wall, in a mountainous landscape with a continental climate of long, cold, dry winters and hot and humid summers with heavy rainfalls. Yung Ho Chang's design concept was inspired by the traditional *si he yuan* architectural style of Beijing housing, which he transposed to a rural environment. Composed of low buildings set out around one or several courtyards, *si he yuan* houses represent more than just a high-density housing model; they embody a social ideal. Comprising four wings set around a patio, they made up the fabric of the Chinese capital for hundreds of years and were linked by a network of streets and lanes, creating quarters or *hutong*. These courtyard houses and *hutong* are gradually being destroyed in the current building craze, unquestionably leading to a loss of identity for China.

Located far from the hustle and bustle of the city, Yung Ho Chang's house has the room to reach out to its surroundings and invite nature into the very heart of its structure. A stream that was discovered on the site was re-routed in order for it to meander through the courtyard and run beneath the glazed floor of the entry pavilion before flowing down the hill. Positioned between mountains and water, the house was split in half with a view to achieving a symbolic union between the natural and artificial worlds, as well as for more pragmatic purposes. These included saving pre-existing trees, separating the more public functions from the more private ones, and enabling just one wing to be used when there are not many residents, to reduce maintenance costs.

One enters the house from the west by climbing several steps. The wooden pavilion that acts as a structural hinge provides access to both the public wing, with its living room, mah-jong room and verandah, and the private wing, comprising a lounge, dining room, kitchen and ancillary areas. The bedrooms are on the first floor, in the middle of each of the two wings. The load-bearing structure is composed of glued-laminated posts and beams, laid on a one-metre grid. Most of the interior walls facing the courtyard are glazed. The thick outer rammed earth walls shield the residents from the cold winters and hot summers, as the compacted raw earth acts as an effective insulator. When it is eventually no longer needed, this vernacular-style house made of earth and wood can be easily dismantled, leaving hardly any trace on the landscape.

site: Shui Guan (Water Gate) of the Great Wall, Yanqing, Beijing, China — programme: two-storey guest house; entry pavilion on the ground floor providing access to a public wing with a living room, mah-jong room and verandah, as well as to a private wing, with a lounge, dining room, kitchen, pantry, staff lodgings and ancillary areas; on the first floor of each of these two wings are a lounge, two bedrooms, two bathrooms and two terraces — client: Red Stone Industrie — architect: Atelier Feichang Jianzhu, Beijing; director and project manager: Yung Ho Chang; other project team members: Liu Xianghui, Lu Xiang, Lucas Gallardo, Wang Hui, Xu Yixing — structural engineer: Xu Minsheng — habitable surface area: 449 m² — schedule: design period – September 2000 to May 2001; construction period – June 2001 to October 2002 — materials and construction system: glued-laminated post-and-beam structure for the main frame (post sections: 100/280 mm on the ground floor, 100/200 mm on the first floor); 50 cm-thick north-east and south-west exterior walls made of rammed earth (raw earth without any additives, compacted layer-by-layer within formwork, using a rammer) — environmental measures: structure that hugs the landform, preserving pre-existing trees; bioclimatic design concept; creation of a prototype generating multiple variants; use of earth and wood – local traditional materials.

The mah-jong room and living room take up the ground floor of the "public" wing of this guest house.

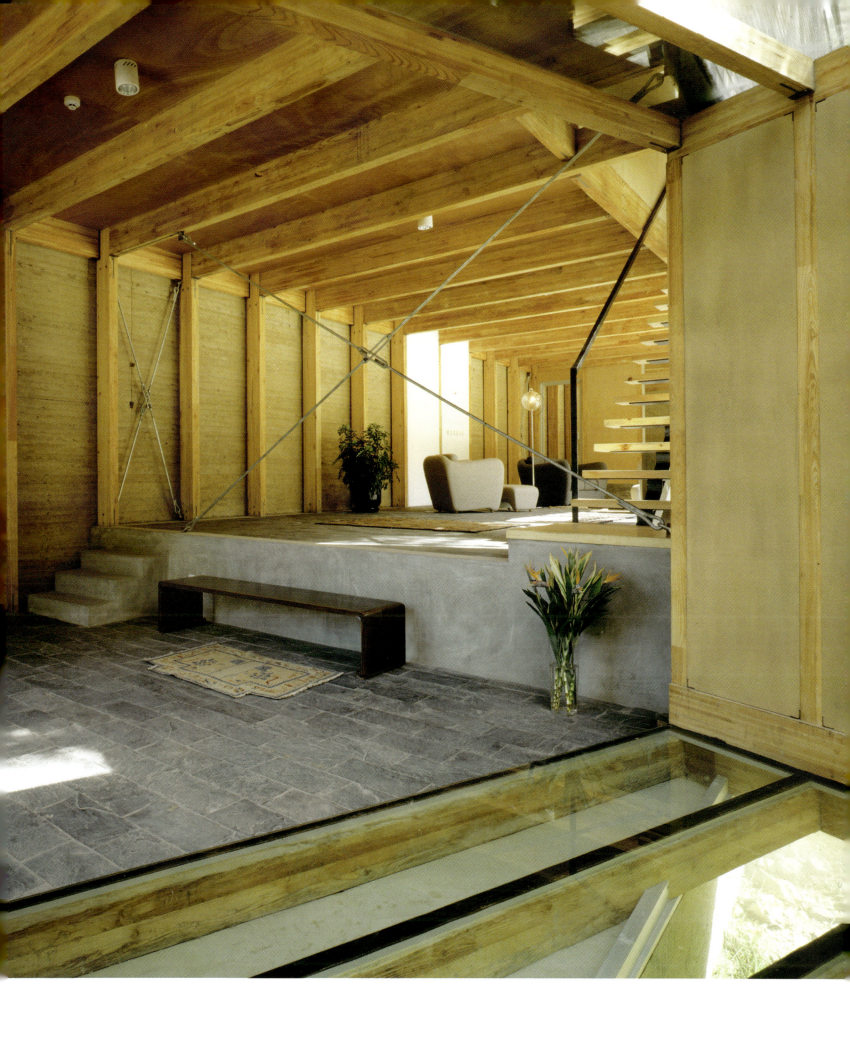

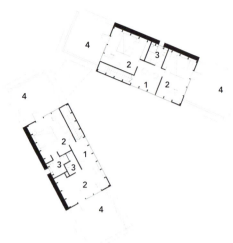

First-floor plan.
1 lounge
2 bedroom
3 bathroom
4 terrace

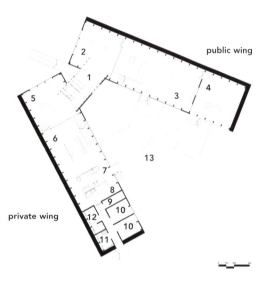

Ground-floor plan.
1 hall
2 mah-jong room
3 living room
4 verandah
5 lounge
6 dining room
7 kitchen
8 pantry
9 storage area
10 staff bedroom
11 bathroom
12 technical
equipment room
13 courtyard

Access to the house via the
north-west corner.

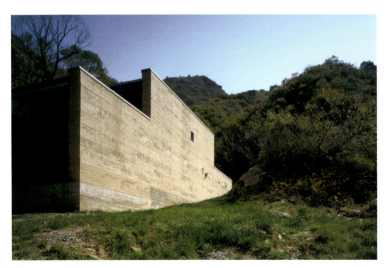

This *shan shui si he yuan*
(courtyard house positioned
between mountains and
water) sits at the foot of
the Great Wall.

Section.

SUSTAINABLE DEVELOPMENT IN CHINA: AN OBJECTIVE FOR THE WHOLE WORLD

At the dawn of the 21st century, buildings are sprouting in China – helped by western members of the design and building trade – that resemble those we were constructing in the West fifty years ago. Between 2000 and 2003, the average habitable surface area of 1.3 billion Chinese people rose from 10 m^2 (a room with a kitchen and bathroom facilities used by several people or even several families) to 23 m^2 (an apartment with a private kitchen and bathroom). Whilst it cannot be denied that the level of individual comfort has risen, transposing building designs used in industrialised countries during a growth period like the one China is currently experiencing is not necessarily the right approach. Many foreign consultants have provided the wrong answers because they were not familiar with the local context. And yet, within China itself, only a few individuals have spoken out to say that it is irresponsible to import into Asia a western model whose negative social and ecological impacts are widely known. Yung Ho Chang, director of the Graduate Centre of Architecture at Beijing University, is one of these rare few; denouncing the dangers of excessive urbanisation, he instead seeks solutions that are more suited to the local culture.

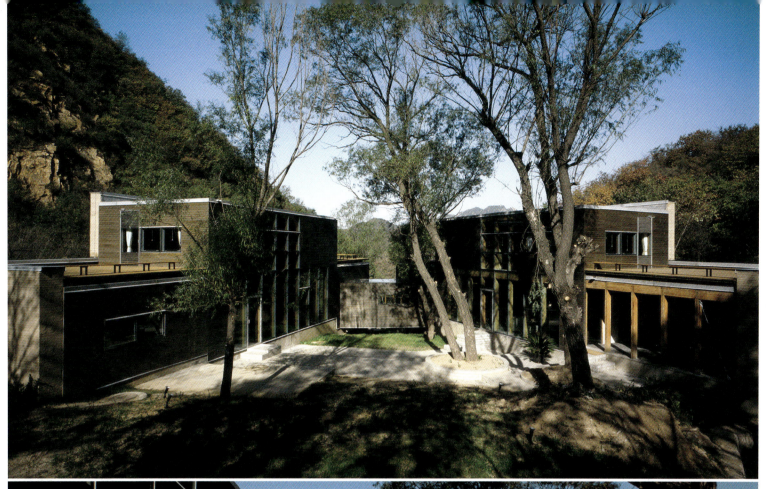

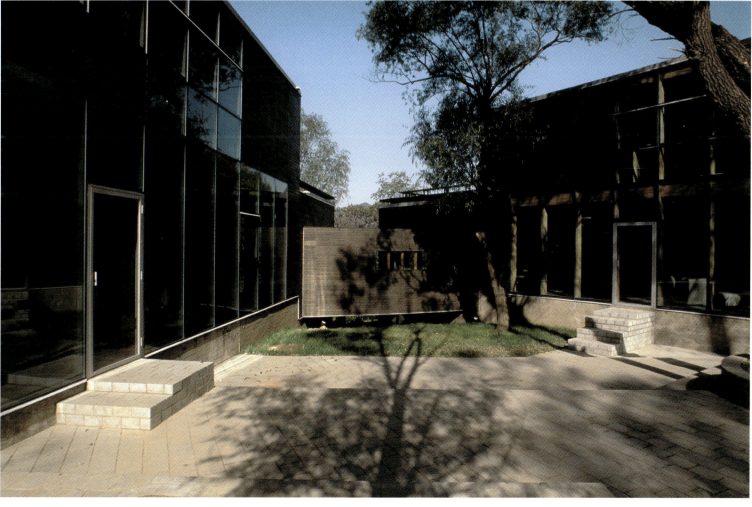

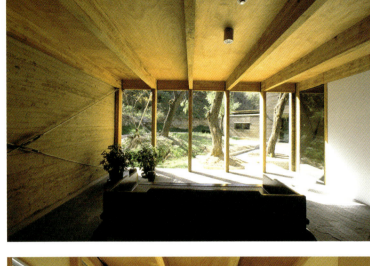

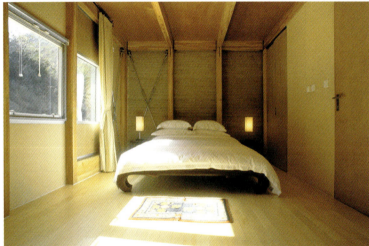

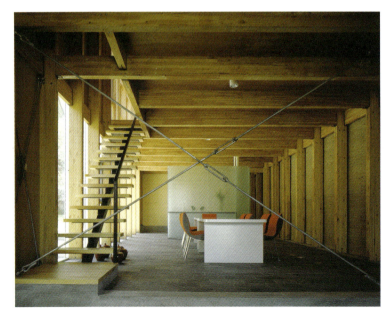

From top to bottom: the verandah and a bedroom in the public wing; dining room in the private wing.

Facing page:
top – entry pavilion;
bottom – living room in the public wing.

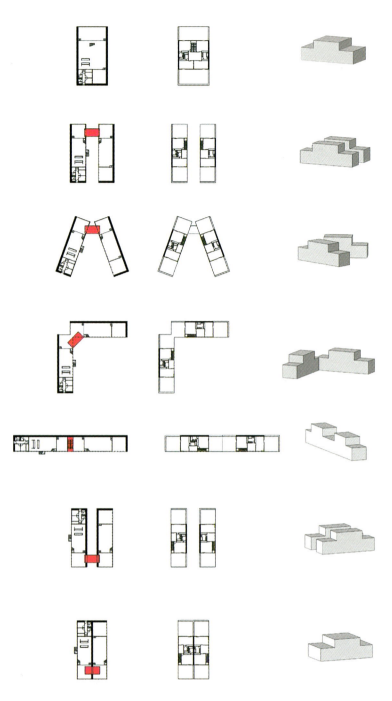

PROTOTYPES WITH MULTIPLE VARIANTS

This house is a prototype, intended to be duplicated several times in the valley. Its design concept is extremely flexible: the corner between the two wings is not fixed, and can therefore be adapted to occupants' requirements as well as to local geographic conditions and landform. The two wings can be placed together lengthwise to form a large detached house or two semi-detached houses, or can even be set one after the other to form a strip. They can also be laid out in parallel fashion on either side of a narrow courtyard or in a way that creates a sharp right angle, generating an exterior space sized in line with the project. Prototypes are based on a simple yet extremely flexible structural principle and offer a broad choice of different spatial and modular layouts. As such, they provide an attractive alternative to banal repetition when faced with the need to build quickly and in quantity.

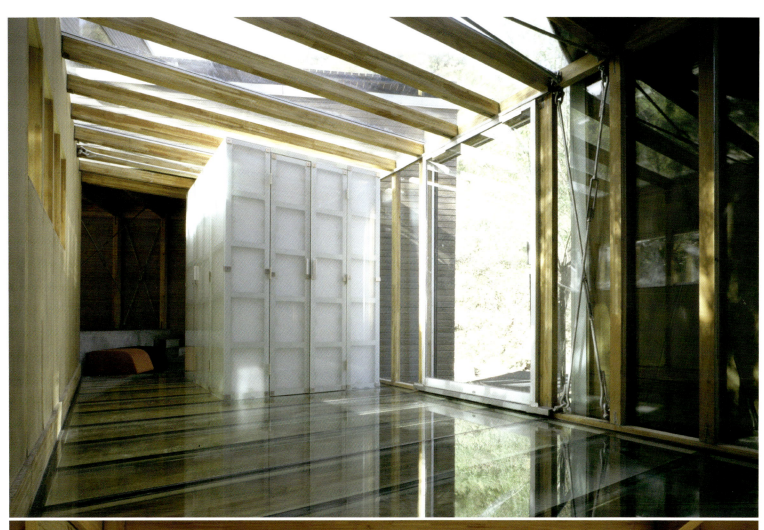

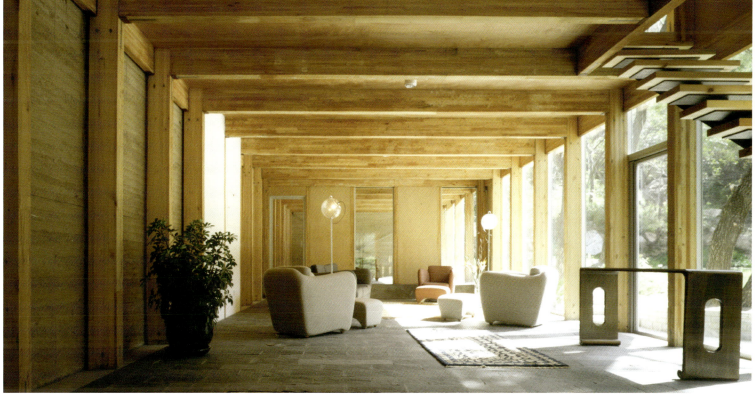

Mediterranean villa in the Balearic Islands, Spain

Ramón Esteve

Ibiza is one of the four main islands in the Balearic archipelago – an autonomous Spanish province with an incredibly rich variety of landscapes, including mountains, interior basins and coastal plains. The climate is hot and sunny in summer and the average winter temperatures always range above 10°C. These ideal weather conditions have attracted foreign visitors since the 1930s, making tourism the economic mainstay of this group of islands. Ibiza's local architecture, which features blocks of white cubes featuring solid walls pierced with small openings, is constantly drawn on for new buildings constructed on the island. Whilst such repetition is often painfully banal, this is certainly not the case for the villa designed by Ramón Esteve, an aesthetic artist specialised in residential architecture, whose designs are always finely detailed.

The house stands in the north-west of the island, on a rocky ridge. It is an isolated spot with dominating views of the Mediterranean, and was chosen for its beauty. The 1,320 m² pentagonal site with a gradient of 11 m lies at the end of a road. Ramón Esteve fine-tuned the structure to its superb surroundings that have remained untouched for centuries, striking up a dialogue between the building and the natural habitat. The villa is built according to Mediterranean tradition, comprising several white volumes that are juxtaposed in line with the slope of the land and arranged so as to create a natural spatial flow. The design principle marries rationality – encapsulated by a modular plan composed of squares whose sides measure some 5 m – with organic growth, rooted in needs and possibilities. It was a solution that also enabled the house to be built over several years, split into three phases of work lasting between 1996 and 2003.

The plan layout and floor-to-ceiling height are staggered in accordance with the uses of the house. This results in fragmented volumes recalling the morphology of the cliff from which the villa emerges as if it were part of the landscape. The roof of several garden-level bedrooms serves as a terrace on the ground floor, which unfurls around an overspill swimming pool. The 40-cm thick concrete walls retain cool air. There are only a few, narrow windows on the east façade and end walls, but daylight floods into the main rooms from the west and slips in through top openings, bouncing off the whitewashed walls. The large openings facing the sea are shielded from the sun by light-coloured canvas sheets, laid tautly over a galvanised steel structure. Panoramic views are framed by the iroko woodwork and the outline of the canopies, whilst in the foreground the water of the swimming pool seems to flow into the endless deep blue Mediterranean sea. Who could resist being captivated by such a vista, sitting on one of the pine benches on the terrace?

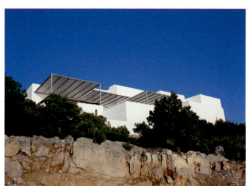

site: Na Xemena, Ibiza, Balearic Islands, Spain — programme: two-storey holiday home that can accommodate up to twelve people; ground floor – living room, dining room, kitchen, study and two bedrooms with en-suite bathroom; terraces and swimming pool; garden level – three bedrooms with en-suite bathroom, staff studio, laundry room, rainwater tank — client: José Gandia — design architect: Ramón Esteve, Valencia (building, interior fittings and furniture); project assistant: Juan A. Ferrero; technical architect: Antonio Calvo — prime contractor: Inrem — surface areas: plot – 1,320 m²; house: 475 m² (gross), 369 m² (habitable) — schedule: design period – 1996; first phase of construction – 1997; second phase – 2001; end of construction – 2003 — materials and construction system: 40 cm-thick concrete-block walls, 30 and 40 cm-thick reinforced concrete floors; whitewashed interior and exterior walls, natural pigments for the coloured surfaces; 7 cm concrete screed floor (polished surface for the interior and untreated surface for the exterior); joinery and built-in furniture made of iroko wood from a sustainably managed forest in West Africa; white-lacquered steel shutters; galvanised steel frames for the canopies; benches made of recycled pine railway sleepers (treated with creosote more than fifty years ago) — environmental measures: adapting the plan and section to the landform to minimise excavation, preserving existing vegetation, transposing a local design type, building very thick walls and floors to retain the cool air, piercing small openings in the end walls and east façade, providing solar protection in front of the glazed bays of the west façade, recovering rainwater and storing it in a 70,000 l tank for domestic use and for the swimming pool.

The study, living room and dining room flow into one another, following the slope of the land.

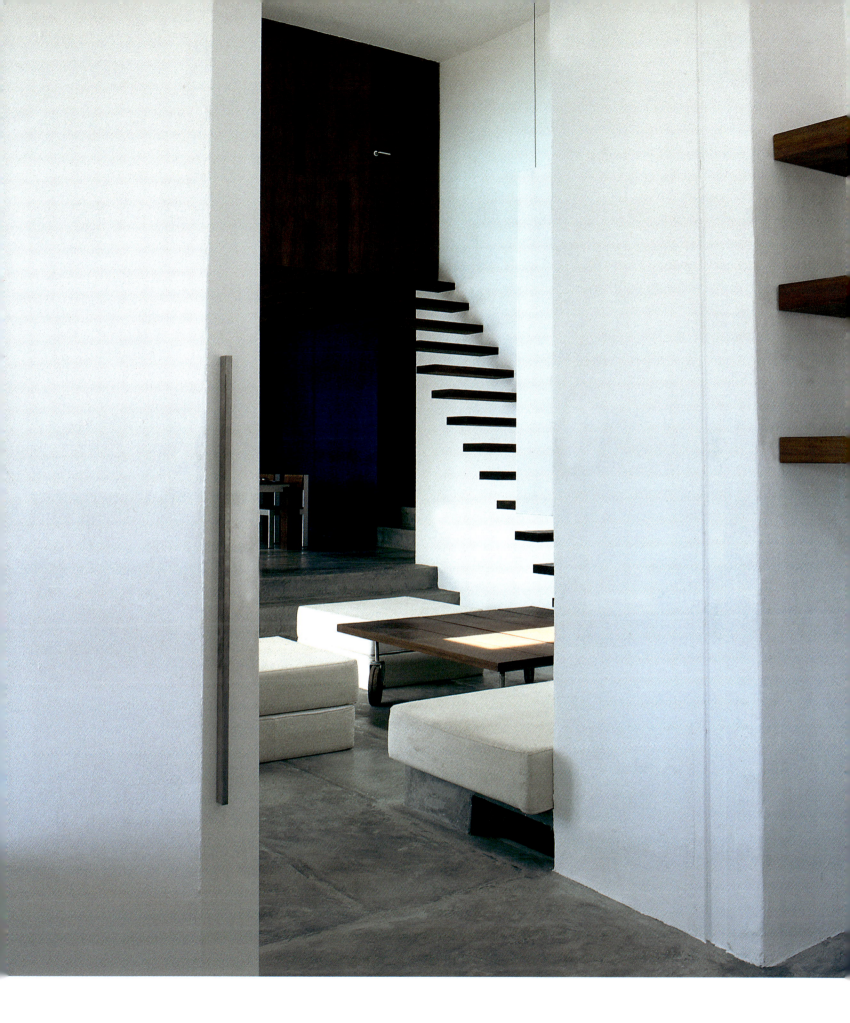

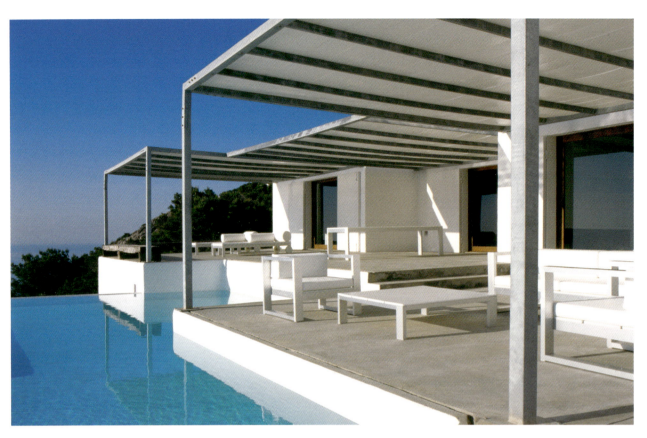

The canopies in front of the west façade are made of canvas, stretched tautly over a galvanised steel frame.

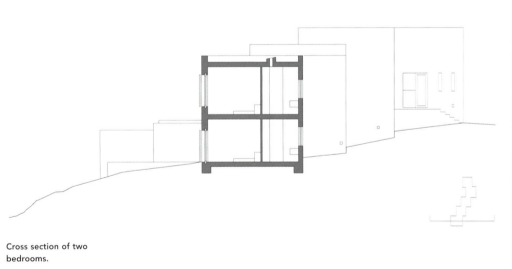

Cross section of two bedrooms.

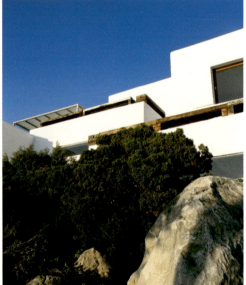

The house's white juxtaposed volumes are nestled amongst pines and savin junipers.

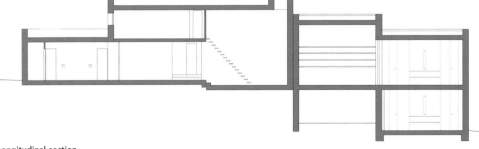

Longitudinal section.

0 5

As in kasbahs, several white staircases slotted into the walls provide access to the varying-level terraces.

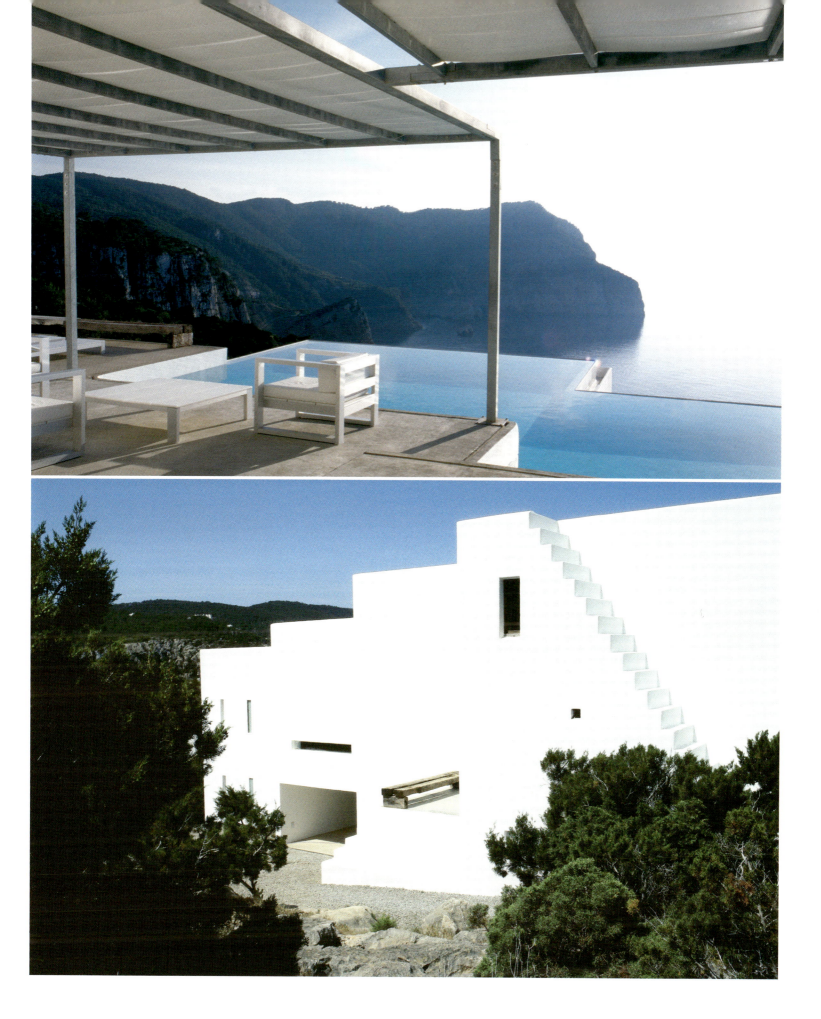

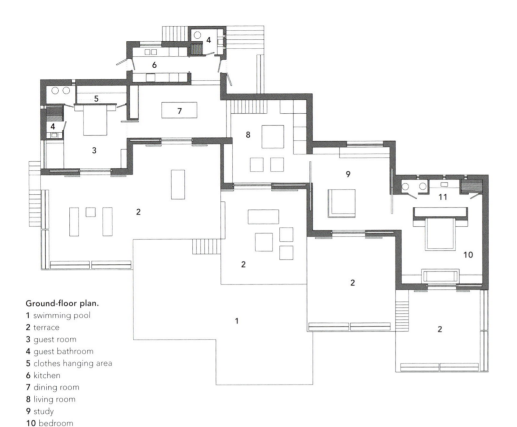

At night, light from square openings at the bottom of the wall casts a warm glow on the grey floor of the terraces.

The furniture was designed by Ramón Esteve and made by Gandia Blasco.

Ground-floor plan.
1 swimming pool
2 terrace
3 guest room
4 guest bathroom
5 clothes hanging area
6 kitchen
7 dining room
8 living room
9 study
10 bedroom
11 large bathroom

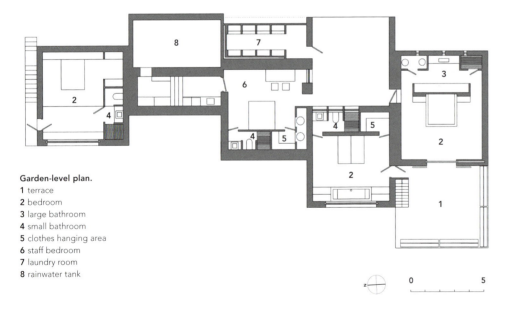

A horizontal eye-level slit in front of the work table in the study frames a strip of the landscape (lower right).

Garden-level plan.
1 terrace
2 bedroom
3 large bathroom
4 small bathroom
5 clothes hanging area
6 staff bedroom
7 laundry room
8 rainwater tank

0 5

ARCHITECTURAL MINIMALISM

A greater balance of wealth can be found by reducing the often artificial needs of our consumer society. In architecture, this translates into deliberate starkness – a formal minimalism, use of commonplace materials, and a restricted palette of colours and textures. The architecture of the house at Na Xemena is highly subdued, merging with the landscape. Its luxurious aspect lies in the site's beauty, as well as in the dwelling's spaciousness and elegant finishings. The brilliant white covering acts as a foil to the grey horizontal surfaces such as the concrete floors and fabric canopies. Inside, several cobalt blue walls lend a splash of colour to the white and grey backdrop. Iroko – an exotic African wood – introduces shimmering warmth into this sober atmosphere and provides continuity between the adjoining rooms, being used for the shelves in the study and for the stairs in the living room that lead to the terrace.

Horizontal section of the wall. The iroko woodwork slides into the thick concrete walls. When they are closed, the white-lacquered steel shutters slot into one another on the planar surface of the outside wall.

Sloping house in Schwarzenberg, Austria
Dietrich I Untertrifaller

The Voralberg *Baukünstler* experience began in the 1970s with bioclimatic timber houses. They were often self-built and typically designed for friends. The Voralberg "building artists" advocate a logical form of architecture that is modern without being militant and ecological without being showy. Focus is on functional use rather than image, and an increasing number of clients have been won over by the concept. The ensuing result is somewhat paradoxical – in one of the rare Austrian provinces where it is not compulsory to use an architect when building a house, the majority of property owners nevertheless prefer to do so.

A recent example of achieving a balance between old and new can be seen in the Kaufmann house in Schwarzenberg, a village renowned for its grand 17th-century timber buildings with sculpted and painted façades. The dwelling draws on the typical design prevalent in this pre-Alpine region – a compact volume capped by a pitched roof and clad in wood shingle. The main divergence from the traditional structures is the size of the openings, as the two levels of the east façade are fully glazed. Helmut Dietrich turned to his advantage the site's major constraint, namely a very steep slope, indulging in an exercise of style. Set in parallel with the curves of the site, the building rises up with minimal impact on its natural terrain. Only the concrete frame of the garage can be perceived along the roadway. The cellar was buried into an intermediate level, from which a small house emerges providing ground-level access to each of the following two storeys. The bedroom and graphic design studio are on the garden level, with a terrace on the east side. The open-plan kitchen, dining room and living room are threaded together beneath the eaves, to capitalise on the sun and views. A terrace positioned in front of the west façade acts as an extension to the living room. The timber structural frame of this floor was assembled in two days on the three partially-buried concrete levels. The six roof panels were delivered with 24 cm of mineral wool between the timber chords and a 22-mm oriented strand board on each side. The panels were strengthened laterally by steel sections soldered on site, to create a span of some 6 m without any intermediate support or tie-bars. A heat pump enables calories drawn from the outside air to warm the house via water-filled coils laid in the screed of the floors. This pump also heats water for domestic use. Additional heating is provided by a masonry wood-burning stove in the living room. Just two species of wood were used for the interior fittings of this room: walnut for the floor and furniture and white fir for the wall facings. The plain design reinforces the uniformity of the room's vast space, oriented towards the strip of glazing that runs the length of the east façade and follows around to the end walls. Storage units run beneath the window, topped by a shelf that temptingly invites one to sit down and admire the views.

site: Schwarzenberg, Vorarlberg, Austria — programme: four-storey house and associated graphic design studio; garage and entrance staircase on the ground floor; cellar in the intermediate basement; garden level – cloakroom, studio, bedroom and bathroom; first floor: large daily living space with open-plan living room, dining room and kitchen — client: C. Kaufmann — architects: Dietrich I Untertrifaller, Bregenz; project manager: Helmut Dietrich — site supervisor: Büro Dragaschnig, Schwarzenberg — statics engineer: Gehrer, Höchst — surface areas: plot – 663 m²; habitable surface area: 151 m² (house and studio) — schedule: design period – 2001; construction period – October 2002 (concrete), March 2003 (timber); handover – November 2003 — materials and construction system: walls with floor contact made of 25 cm exposed concrete, extruded polystyrene foam (18 cm XPS Floormate) for the external insulation; top storey walls made of pre-fabricated timber-framed boards, with 20 cm mineral wool inserts between the studs and a 10 cm layer of crossed insulation on the outer side; 18 cm solid wood tongue-and-groove floor in the living room (Holzbau Greber); roof made of panels of pre-fabricated timber coffers containing 24 cm-thick mineral wool and an 8 cm layer of crossed insulation on the inside; triple-glazed windows with argon gas fill in the white fir frames; walnut wood floor; white fir interior cladding in the living room (veneered boards for the end walls and tongue-and-groove panelling on the ceiling); white fir terrace decking; ventilated white fir shingle for the exterior cladding; Eternit fibre-cement slate roof — environmental measures: respecting the natural steep slope of the land; use of local resources (white fir from Vorarlberg); highly insulating building envelope; use of wood that has not undergone any chemical or surface treatment; reversible air/water heat pump for the underfloor heating and domestic hot water; back-up heating from a masonry wood-burning stove — heat transfer coefficients: triple glazing – U = 0.6 W/m²K; wood joinery and glazing – U = 0.9 W/m²K — heating consumption: 48 kWh/m²/year.

Born in Bregenzer Wald, Helmut Dietrich has built several houses there that respect the site's surroundings.

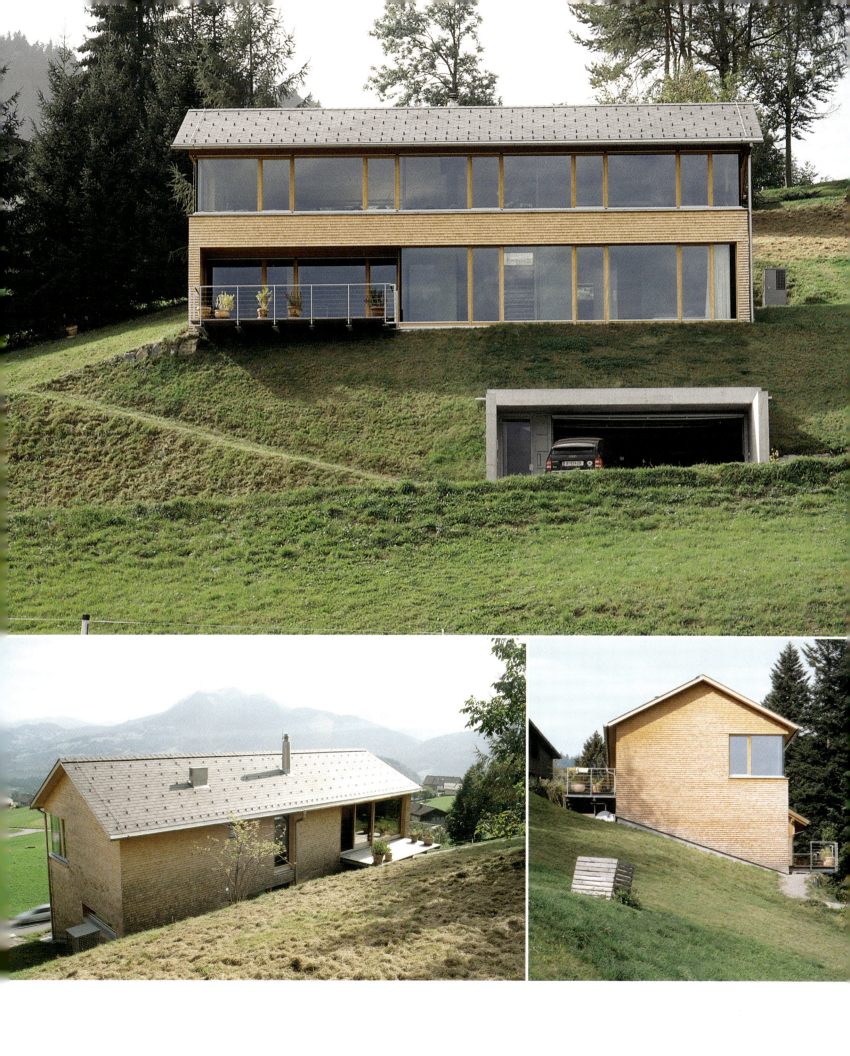

First-floor plan.
1 living room
2 dining room
3 kitchen
4 terrace

Garden-level plan.
1 studio
2 cloakroom
3 bedroom
4 bathroom
5 terrace

Ground-floor and basement plan.
1 garage
2 entrance staircase
3 cellar

0 2,5 5

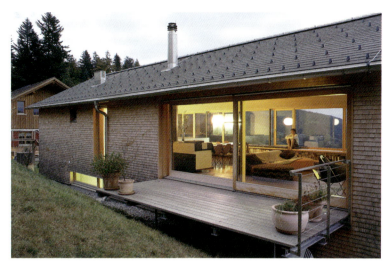

The shingle – small white fir chippings chopped by axe and which overlap over a triple layer of thickness – have clad houses in Bregenzer Wald for centuries.

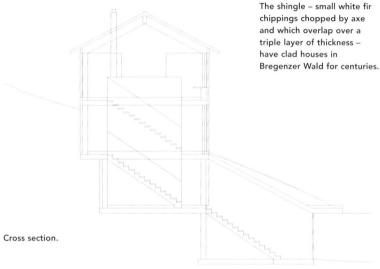

Cross section.

MIX OF MATERIALS

Combining solid wood and wood-based products with metal or mineral materials enables construction objectives to be aligned with an ecological and economical approach. It allows the capacities of each material to be leveraged, whilst reducing to a bare minimum the quantity of materials used. Concrete, stone, fired clay and earth have high thermal mass, keeping the house cool in summer and also serving as acoustic screens and fire breaks. Plates, pins and other steel components make up a structural system that is both high performing and elegant. Cables and metal rods allow for thin sections of the timber parts by taking up the traction. This rigorous construction logic, allied with a quest for matching form with function, is one of the main cogs that drive the wheel of contemporary Vorarlberg housing.

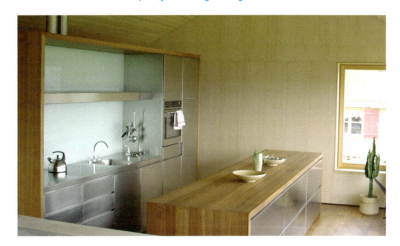

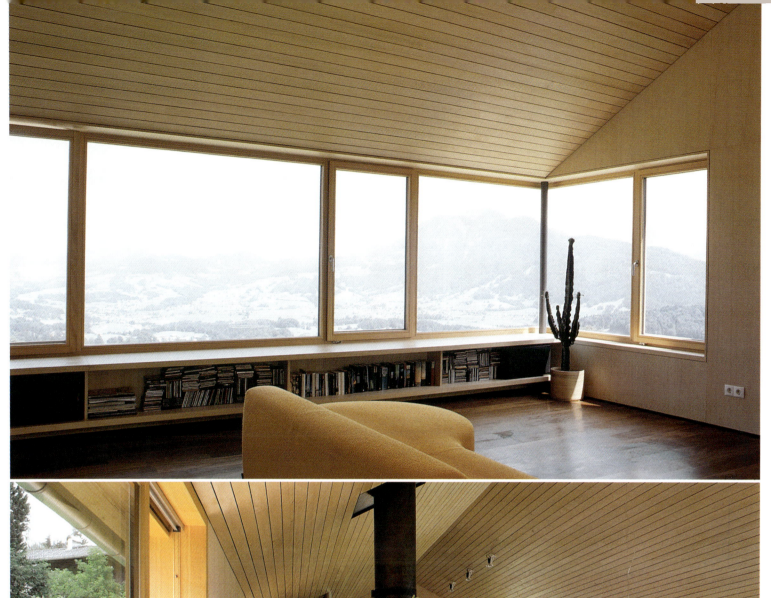

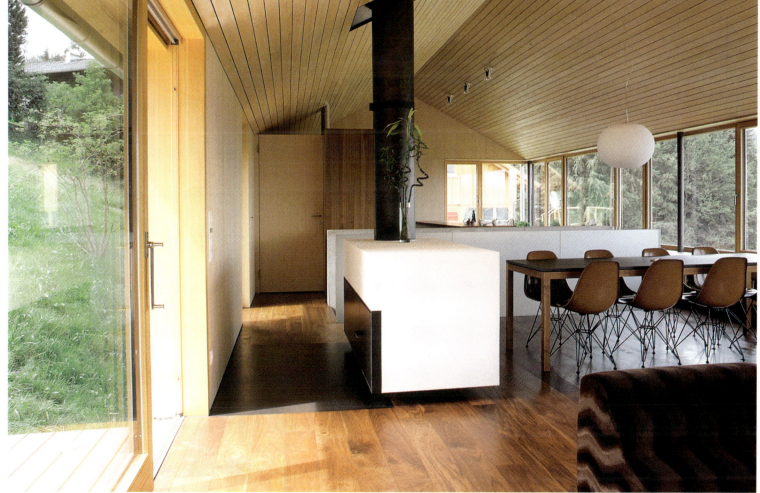

Private house on Orcas Island, USA
Cutler Anderson Architects

James Cutler and Bruce Anderson's work is in tune with the process begun by Frank Lloyd Wright in the early 20th century. Once they have carefully analysed the site, they use local materials and transpose a number of components of the region's vernacular housing, yet without renouncing modernity. Their residential architecture fuses gently with the natural habitat of the group of islands that stretches between Seattle and Vancouver, and underscores the beauty of the unspoilt landscape. The houses they build are both contemporary and organic, slotted into their environmental surroundings. A solid stone or concrete base rises up from the preserved natural ground, followed by an exposed frame and timber cladding sheltered by a projecting roof.

Long Residence on Orcas Island is representative of the architects' intuitive handling of the site and craftsman's approach to building with timber. Set on the edge of an evergreen forest on the shore of a saltwater channel, the house stretches from east to west, parallel with the contours of the land. The large living room, dining room and two bedrooms face south, towards the waterscape. In the north, the roof's single slope almost touches the ground, whereas in the south it reaches up as high as 4.6 m, and the two corners are glazed in order to draw in sunlight and permit views. The interior spaces flow into one another, with hardly any doors to contain them. The exposed concrete base is surrounded by several terraces stepped along the slope.

The most striking feature of the house is its highly expressive timber frame. Tripod supports composed of poles measuring some 15 cm in diameter bear the weight of large horizontal beams ranging from 3.7 to 18.3 m in length. This load-bearing frame is red cedar (*Thuja plicata*), a slow-growing conifer whose solid, lightweight wood is resistant to insects and fungi. The trunks were specially selected when the trees were still standing, from a forest belonging to the building contractor's father, and their bark was stripped using pressurised water. Their smooth, glossy surface resembles the softness of bamboo skin. A steel plate inserted into the web of the beam facilitates the connection to the poles, with six dark cedar false pegs concealing the recessed bolts, yielding an overall effect of Japanese-type elegance.

The house is clad in red cedar shingle, made from split wood then bevelled with a saw, creating a more even texture and shape than traditional split wood shakes. The red cedar is best-class (Blue Label), cleaned of sapwood and imperfections. On the north façade, a strip of glazed imposts placed in front of the round beams and vertical openings positioned before the tripod supports automatically draw the eye of visitors. Wood from other species of trees was used inside the house in an even more refined form: the floor is in beech, the walls are in strips of whitewashed pine, whilst the exposed rafters, ceiling and built-in furniture are made of Douglas fir.

site: Orcas Island, State of Washington, United States — programme: single-storey holiday home for a couple and their guests; entrance, study, open-plan living room, dining room and kitchen, two bedrooms, two bathrooms and several terraces — clients: Dixon and Ruthanne Long — architects: Cutler Anderson Architects, Bainbridge Island; project team – Jim Cutler, Julie Cripe, Chad Harding — structural engineer: De Ann Arnholtz SE, Coffman Engineers, Spokane, Washington — prime contractor: Alford Homes, Poulsbo, Washington — habitable surface area: 183 m² — schedule: design period – 2000; construction period – 2003 — materials and construction system: exposed concrete base; stripped roundwood (western red cedar) post-and-beam structure for the main frame, composed of log tripods bearing the weight of thicker horizontal log beams; wooden frame for the external wall, containing 14 cm-thick rigid insulation, interior facing made of vertical whitewashed pine strips, and Blue Label red cedar shingle for the exterior cladding; anodized aluminium joinery; beech wood floor; Douglas fir interior fittings and built-in furniture; Douglas fir tongue-and-groove ceiling with exposed rafters; roof made of Easy Lock steel troughs (Taylor Metal).

Two posts of each tripod are anchored to the concrete base by a folded stainless steel sheet that reaches into the core of the poles.

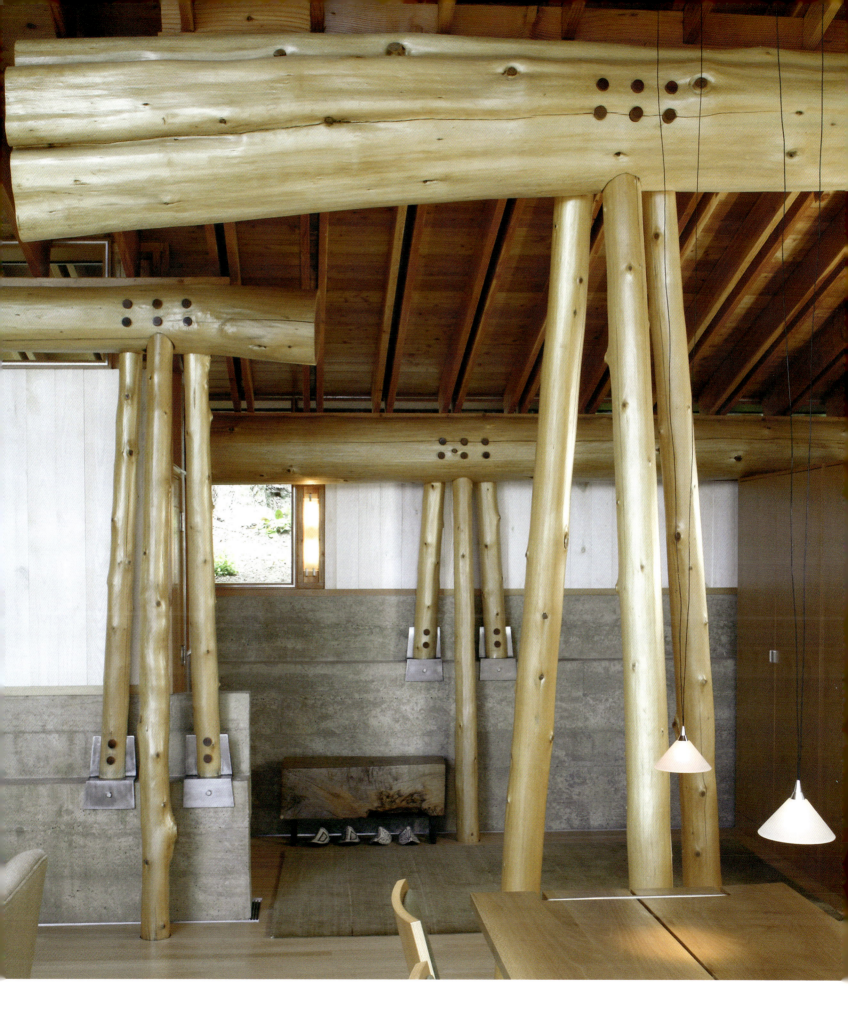

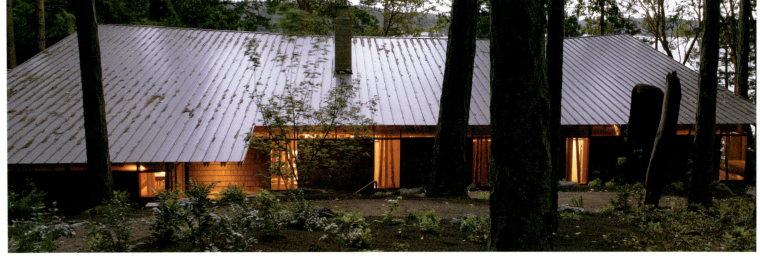

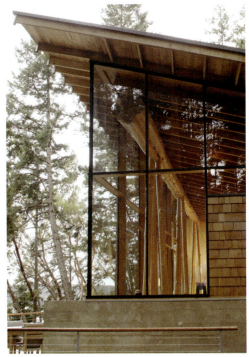

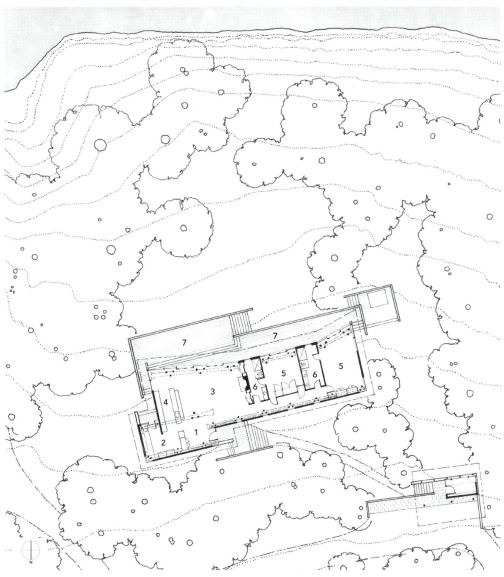

Ground-floor plan.
1 entrance
2 study
3 living room
and dining room
4 kitchen
5 bedroom
6 bathroom
7 terrace

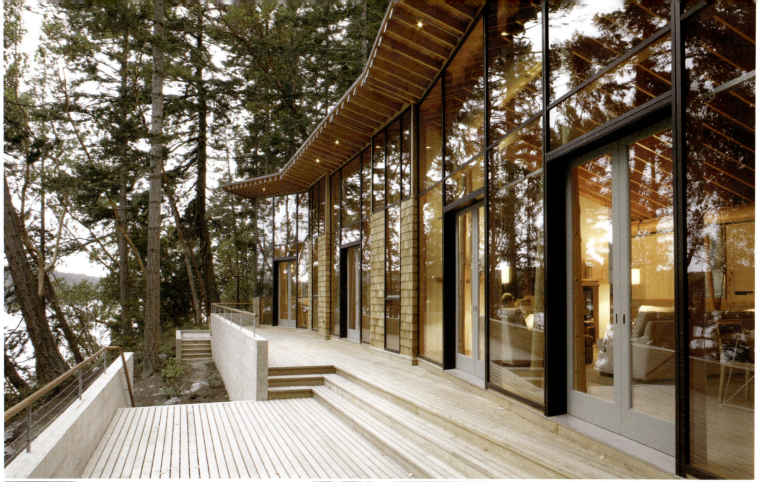

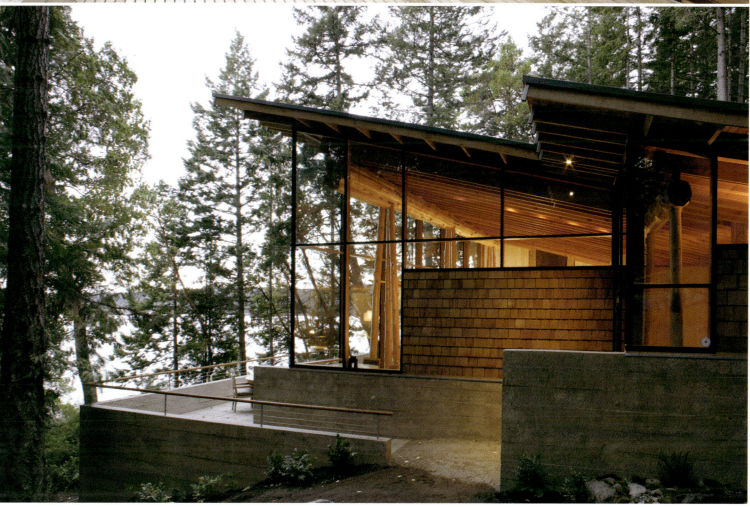

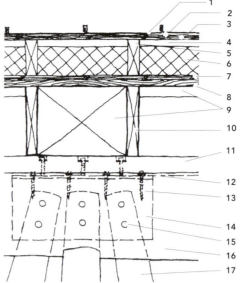

Longitudinal section of the roof, structural frame and assembly system of the beam and three round posts.

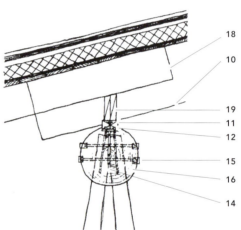

Cross section of the assembly system of the beam and round posts.

1 Easy Lock steel-trough roof
2 rainscreen
3 plywood (13 mm-thick)
4 air gap
5 rafter (3.8 x 14 cm) – 40 cm spacing between centre lines
6 rigid insulation
7 plywood (13 mm-thick)
8 Douglas fir tongue-and-groove ceiling (1.9 x 14 cm)
9 air gap
10 Douglas fir rafter (3.8 x 28.6 cm) – 40 cm spacing between centre lines
11 metal assembly component (9 x 9 cm)
12 metal plate (0.6 x 9 x 61 cm)
13 screw – 9.5 mm diameter, 7.6 cm spacing between centre lines
14 steel fixing plate (1.6 x 25 x 61 cm)
15 false wooden pegs concealing recessed bolts
16 round red cedar beam
17 round red cedar post
18 Douglas fir rafter (3.8 cm x 18.4 cm) – 40 cm spacing between centre lines
19 transverse piece of wood (3.8 x 23.5 cm)

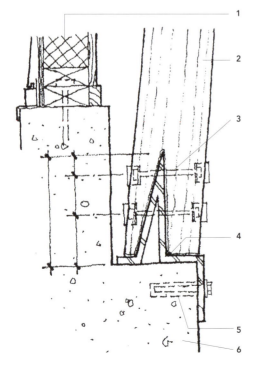

Section showing how the round posts are fixed onto the concrete base.

1 timber-framed exterior wall with 3.8 x 14 cm studs
2 round red cedar post
3 bolted rod (1.9 cm diameter)
4 stainless steel assembly component (1.3 cm-thick)
5 bolted anchor rod
6 concrete base

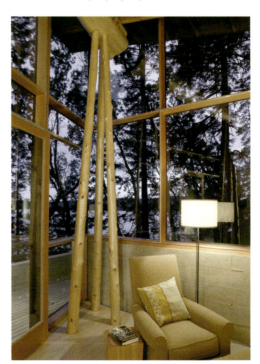

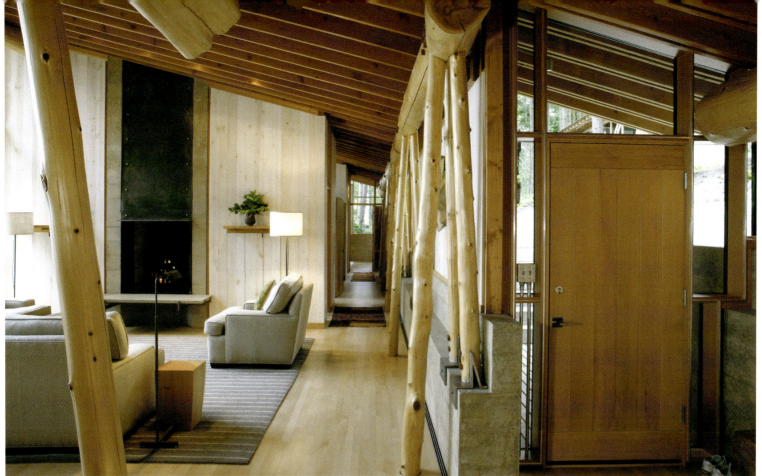

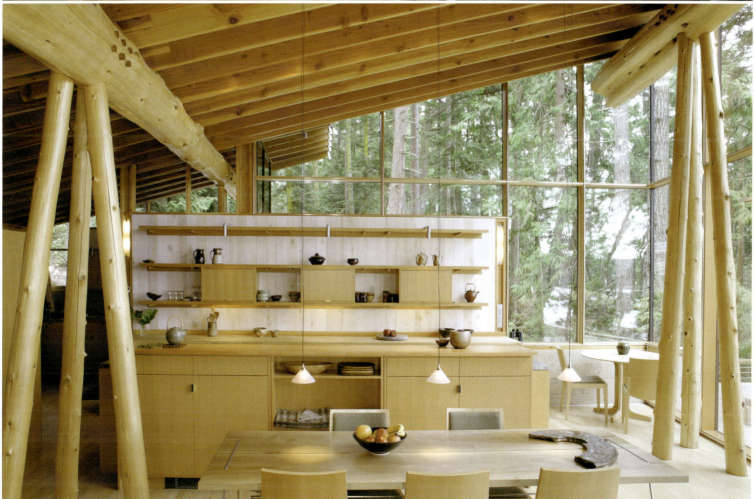

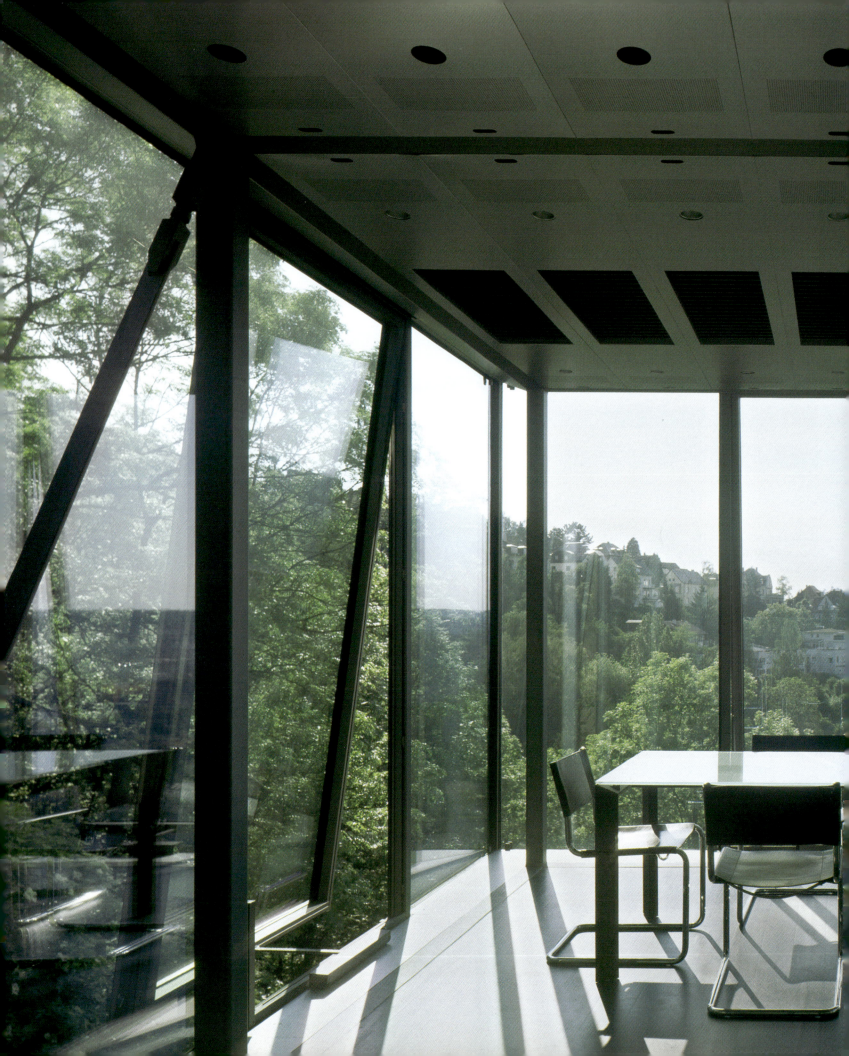

Energy self-sufficient home in Stuttgart, Germany

Werner Sobek

Werner Sobek used the opportunity of building his family home to experiment with his housing design concept for the 21st century, in conjunction with climate engineering and systems specialists. The end result is an uncompromising manifesto. No curtains hide the transparency of this cube that runs on self-sufficient energy sources. It is glazed on all four sides and made from modular components that can be easily recycled when there is no longer any need for them. The structure's impact on the site and pre-existing vegetation is minimal, as it has a small footprint, features foundation beams and has no underground pipework.

The house stands on one of the woody slopes that soar above the centre of Stuttgart rising up to 300 m in places. A narrow metal footbridge leads to the top floor, containing the entrance, kitchen and dining room, as well as a void over the living room and study area situated below. The following floor is given over to the main bedroom, whilst the second bedroom is on the garden level. The only spaces enclosed are the two bathroom blocks and technical equipment rooms. The other areas are open and evolving, linked by openings in the floor structure that unleash views from all sides out to the abundant greenery and landscape. The overriding ambience is stark minimalism. The bath and few pieces of furniture were designed by the architect, and the chairs and armchairs were selected from the repertoire of famous modern architects.

Based on a 2.90 x 3.85 m grid, the exposed structural frame comprises IPE 200 beams fixed onto square 10-cm posts. It is wind-braced by means of St. Andrew's crosses. Pre-fabricated "mono-material" components were added to this steel frame that was bolted onto the site in four days. These include plywood floorboards, aluminium false ceilings and 1.40 x 2.80 m glazed bays, set 40 cm in front of the structural frame.

This "intelligent house" is run on a remote controlled house automation system. It features a number of innovative technological solutions, including triple glazing that insulates as effectively as 10 cm of mineral wool. Thanks to solar efficiency, overall energy gains outstrip heat loss. Several of the openings are motorised to enable air to flow out and help create natural ventilation via a chimney effect. Thermal comfort is provided by coils in which hot or cold water circulates. This is fed by a 12 m^3 tank able to store over the long term the heat capacity accumulated in the summer. The energy design of the house was optimised using the Trnsys software developed by the climate engineering firm Transsolar, whose founder Matthias Schuler is renowned for his insightful solutions that are always customised to the architectural project in question.

site: Stuttgart, Baden-Württemberg, Germany — programme: four-storey home for a couple and their son, with the main entrance on the top floor; level 0: entrance, kitchen and dining room; level -1, living room, study area and WC/washing facilities; level -2: bedroom, large bathroom and WC/washing facilities; level -3: bedroom, technical equipment rooms and secondary access — clients: Ursula and Werner Sobek — architect and structural engineer: Werner Sobek; Werner Sobek Ingenieure, Stuttgart; — technical engineers: Transsolar Energietechnik, Stuttgart, Matthias Schuler (climatic engineering); Büro Frank Müller, Weissach (supply systems and networks); Baumgartner, Kippenheim (house automation) — habitable surface area: 250 m^2 — schedule: design period – 1998; construction period – 1999 to June 2000 — materials and construction system: steel for the main frame, with 100 x 100 x 10 mm posts and IPE 200 beams, horizontally and vertically windbraced by St. Andrew's crosses made of 10 x 60 mm steel bars; floors made of 2.80 x 3.75 m plywood boards (6 cm thick), laid on neoprene-sealed boules; triple-glazed building envelope with low-emission and high-transmission properties, containing argon gas infill — environmental measures: minimal impact on the site, and house built in line with the landform; dry construction without plaster or concrete (apart from the foundations); lightweight structural frame made of "mono-material" pre-fabricated components that can be easily dismantled and recycled; energy self-sufficient in terms of heating and cooling; reinforced insulation for the building envelope with triple glazing for the façades, as well as mineral wool beneath the lower deck of the garden level (24 cm) and in the roof (32 cm); natural ventilation (motorised openings) — specific equipment: earth energy system to temper incoming air; copper tube heating and cooling components incorporated into the aluminium false ceilings (40% of the habitable surface area); dual-flow ventilation system with a heat exchanger that recovers a high proportion of calories from the used air; photovoltaic micro-central system connected to the public network (48 modules of 81.5 x 137.5 cm with maximum power of 6.72 kW); 12 m^3 water-filled tank enabling heat capacity accumulated in summer to be stored over the long term; house automation system managed by computer with a remote control device (for opening doors and windows, regulating temperature, watering the garden, etc.) — heat transfer coefficient of the special-purpose triple glazing: U = 0.45 W/m^2K.

This glass house is nestled amongst trees, close to both nature and the city.

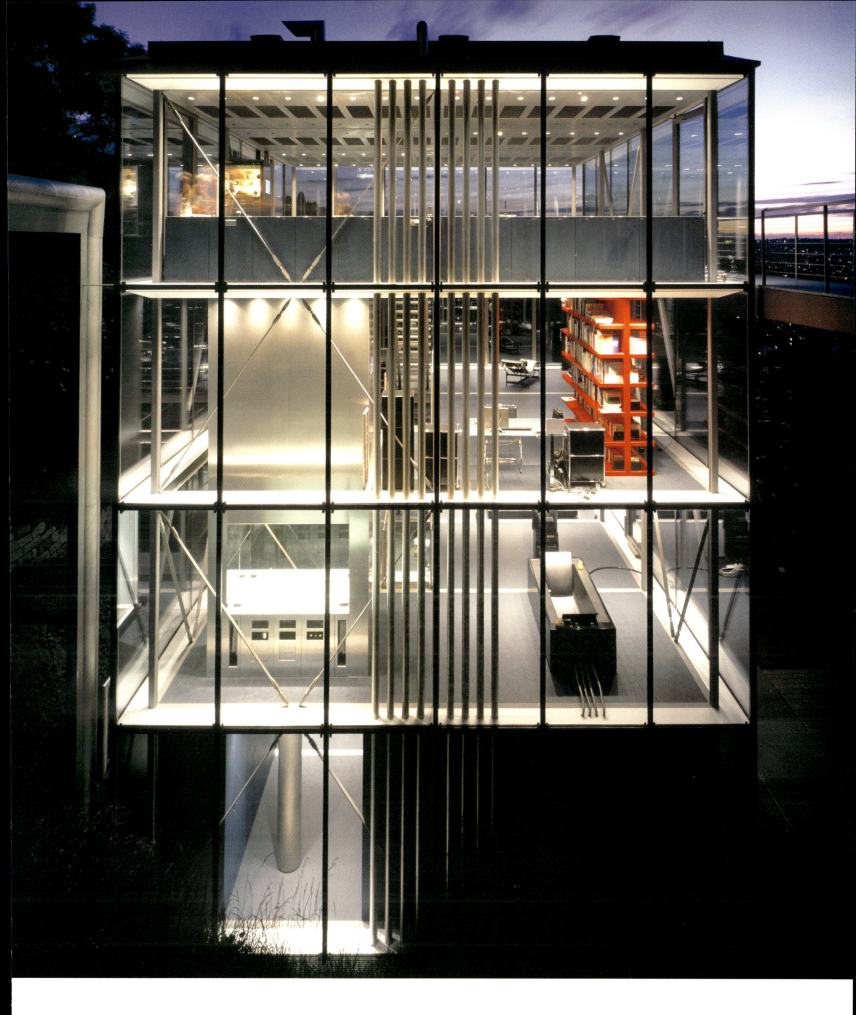

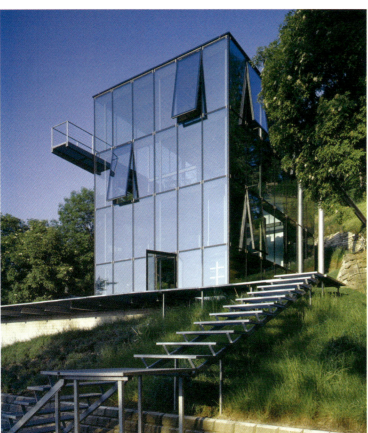

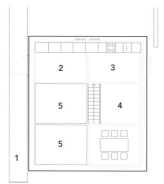

Plan of 0 level.
1 entrance footbridge
2 entrance
3 kitchen
4 dining room
5 void over the living room

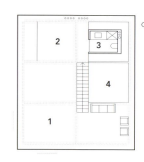

Plan of –1 level.
1 living room
2 study area
3 WC/washing facilities
4 void

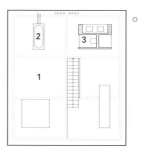

Plan of –2 level.
1 bedroom
2 bathroom
3 WC/washing facilities

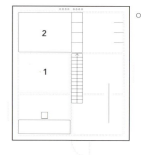

Plan of –3 level.
1 bedroom
2 water tank

The dining room and living room, situated on the top two floors, overlook the tree tops and enjoy sweeping views of the city.

To facilitate access and maintenance, the supply systems and networks are grouped in horizontal aluminium casings, located between the structural frame and the building envelope, as well as in vertical shafts.

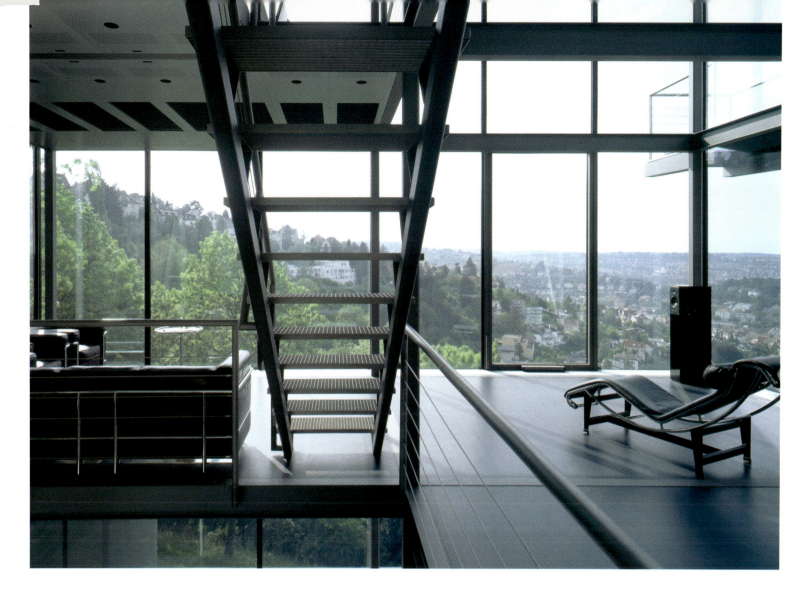

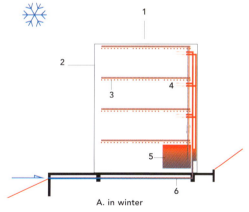

A. in winter

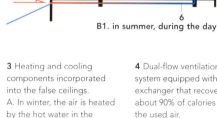

B1. in summer, during the day

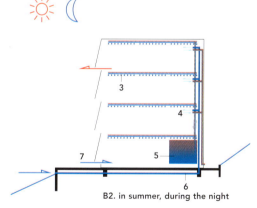

B2. in summer, during the night

Energy concept.

1 Photovoltaic micro-central system linked to the public network. The 48 modules placed horizontally in the roof (6.72 kW maximum power) generate the necessary energy for technical equipment (heat pump, mechanical ventilation, etc.).

2 Triple-glazed openings.
A. Thanks to a low heat transfer coefficient (U = 0.45 W/m²K), there is minimal heat loss in winter and the interior glazing can cover a large surface area.
B. Overheating in summer is reduced by means of a protective film reflecting the infra-red rays that hit the glazing.

3 Heating and cooling components incorporated into the false ceilings.
A. In winter, the air is heated by the hot water in the copper tubes.
B. In summer, the air is cooled by the cold water in the coils. An exchanger recovers the calories of the cold water that is heated whilst passing through the pipes.

4 Dual-flow ventilation system equipped with a heat exchanger that recovers about 90% of calories from the used air.

5 Water tank (12 m³).
A. Calories recovered in summer are used in winter.
B. Calories recovered in summer are stored long-term in the water.

6 Earth-energy system that capitalises on the near-constant underground temperature.
A. In winter, incoming air is naturally pre-heated in underground pipes.
B. In summer, incoming air is cooled as it passes through the pipes.

7 The motorised opening of some windows (at least two per storey) helps to naturally ventilate the interior via a chimney effect.

Mountain residence in the Vorarlberg region, Austria
Wolfgang Ritsch

Wolfgang Ritsch was one of the leaders of the 1970s movement that set a young group of professionals from the Voralberg region against Vienna's Society of Architects. With this elegant and functional mountain residence he testifies to the balance that the *Baukünstler* were able to strike between tradition and modernity. Together with a pre-existing golf club, the house forms an ensemble delicately set in a winter resort, at an altitude of 1,020 m. The main residential part is on the upper level, above an office and two small flats that are rented out. Circulation and service areas run the length of the north façade, playing the role of buffers. The near-opaque western end wall and low north façade, which shield the house from bad weather, are clad in white fir shingles that can be typically found in the region. The southern façade and eastern end wall are glazed to let in sun and views. The wide projection of the roof slope, which is raised on the southern side, covers the balcony that runs in front of the living room and bedrooms, and casts a shadow on the glazing in summer. The dwelling consumes a low amount of energy, thanks to a design concept that combines bioclimatic measures and optimal use of technical fittings. These include an earth energy system, dual-flow ventilation and solar collectors for heating the domestic water. The masonry wood-burning stove, which is fitted with an exchanger, directly warms the living room and corridor and heats to 30°C the water that circulates in the underfloor heating system. Since the temperature often falls to -15°C in the Brandnertal area, the cosy *Stube* forms the heart of family life. With its light wood walls, low ceiling and wood-burning stove, it is symbolically attuned to the region's local culture. The house's modern aspect lies in its minimalist design and mix of materials. On the ground floor, pre-fabricated timber-framed panels are slotted between slender steel posts that bear the weight of the intermediate deck. The slabs are made of reinforced concrete, as are the garage walls, acting as a windbrace for the structural frame. The upper floor panels are load-bearing, with steel posts only placed in the south-east corner, behind the glazed walls. The roof components are made of two triple-pleated panels fixed onto glued-laminated chords. These K-Multibox pre-fabricated coffers, which enable the roof to jut out substantially, offer a cutting-edge construction system from both a mechanical and a cost-saving perspective.

site: Brand, Vorarlberg, Austria — programme: house with a main residential part and two holiday flats; ground floor – a one-bedroom flat and studio flat, independent office, garage, technical equipment room and storage area; first floor – main residence with lounge-library, *Stube*, open-plan dining room and kitchen, 3 bedrooms, bathroom, 2 storage areas — client: Schedler family — architect: Wolfgang Ritsch, Dornbirn — structural engineer: Christian Gantner — surface areas: plot – 7,331 m², house – 226 m² (habitable) — schedule: design period – 2001; construction period – June 2001 to September 2002 — materials and construction system: combined concrete/wood/metal system with reinforced concrete for the decks and garage walls, outer steel posts, timber-framed exterior and interior walls (36 cm of mineral wool), 35 cm-thick spruce coffered roof panels (30 cm of mineral wool); thermal and acoustic insulation via 23 cm Thermotec® decks, made of recycled polystyrene and a mineral binding agent; interior cladding, ceiling and built-in furniture made of Vorarlberg white fir; maple wood floor; larch-slatted grid fixed invisibly onto the free-running balcony; triple-pleated panels of grey-painted spruce on the south façade and eastern end wall; Vorarlberg white fir shingles on the north façade and western end wall; copper roof — environmental measures: compact volume to reduce heat loss; main rooms facing south and service areas facing north; southern aspect for the main façade to profit from solar gains; highly insulated building envelope; use of local resources (white fir) — specific equipment: earth energy system (two tubes with 20 cm diameter and total length of 43 m); dual-flow ventilation system with a heat exchanger that recovers a high proportion of calories from the extracted air; masonry wood-burning stove providing direct heat (50%) with water heater to supply the underfloor heating (50%); domestic water heated by solar collectors (14 m²) and electricity programmed to economical time slots (night rates) — heat transfer coefficients: timber-framed walls – U = 0.11 W/m²K; underground base for the north façade – U = 0.25 W/m²K; glazing – U = 0.7 W/m²K; ground-floor lower deck – U = 0.11 W/m²K; roof – U = 0.11 W/m²K — energy consumption: 22.5 kWh/m²/year.

The house blends smoothly into its mountain site, providing a successful example of a structural system that combines reinforced concrete, steel and local timber.

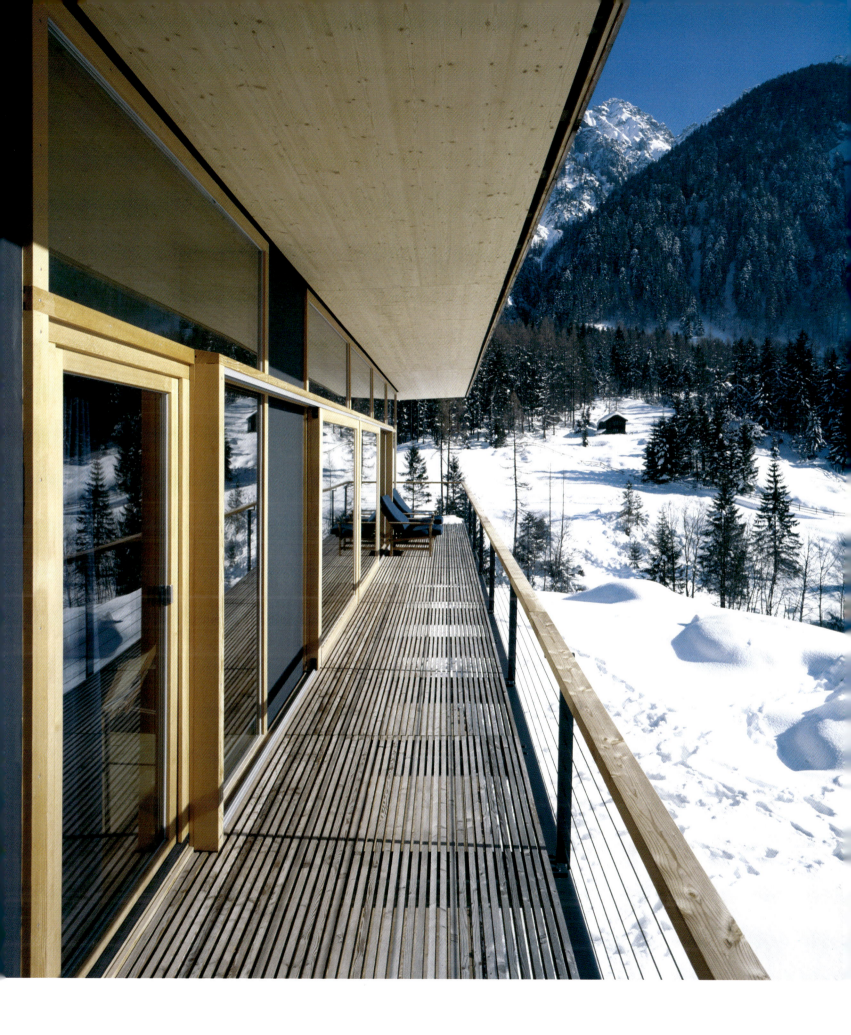

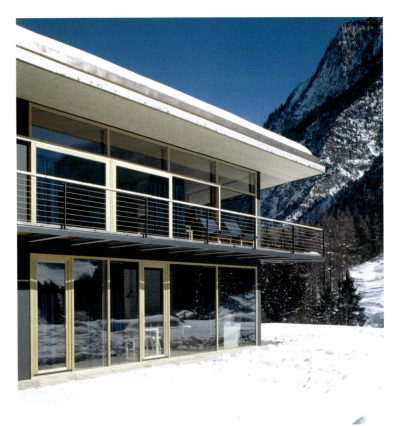

Passive thermal control principles help to achieve energy savings such as the building's form, exposure of the rooms and reinforced insulation of the building envelope.

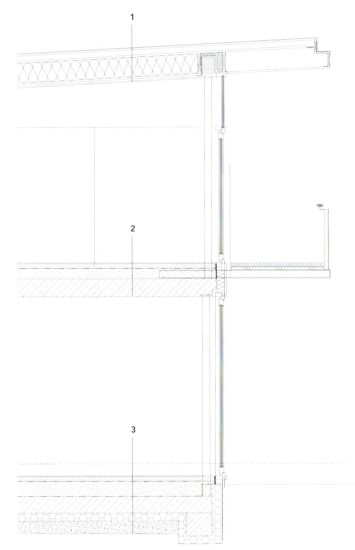

VORARLBERG'S CULTURAL DIFFERENCE

Energy-saving timber constructions have become increasingly popular in Vorarlberg – a small province with a population count of 350,000, positioned in the western tip of Austria. Yet this ecologically correct type of architecture represents only the visible part of a process that began in the 1970s, when several professionals grouped together under the name *Baukünstler* and stood up against the dictates of Vienna's Society of Architects. Vorarlberg's cultural difference is rooted first and foremost in the quality of human relations there and the climate of trust and loyalty that prevails whereby each person gives of their best in order to drive the region's future. This move towards a more creative, fairer, and community-minded society is helped by a lack of technocracy and a pragmatic approach adopted by a population whose poverty over the years has incited it to make the most of local resources. By demonstrating the advantages of transposing the principles of sustainable development into everyday life, the example set by Vorarlberg – a region that is both open to the world yet proud of its identity – is extremely motivating.

Cross section.

Longitudinal section.

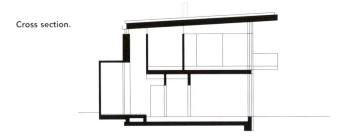

Vertical section of the north façade.

1 Roof
- copper cladding
- asphalt felt
- 24 mm timber roof boarding
- 80 x 80 mm rafters
- Multibox coffer (35 cm) K1 Multiplan triple-pleated panel (27 mm) glued-laminated chord mineral wool insulation between the chords (30 cm) K1 Multiplan triple-pleated panel (27 mm)
- vapour barrier
- 30 x 50 mm lathing
- 30 x 50 mm counter-lathing
- insulation between the lathing

- 12 mm-thick Vorarlberg white fir ceiling

2 First-floor deck
- 10 mm maple wood floor
- 70 mm cement screed with underfloor heating
- 23 cm Thermotec® thermal and acoustic insulation – recycled polystyrene and a mineral binding agent
- 25 cm reinforced concrete slab

3 Ground-floor deck
- 10 mm maple wood floor
- 70 mm cement screed with underfloor heating
- vapour barrier
- 23 cm Thermotec® thermal and acoustic insulation – recycled polystyrene and a mineral binding agent
- waterproofing membrane
- 25 cm reinforced concrete slab
- 12 cm Floormate 500 (insulation board made of extruded polystyrene)
- felt
- 15 to 20 cm drainage layer

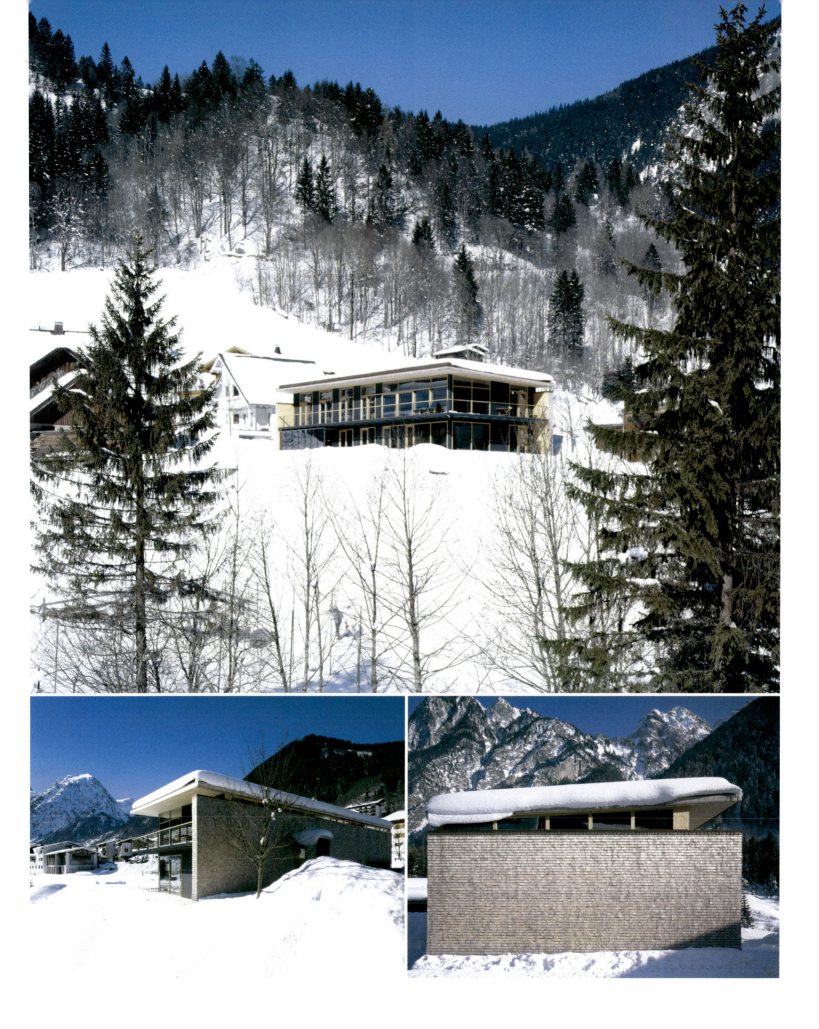

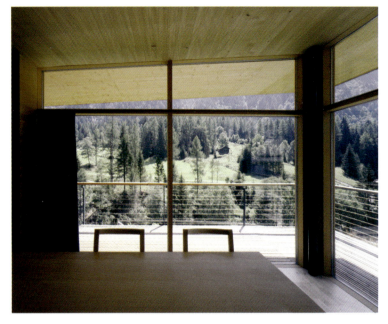

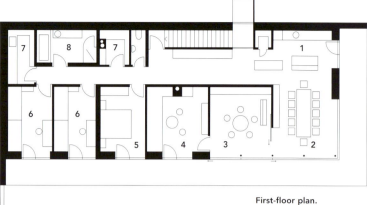

First-floor plan.
1 kitchen
2 dining room
3 lounge-library
4 *Stube* (sitting room)
5 bedroom
6 child's bedroom
7 storage area
8 bathroom

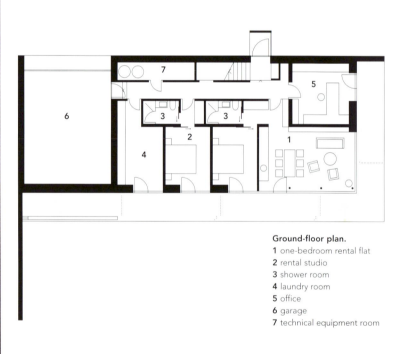

Ground-floor plan.
1 one-bedroom rental flat
2 rental studio
3 shower room
4 laundry room
5 office
6 garage
7 technical equipment room

0 1 5 10

Using pre-fabricated components to reduce costs and enhance precision
Significant technological developments since the 1990s have generated an industrial-based
process and widespread use of computer systems in the Vorarlberg region, where timber
manufacturing is of high quality. Pre-fabrication improves working conditions, increases precision,
contributes to containing costs and facilitates the management of waste, which is often burnt
to heat the workshops and offices. Industrial production processes shorten construction time
– but not the schedule of the project as a whole. On the contrary, they necessitate an extremely
rigorous design process, with many decisions having to be made earlier than for a conventional
construction scheme. Pre-fabrication also requires great commitment by each player and close
collaboration between architects, engineers and building contractors, especially during the
experimentation phase. However, the details that are carefully fine-tuned for one project can
be reproduced and gradually optimised for others, with everyone swiftly benefiting from each
other's feedback and experience.

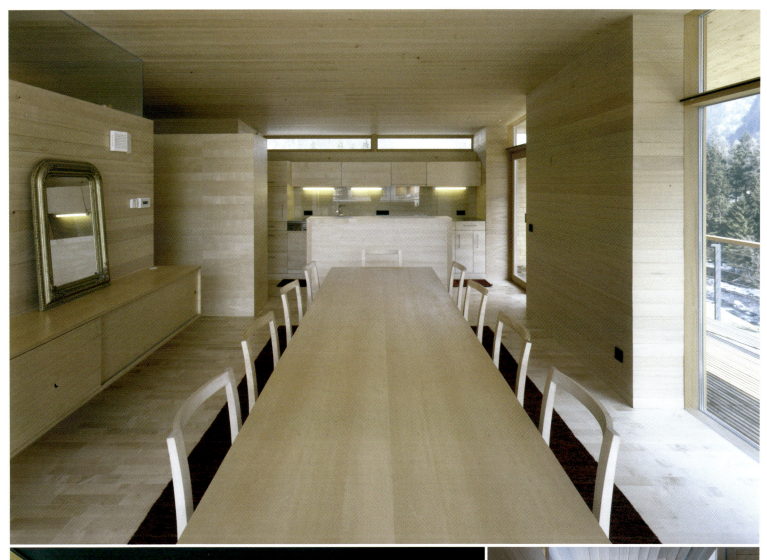

73

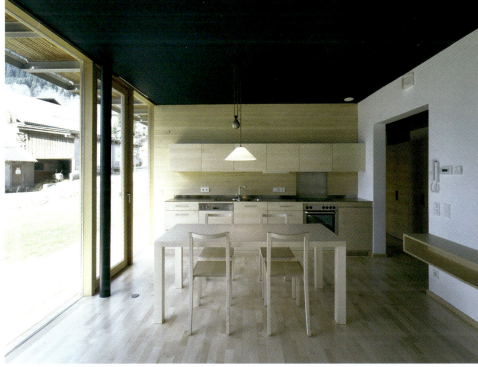

Three terraced houses in Küsnacht, Switzerland

Barbara Weber and Bruno Oertli

These terraced houses are located in a residential estate in Küsnacht, a suburb of Zurich situated on the north shore of the lake Zurich. Originally, the 1,108 m² plot was intended for a single private residence, but this plan was extended to three, bearing witness to how housing is being built more closely together in central Europe. It is a deliberate strategy, underpinned by the aim of preventing urban sprawl and minimising travel time which has proved to be a source of pollution and stress. Combining work and living space in one and the same structure has also become an economic necessity due to the boom in property prices.

The sharply sloping terrain enjoys a south-west exposure. Building regulations prohibit the construction of structures with more than three storeys, so as not to encroach on the views of neighbouring buildings. The houses are divided into split levels, in order to follow the curve of the land. There is a clear separation between exterior spaces, which are segregated by low exposed concrete walls, enabling maximum use of very small plots (230 m² for the middle house). Three concrete slab paths lead from the street to the entrance of each house. The garages, positioned in front of the south-west façade, are independent structures buried partially into the ground and topped by a planted terrace that can be accessed via a small entrance courtyard.

In the middle house, where the architects Weber and Oertli live and work, the ground floor is dedicated to the architectural practice. Above are two bedrooms with a balcony, facing south-west. The main bedroom, located at the rear of the house, opens on to a private courtyard, linked to the upper floor by a spiral staircase. The living room and dining room take up the last split-level, boasting views over the lake. The rooms with running water sit one above the other in the north-east corner. The houses are soundproofed by 6 cm of insulation placed between two 15 cm-thick brick walls making up the separating walls and via two 2 cm-thick fibreboards in the decks, which detach the reinforced concrete slab from the cement screed.

The most noticeable exterior aspect of the three houses is the rough-sawn red cedar cladding on the end walls and north-east façade. The wood was pre-weathered using weathering stain – a finish that discolours timber as would happen naturally and which gives it an even tone. The anthracite fibre-cement boards used to clad the south-west façade also act as shutters for the bedrooms and office.

Rough-shuttered concrete walls and galvanised steel supports bearing the weight of the balcony and pergola complete the grey palette, brightened by the greenery of climbing plants on the low walls, foliage on the roofs as well as by trees and shrubs.

site: Steinackerstrasse 1b, 8700 Küsnacht, Switzerland — programme: three terraced town houses comprising seven split levels; middle house – entrance and office on level 0, technical equipment room on level + 1/2, bedrooms on levels + 1 and + 1 1/2, living room on level + 2, kitchen and eating area on level + 2 1/2, terrace on level + 3 — client: private — architects: Barbara Weber and Bruno Oertli, Küsnacht — surface areas of the middle house: plot – 230 m²; house – 193 m² (habitable); office – 36 m² (useable); garage and ancillary areas – 50 m² — schedule: design period – October 1997; construction period – June 1998 to July 1999 — construction cost – around EUR 1,980 incl. VAT/habitable m² — materials and construction system: reinforced concrete exterior walls and decks; 15 cm brick double wall for the party walls; rough-sawn red cedar cladding (pre-weathered) for the end wall and east façade; fibre-cement boards for the west façade cladding; galvanised steel supports for the balcony and pergola — environmental measures: increasing housing density (terraced houses), compact volume with reinforced insulation (24 cm of mineral wool), flue heat recovery system, passive and active solar gains (thermal collectors), low-energy lamps, planted flat roof — overall energy consumption (house and office): 61 kWh/m²/year, of which 39 kWh/m²/year for heating.

Each house has a large rooftop terrace, providing a private area from which residents can enjoy the sun and views of the lake.

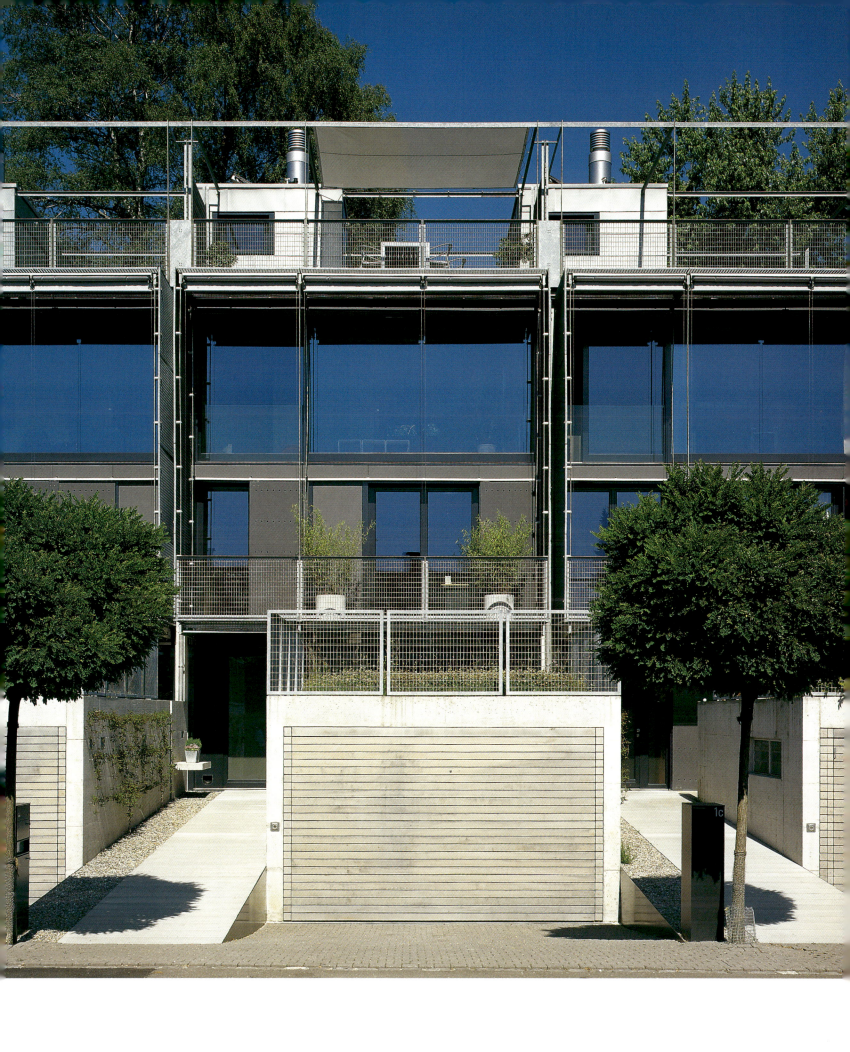

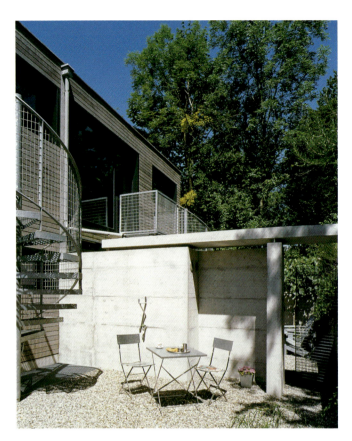

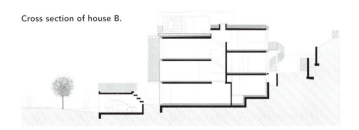

Cross section of house B.

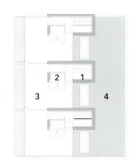

Plan of + 3 split level.
1 storage area
2 boiler room
3 accessible terrace
4 planted rooftop

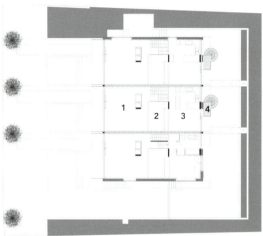

**Plan of + 2 and
+ 2 1/2 split levels.**
1 living room
2 void
3 kitchen-eating area
4 balcony

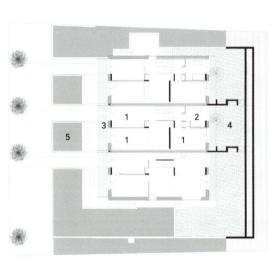

**Plan of + 1 and
+ 1 1/2 split levels.**
1 bedroom
2 bathroom
3 balcony
4 courtyard
5 accessible flat roof

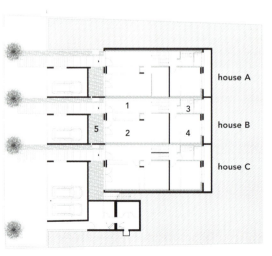

house A

house B

house C

**Plan of 0 and
+ 1/2 split levels.**
1 entrance
2 office
3 small bathroom
4 technical equipment room
5 courtyard

0 5

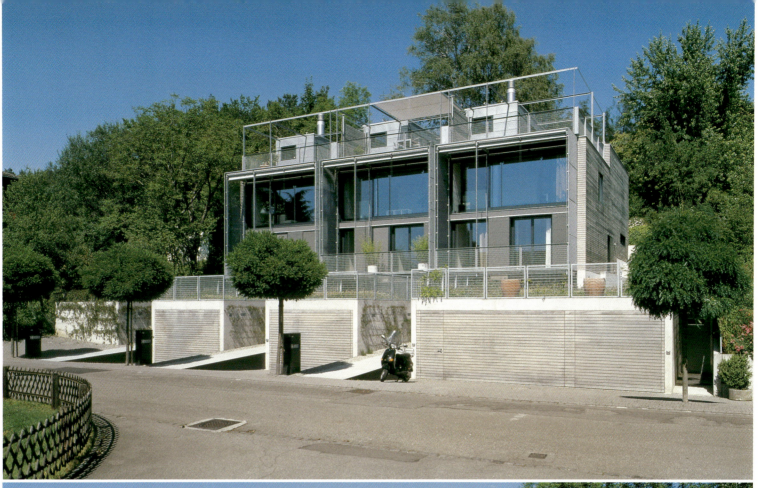

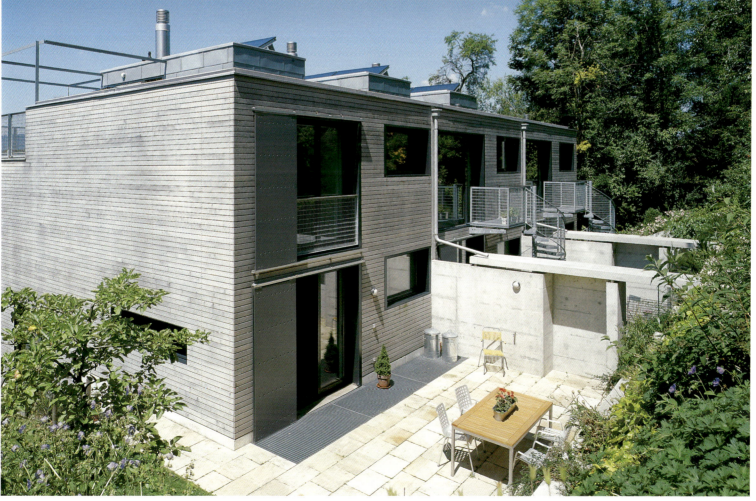

Daylight slips into the heart of the deep layout grid via top lighting above the stairs.

A DESIGN CONCEPT THAT COMBINES PASSIVE AND ACTIVE ENERGY GAINS

The reinforced concrete end walls and decks help provide efficient thermal control. On the south-west façade, overheating of the glazing is avoided by means of sliding shutters on the lower levels of the house, and by an awning and blinds in front of the living room. The solar thermal collectors, fixed onto the roof above the technical equipment room containing the water heater, entirely cover domestic hot water requirements on fine days. The dual-flow mechanical ventilation system is equipped with a heat exchanger that recovers a high proportion of calories from the used air. The gas-condensing boiler is only used in winter. In mid-season, heating is supplied by a "hot-air" fire in the living room whose heat recovery system doubles efficiency gains compared with a traditional open fire.

Bioclimatic villa near Munich, Germany

Markus Julian Mayer with Christian Schießl

When commissioning the construction of their home, an increasing number of clients now seek solutions that guarantee a better quality of life such as thermal comfort, materials and finishings containing a minimum amount of chemical products as well as a healthy interior climate in which the humidity level is naturally regulated. Timber – the only renewable structural material – is already 90% used in Sweden and 60% in Finland, but only 10% in France and 20% in Germany. Overall, however, in western Europe, the demand for architect-built houses featuring timber for the frame, interior facing and exterior cladding is currently rising sharply.

The Schießl family home, designed by Markus Julian Mayer in conjunction with Christian Schießl, who was an architecture student at the time, bears all the traits of a contemporary timber house, with pure lines, functional layout, spatial volumes extending generously towards the exterior, and an optimal construction system that allies wood with other materials. Built in the suburbs of Munich, on the site of a 1950's house, it has the advantage of being set in green surroundings within an urban environment. Its hybrid, bioclimatic architecture represents a practical combination of wood, metal and concrete aimed at leveraging materials and energy.

The two cross walls together with the reinforced concrete deck slabs have high thermal mass and at the same time act as a wind brace. The dark floor made of Blaustein – a blackish grey limestone with a shell-like fracture – enhances the storage of heat. The structural envelope of the north façade and end walls comprises pre-fabricated timber boards with cellulose inserted between the studs of the frame, which insulates much more effectively than a solid wall of the same thickness. The main façade faces south to capture solar gains, and is designed as a timber-framed curtain wall. Its glued-laminated posts, set out on a 1.20-m grid, are protected on the outside by an aluminium capping. This largely glazed façade merges the interior with the exterior, offering extensive views out to a lushly planted garden. Sliding openwork shutters made of larch are hung on metal rails, their thin slats of wood separated by toothed jambs, safeguarding occupants' privacy and ensuring the house does not become overheated.

The underlying design concept hinged on blending the building with greenery. The landscape designer Alexander Koch put this concept to work by playing on contrast, based on the view that "the tauter the lines of the house, the greater the soothing effect of greenery". The overall composition is arranged around several juneberry shrubs that give a beautiful blossom and a flower-lined pond, resulting in an expansive feel to the 1,000 m² garden.

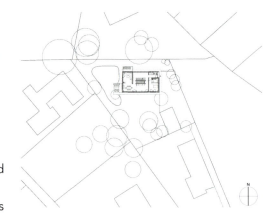

site: Gauting, Barvaria, Germany — programme: main residence with two storeys + basement; ground floor – entrance, living room, dining room, kitchen, studio with bathroom; first floor – study and two bedrooms with bathrooms — client: Schießl family — architects: Markus Julian Mayer (Munich), in conjunction with Christian Schießl; landscape designer: Alexander Koch, Starnberg — technical engineer: Vasco Schindler — surface areas: plot – 1,100 m²; house – 310 m² (habitable) — schedule: design period – 1999; construction period – October 1999 to December 2000 — cost: construction – EUR 584,000 excl. VAT; total cost – EUR 767,000 excl. VAT but including furnishings, supply systems and networks, green areas and fees — materials and construction system – combined concrete/metal/timber structural frame, reinforced concrete deck slabs supported by concrete cross walls and steel outer posts, timber-framed exterior walls; spruce joinery, interior cladding made of chipboard with maple wood facing, limestone slab flooring in the living room, dining room and terraces, red hexagonal floor tiles in the kitchen, beech wood floor in the bedrooms, exterior cladding and sliding shutters made of 25/120 mm larch strips laid on a galvanised steel surround, concrete roof tiles — environmental measures: compact building positioned along an east-west axis; largely glazed south façade to capitalise on passive solar gains, opaque north façade with reinforced insulation (24.5 cm), solid decks and cross walls for thermal efficiency, openwork shutters to create a draught in summer, natural insulation (cellulose and softwood fibre), recycled limestone for the flooring on the ground level, untreated larch cladding — specific equipment: high-efficient gas-condensing boiler, solar collectors for heating domestic water, with vacuum tubes fixed onto the southern roof section — heat transfer coefficients: timber-framed walls – U = 0.18 W/m²K; underground walls of the basement – U = 0.2 W/m²K; roof – U = 0.15 W/m²K; glazing – U = 1.0 W/m²K; windows – U = 1.2 W/m²K.

The biotope pond that adorns the terrace in front of the western end wall attracts insects and small batrachians.

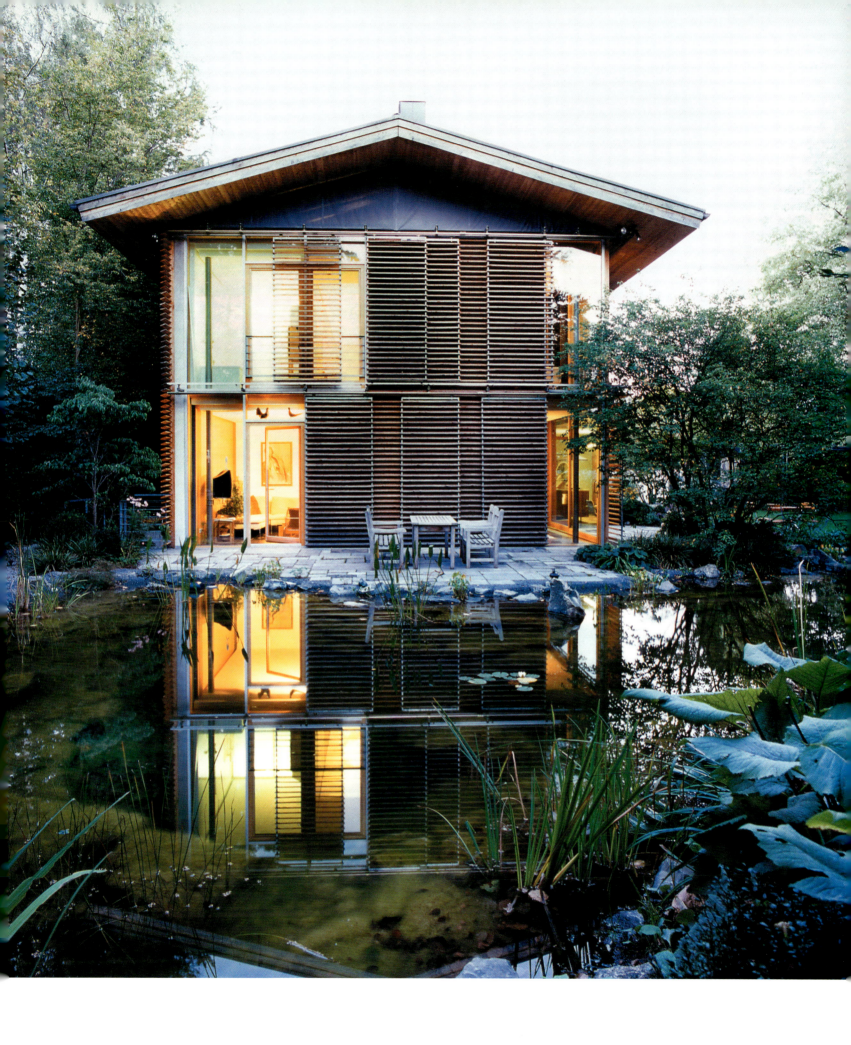

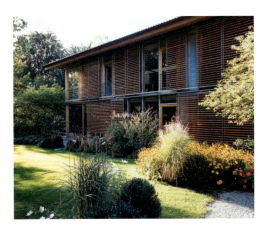

The exterior cladding and shutters merge into one, concealing the openings when the shutters are closed.

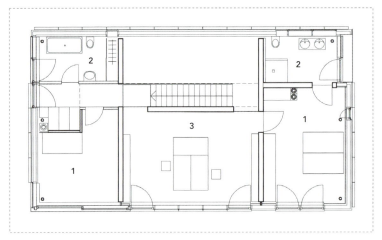

First-floor plan.
1 bedroom
2 bathroom
3 study

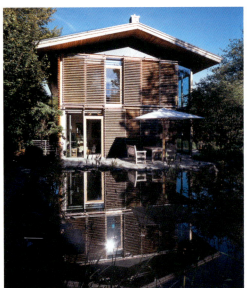

82

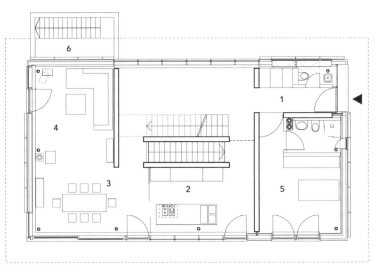

Ground-floor plan.
1 entrance
2 kitchen
3 dining room
4 living room
5 studio
6 access to the sauna

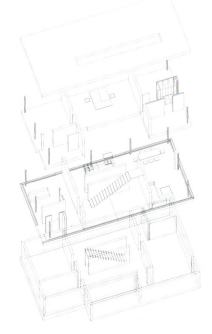

Isometric plan showing the construction principle.

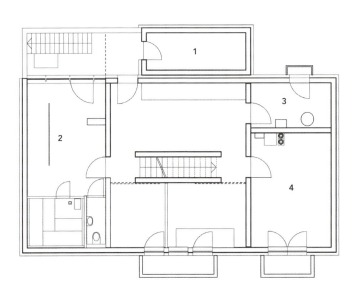

Basement plan.
1 cellar
2 sauna
3 laundry room
4 technical equipment room

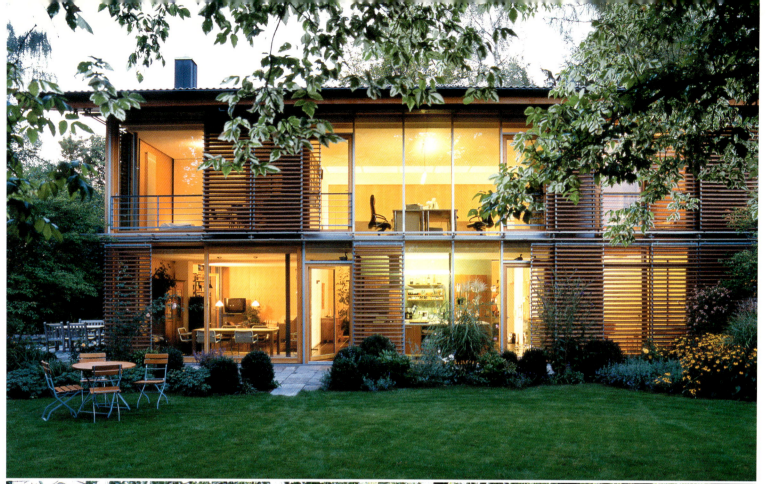

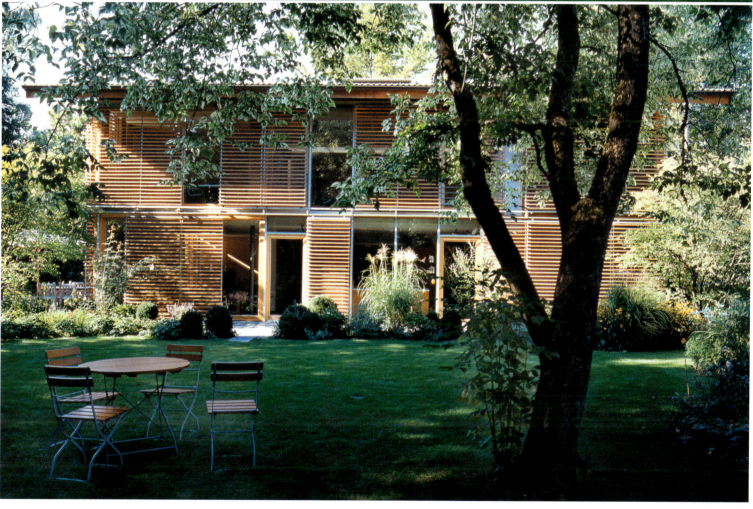

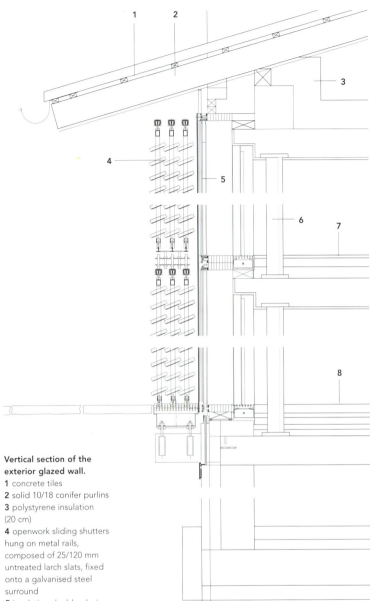

Vertical section of the exterior glazed wall.

1 concrete tiles
2 solid 10/18 conifer purlins
3 polystyrene insulation (20 cm)
4 openwork sliding shutters hung on metal rails, composed of 25/120 mm untreated larch slats, fixed onto a galvanised steel surround
5 insulating double glazing set in front of the timber structural frame with Eloxal aluminium glazing fillets
6 steel post (15 cm diameter)
7 first-floor deck
• 20 mm beech wood floor
• 60 mm battens
• 80 mm cellulose soundproofing
• 20 cm reinforced concrete slab
• plaster rendering
8 ground-floor deck
• 60 mm recycled Blaustein limestone slabs
• 30 mm mortar
• 85 mm cement screed with underfloor heating
• 45 mm polystyrene insulation
• 20 cm reinforced concrete slab
• plaster rendering

The dark limestone floor on the ground level increases the structure's capacity to accumulate solar heat, which is then released at night.

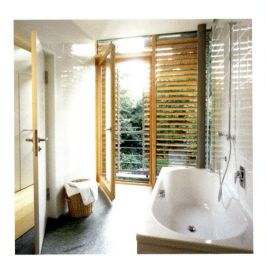

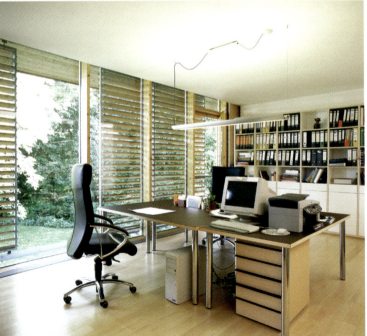

AN EVOLUTIONARY HOUSE
One of the principle requirements of sustainable architectural development is anticipating occupants' changing needs and designing buildings that can be adapted without any major construction work. The Schießl home, designed for a family with children, gives each resident maximum spatial autonomy. Once the children have left home, the staircase can be enclosed, enabling a rental office or flat to be created on the first floor. In addition, the ground-floor studio provides the facilities for elderly residents to continue living in the house even if their physical capabilities are reduced, or for the accommodation of a home-help.

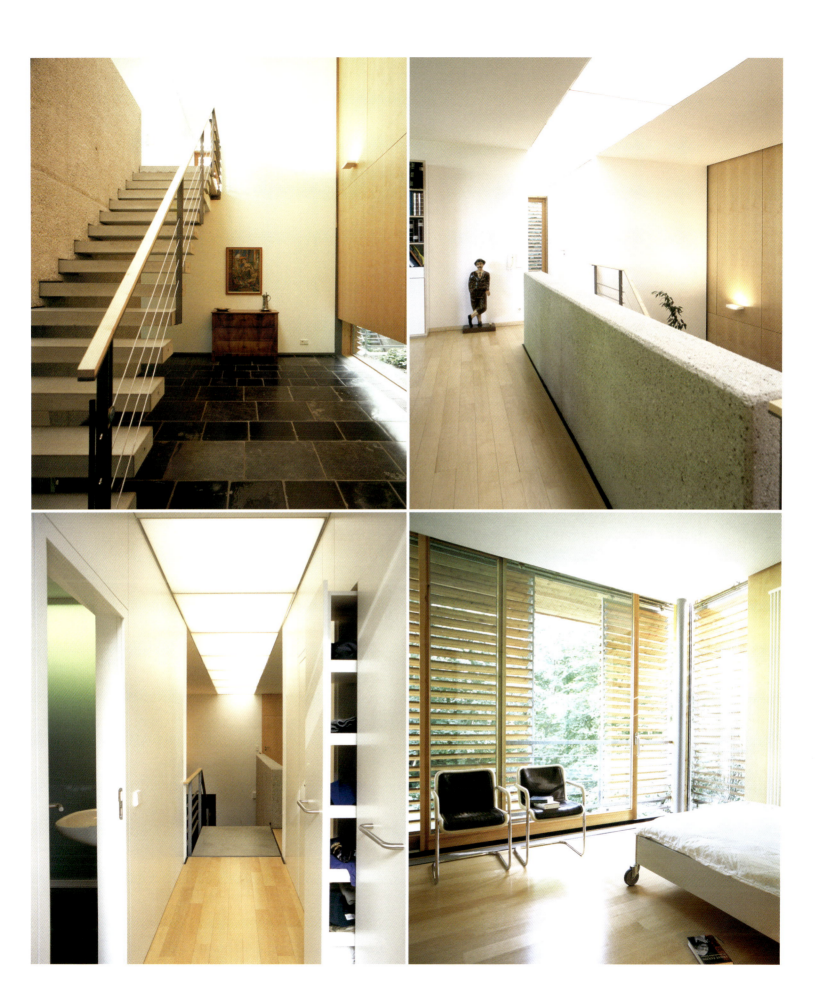

Beach house at São Sebastião, Brazil

Lua and Pedro Nitsche

La Barra do Sahy is a beach that lies on the northern shores of the state of São Paulo, where environmental concerns are of great importance. This part of the Mata Atlantica is characterised by a mountainous landscape, thick and varied vegetation and a tropical climate that is extremely hot and humid. In summer (December to February), temperatures range from around 33°C during the day to 22°C at night, and the humidity can reach 100%. These geographic and climatic conditions played a decisive role in the design of this beach house for a São Paulo lawyer.

Lua Nitsche and her brother Pedro sought to "create a structure that would put the occupants into contact with the lush surrounding nature, whilst at the same time protecting them from it". The holiday home – the architects' first residential design – resembles a long verandah positioned on a south-east/north-west axis. The interior spaces, sheltered from bad weather by a widely jutting roof, are separated from the exterior merely by sliding panels that in some places are transparent and in others translucent. A 336 m² slab with pre-fabricated components made of reinforced concrete serves as a base for the house and protects it from humidity. The residence is clad in *são tomé*, a stone from the Minas Gerais region in central Brazil. Set on foundation beams, it is raised from the ground to limit the building's impact on the fragile ecosystem of the sandy shore.

The overall surface area is reduced to a minimum, with the different areas set in juxtaposition with one another without any interior connections. The three bedrooms, the communal room and the laundry are accessed from the terrace via an exterior path, providing residents with a large degree of independence. When the living room glass doors are open, the light-coloured stone slabs laid indoors and outdoors fuse the interior with the exterior.

The construction process was based on a rational system, using a modular structural frame and factory-made components to reduce costs and the building schedule. Measuring 5.85 m in width, the house is divided lengthwise into six 3.85-m grids: one for each of the bedrooms, two for the living room and one for the kitchen and laundry. White and yellow-painted concrete blocks cover the end walls and interior facing. The frame of the façades is made of jatoba – an extremely hard wood – from a sustainably managed Brazilian forest.

The post-and-beam structure, mounted in just five days, supports thermo-acoustic boards comprising polyurethane foam set between two lacquered aluminium sheets. The space between the ceiling and the roof helps create natural ventilation, reducing the risk of overheating, and contains technical equipment. The joinery is made of aluminium and extends from the jatoba structural frame. Brightly coloured green, yellow and red curtains effectively and inexpensively screen the bedrooms, lending a splash of colour to the plain design.

site: rua Gabriel Tavares, 172 Barra do Sahy, São Sebastião, Brazil — programme: single-storey holiday home comprising an open-plan living room, dining room and kitchen area, three bedrooms each with an en-suite bathroom, and service block with laundry room — client: Fernando Albino — project manager: Nitsche Arquitetos Assiociados, São Paulo; architects: Lua and Pedro Nitsche; other project team member: Marina Mermelstein — engineer and manufacturer of the timber structural frame: Helio Olga, Ita Construtora, São Paulo — surface areas: plot – 805 m²; platform – 336 m²; roofed part – 190 m²; habitable part – 126 m² — schedule: design period – 2000; construction period – July to December 2002 — construction cost: around EUR 350/m² — materials and construction system: reinforced concrete platform; end walls and cross walls made of 9 cm-thick concrete blocks; jatoba wood-framed façades; aluminium joinery; roof made of 7 cm-thick thermo-acoustic sandwich panels, comprising polyurethane foam inserted between two sheets of aluminium; *são tome* flooring — environmental measures: building slab laid on foundation beams and modular system with pre-fabricated components to minimise impact on the terrain; local timber from a sustainably managed forest; natural ventilation; rainwater recovery system.

This functional and economical beach villa is characterised by independent access, an exposed structural frame and use of industrial materials to simplify on-site assembly.

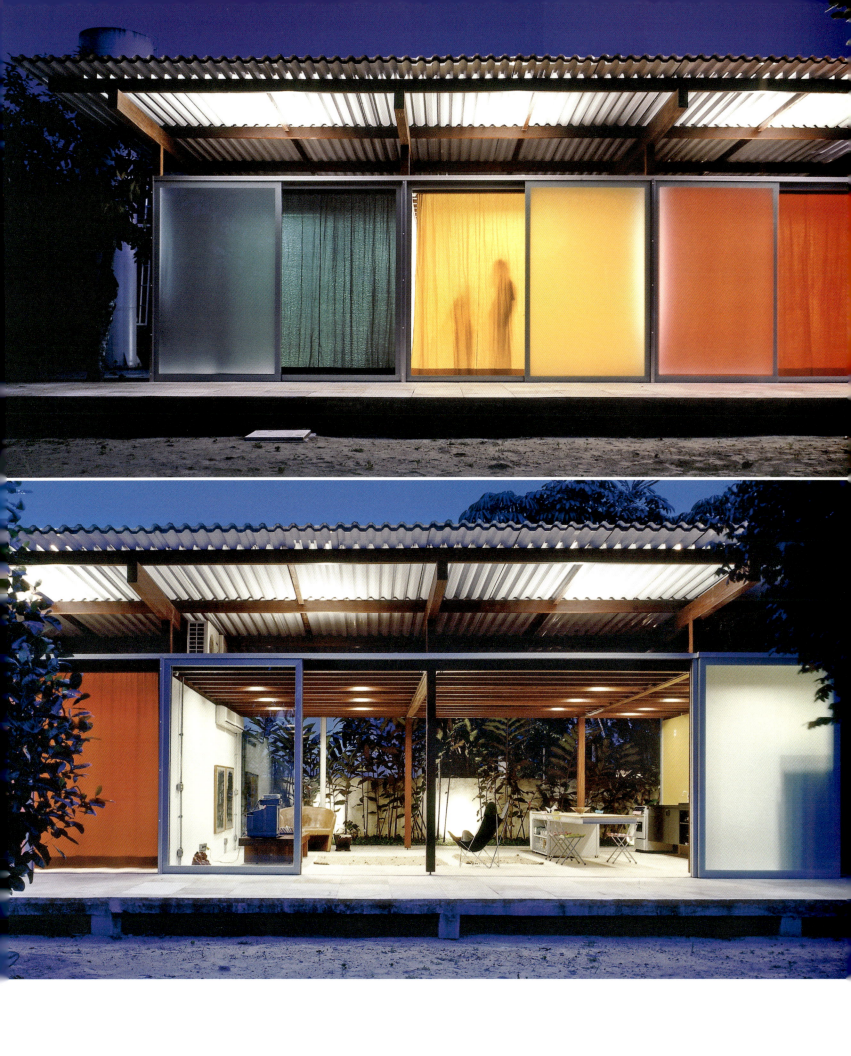

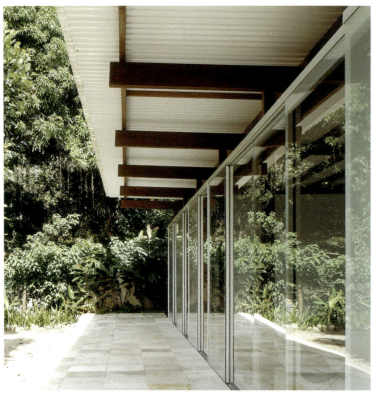

TIMBER FRAME WITH OPTIMAL USE OF SECTIONS

The jabota wood-framed sections are very slender. The 12 x 12 cm posts, which are raised from the ground to protect them from humidity, are laid on metal plates and anchored to the foundation slab by steel rods. The cross joists set into 12 x 16 cm beams support pre-painted white MDF boards (a wood-based product) that form the house's ceiling. The weight of the roof's sandwich panels is borne by purlins laid on 12 x 20 cm inclined beams. Jatoba is a tropical tree that is sometimes called courbaril, and grows in several South American countries. It is an extremely hard wood with a density close to 1, and can naturally sustain exterior usage.

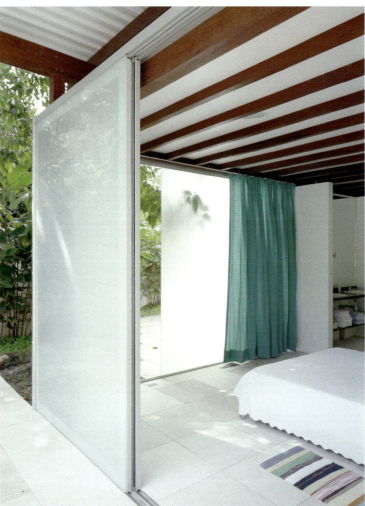

Section of the exterior wall.
1 aluminium sandwich board (7 cm)
2 jatoba purlin
3 main beam made of jatoba wood
4 pre-painted MDF ceiling
5 jatoba beam (12 x 16 cm)
6 jatoba post (12 x 12 cm)
7 metal plate and galvanised steel rod
8 aluminium support for the sliding doors (12 cm)
9 aluminium rail
10 transparent/translucent 8 mm-thick laminated sheet of glass
11 sliding doors (kitchen and living room)
12 stainless steel groove
13 são tomé flooring (finished floor 0.45 m above the natural ground)
14 mortar
15 reinforced concrete slab
16 natural ground (+/- 0.00 m)

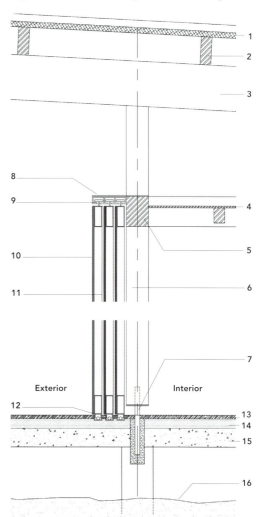

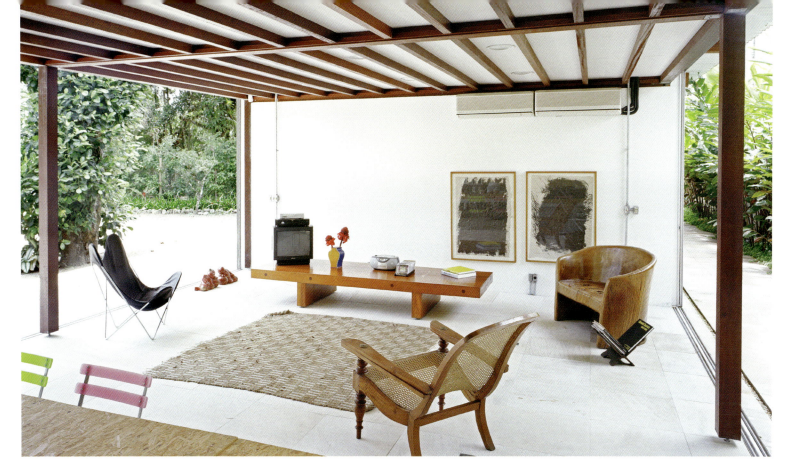

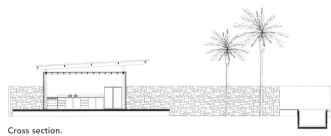

Cross section.

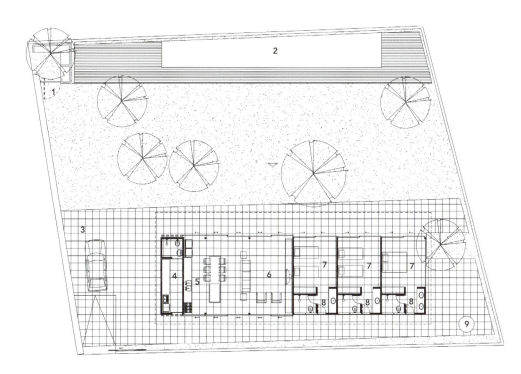

Ground-floor plan.
1 access to the beach
2 water feature
3 parking area
4 laundry room
5 kitchen
6 living room
7 bedroom
8 bathroom
9 water tank

Barra do Sahy beach is not connected to a public water system. Instead, it receives water from a natural spring at the foot of the mountain. A stainless steel tower that can hold up to 5,000 litres of rainwater stands in the north corner of the terrace.

Passive Housing residence in Giessen, Germany

Anke Lubenow and Carsten Peters

Based on a contemporary design featuring natural materials, a planted roof and an eco-pool, this house is almost totally energy self-sufficient and is one of the most forceful ecological structures built to date in Germany. Such an achievement is due both to the expertise of its designers and to the determination of the clients, who wanted a home made of healthy, renewable and recyclable materials, and who sought to actively use solar gains in order to generate considerable water and energy savings.

The dwelling's airy volumes are arranged freely around a central staircase, with low walls extending the building out to the exterior to preserve the occupants' privacy. Wooden decking surrounds a natural swimming pool, generating a calm, relaxing atmosphere that visitors would not expect to feel in this housing estate set in busy central Germany not far from Frankfurt am Main.

The building meets the definition of Passive Housing design, whose underpinning principle is that heat consumption should not exceed 15 kWh/m²/year. Attaining such an ambitious objective required combining high-performing technical fittings with a common-sense approach. The shape and the orientation of the house make optimal use of thermal mass – the structure is compact, topped by a gently sloping pitched roof. The main rooms open out to the 60%-glazed south façade, whilst the ancillary areas are grouped in an outhouse that is partially buried into the ground and backs onto the north façade, acting as a thermal buffer.

To minimise heat loss, the structure is wrapped in an extremely airtight, insulating coat. Insufflated cellulose was inserted between the studs of the timber-framed load-bearing panels, complemented on the outside by a second layer crossed between wood-based I-beams and by softwood fibreboards that serve as a support for the rendering.

The reinforced concrete roof and the foundation slab are insulated by 35.6-cm of cellulose inserted between TJI-beams. The partitions and interior wall facing are made of 10 cm-thick blocks composed of clay and sawdust assembled in a tongue-and-groove arrangement, as well as of hardwood fibreboard plastered with clay. A dry screed made of clay blocks was laid on the intermediate deck comprising boards nailed edge-to-edge lengthways, and whose planed underside serves as a ceiling.

The triple glazing of the south façade is incorporated into the post-and-beam frame by means of special-purpose aluminium sections. The horizontal metal grid set mid-way up is wide enough to prevent the sun from hitting the living room in summer, and blinds protect the bedroom windows on the first floor. Shadows are cast on the east and west end walls by free-running balconies and a wide roof overhang. The combination of these fixed and mobile sunscreens passively ensures that the house does not become overheated in summer.

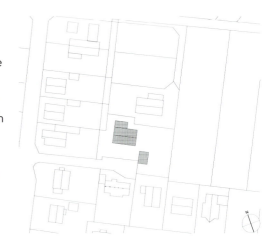

site: Giessen, Hesse, Germany — programme: main residence; ground floor – entrance, study, open-plan living room, dining room and kitchen, WC, storage space and technical equipment room; first floor – mezzanine overlooking the living room, two bedrooms, bathroom — clients: Volker and Erika Peters — architects: Planungsgruppe Bau + Energie/Anke Lubenow, Carsten Peters and Steffen Berge — thermal engineer: sun-trieb/M. Faulhaber — surface areas: plot – 1,165 m²; house – 189 m² (habitable), ancillary areas – 44 m² — schedule: start of design period – June 1998; construction period – August 2000 to April 2001 — total cost: EUR 501,000 incl. VAT, i.e. EUR 2,150/m² — materials and construction system: post-and-beam timber frame on the south façade with triple glazing incorporated into aluminium sections (*Passivhausfassade* by Raico); partitions and other walls made of a timber frame whose interior facing comprises elements composed of 75% clay and 25% sawdust (100 x 250 x 500 mm Karphosit blocks) as well as hardwood fibreboards (Heraklit) plastered in clay; intermediate deck made of boards nailed edge-to-edge lengthways, clad in clay and sawdust panels (50 x 250 x 1,000 mm Karphosit); reinforced layer of insulation (Isofloc cellulose) set between TJI wood-based beams (Trus Joist); on the south façade, Kapilux transparent thermal insulation (made by Okalux) — environmental measures: systematic use of healthy, renewable and recyclable materials (wood, clay, cellulose); application of bioclimatic measures; highly reinforced insulation (triple glazing and over 35 cm-thick continuous layer of insulation); innovative technical fittings to save energy and water; natural swimming pool with a biological self-cleaning system — heat transfer coefficients: timber-framed exterior walls – U = 0.113 W/m²K; roof – U = 0.123 W/m²K; windows – U = 0.778 W/m²K (glazing and frames); lower deck of the ground floor – U = 0.134 W/m²K; air tightness: 0.32 (in the Blower Door tests, anything below 1 is qualified as "very airtight") — heating energy consumption: 10.2 kWh/m²/year.

Located in a residential district, the plot gently slopes towards the south-east, unlatching views over the landscape.

THERMAL COMFORT

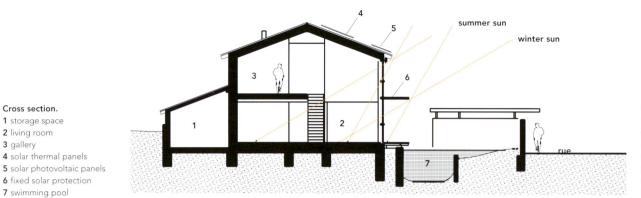

Cross section.
1 storage space
2 living room
3 gallery
4 solar thermal panels
5 solar photovoltaic panels
6 fixed solar protection
7 swimming pool

summer sun

winter sun

rue

The clay sheets of the interior facing and the solid wood intermediate deck have high thermal mass, helping to create a healthy interior climate with a naturally regulated humidity level.

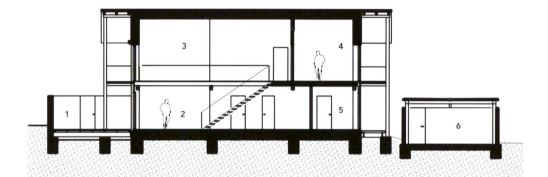

Longitudinal section.
1 terrace
2 living room
3 gallery
4 bedroom
5 entrance
6 car port

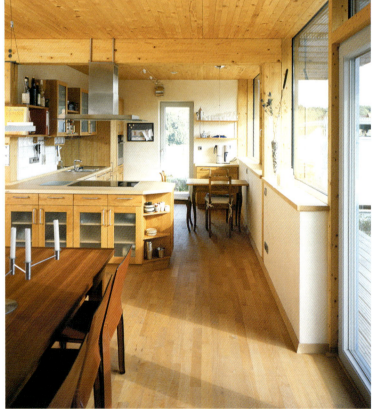

USING INNOVATIVE EQUIPMENT TO SAVE ENERGY AND WATER

By adopting a passive energy design strategy for the building envelope, and thanks to high-performing equipment, the house's energy consumption is as low as 10.2 kWh/m^2 per year (simulation value using Helios/Helix software). The transparent thermal insulation (Kapilux) on the south façade plays a major role in the overall energy design concept. Composed of a polycarbonate capillary structure encapsulated between two panes of glass, it creates a passive solar collector in conjunction with the interior clay wall. The heat stored in the earth, which acts as an absorber, is transmitted into the house and at the end of the day takes over from the gains received via the glazing. Air serves as a heating and cooling vector by means of a dual-flow ventilation system featuring a heat exchanger that recovers 85% to 90% of calories from the used air. An earth energy system comprising 35 m of polyethylene tubes measuring 30 cm in diameter enables incoming air to be tempered naturally. Three tubular solar collectors (8.2 m^2) are fitted into the roof, and help to supply hot water and heating. A Wodke wood-pellet stove with an automatic supply system and built-in hot water exchanger meets additional energy needs. A continuous strip of thirty-two BP 585 photovoltaic modules with a total power of 3.6kW is fixed onto the edge of the thickly planted southern roof section. Domestic waste water from the wash basins, sinks, showers and washing machines is recovered and filtered, and is re-used for the toilet flush system.

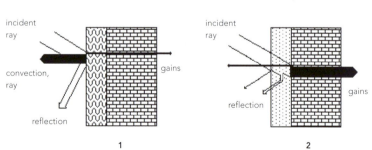

incident ray

convection, ray

gains

reflection

1

incident ray

reflection

gains

2

Comparison of solar gains:
1 using traditional exterior insulation
2 using transparent insulation

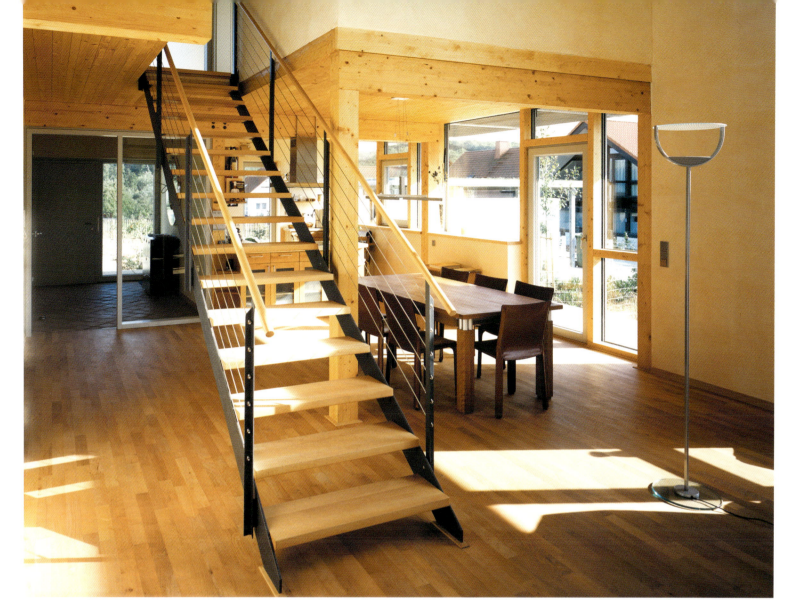

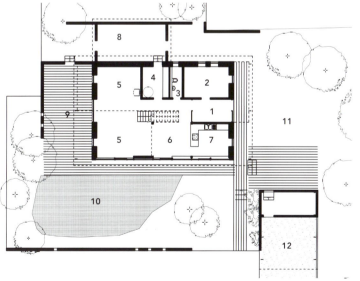

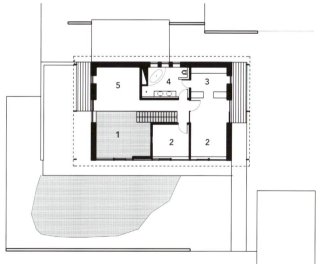

Ground-floor plan.
1 entrance
2 study
3 WC
4 technical equipment room
5 living room
6 dining room
7 kitchen
8 storage area
9 terrace
10 swimming pool
11 orchard
12 car port

First-floor plan.
1 void over the living room
2 bedroom
3 clothes hanging area
4 bathroom
5 gallery

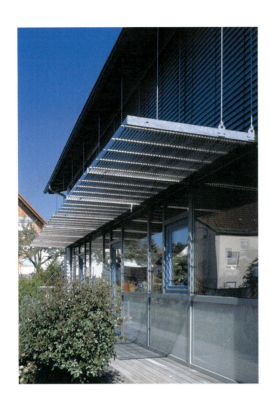

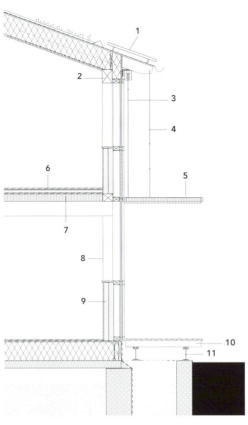

**Vertical section
of the south façade.**
1 photovoltaic modules
2 glued-laminated beam
(20/26 cm)
3 blinds with horizontal slats
4 round steel suspender of
the solar protection device
(12 mm diameter)
5 fixed steel solar protection
6 first-floor deck
• cork flooring
• 22 mm Pavafloor wood
fibre under-layer
(by Pavatex)
• Karphosit boarding made
of clay and sawdust (50 mm)
• 10 mm distribution layer
• 22 mm OSB panel
• 15 cm deck made of boards
nailed edge-to-edge
lengthways
7 glued-laminated beam
(20/28 cm)

8 glazed wall
• fixed glazed part
• glued-laminated post-and-
beam timber structure
• triple glazed insulation
(U = 0.778 W/m²K)
incorporated into aluminium
sections with reinforced
insulation (Raico HP 76)
9 spandrel
• clay-based rendering
(15 mm)
• 20 cm Karphosit clay and
sawdust blocks
• air gap
• Kapilux transparent thermal
insulation (made by Okalux)
10 wooden beam (8/12 cm)
11 IPE 200 steel beam

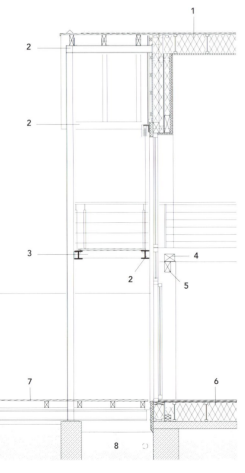

**Vertical section of the west
façade.**
1 roof
• large expanse of sedum
bushes
• 35 mm substrate
• 10 mm drainage cushion
• waterproofing
• 22 mm OSB panel
• 35.6 cm TJI I-beam
• 35.6 cm Isofloc cellulose
insulation
• vapour barrier
• lathing
• 10 mm plasterboard
2 HEB 140 steel beam
3 wooden beam (8/14 cm)
4 glued-laminated beam
(18/14 cm)
5 lintel (12/20 cm)
6 ground-floor deck
• 22 mm beech wood
flooring
• 22 mm OSB panel
• 35.6 cm TJI I-beam
• 35.6 cm Isofloc cellulose
insulation
• waterproofing membrane
• 14 cm base slab
7 terrace
• 35 mm teak boards
• 8 x 12 cm larch joists
• 40 mm larch boards
• IPE 200 steel beam
8 drainage

ECO-POOL

A natural swimming pool marries the creation of an ecosystem with the pleasure of bathing amongst plants and fish. In traditional swimming pools, the quality of the water is artificially maintained by disinfectant chemicals. In eco-pools, the bottom of the structure is clad in waterproofing and felt, with the pool itself taking up no more than two-thirds of the water space. The remainder is given over to purifying, oxygen-producing aquatic plants that also serve a decorative purpose. Pumps send water to this part of the pool. During the biological cleaning process (nitrogen cycle), the plants eliminate bacteria generated by the accumulation of organic waste in the water. In this particular design, rainwater from the roof is channelled down to the eco-pool, featuring a 30 m² basin reaching 1.80 m in depth and a 24 m² waste purifying area. The filter garden is planted with several varieties of reeds and irises; grass and flowers grow on the banks of the pool, and water lilies float on the edge of the bathing area.

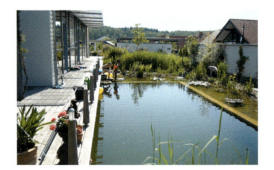

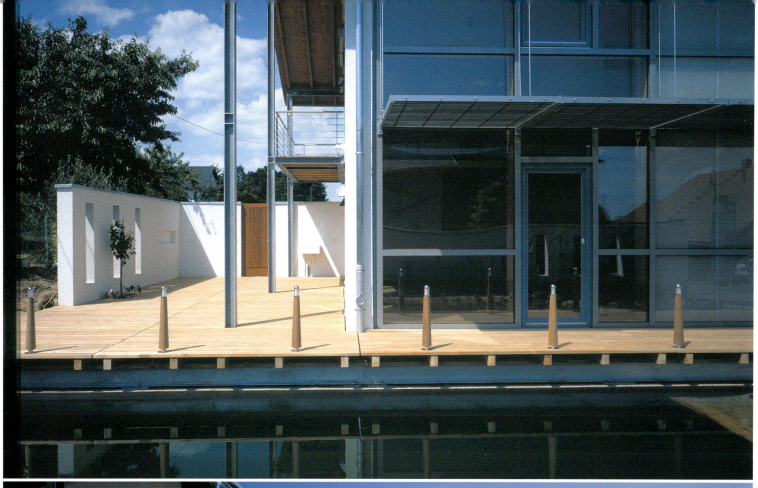

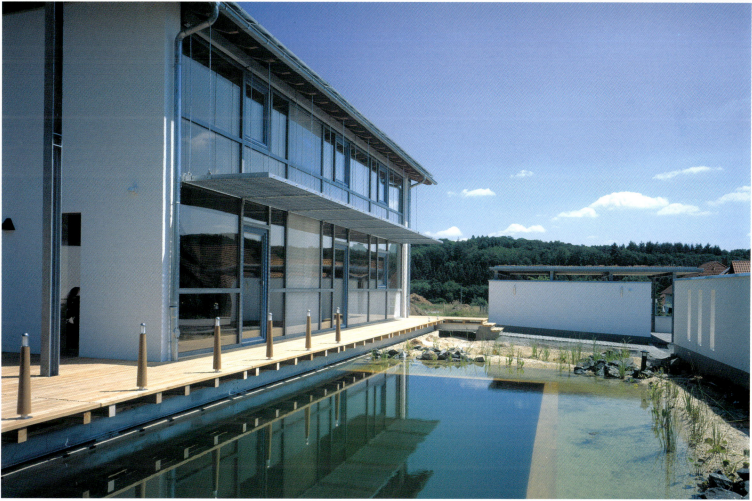

Villa between pine trees, Cap Ferret, France

Marc Daufresne and Ivan Le Garrec

Under the impetus of Pierre Lajus and Michel Sadirac, since the 1970s, Arcachon and its surrounding area has become the epicentre of contemporary holiday residences in south-western France, whose architecture is styled on local fishermen's dwellings that stand on stilts, and which are often built entirely or partly of timber.

Marc Daufresne and Ivan Le Garrec's holiday home was constructed in accordance with this tradition, thus respecting the *genius loci*. The focal point of the scheme was to find a synthesis between anchoring the building to its plot and slipping it surreptitiously between the trees without rustling a leaf.

The house is gently set in the midst of pine trees, on a sand dune facing the Arcachon Basin. There is a clear programmatic division by each storey, with daily living space on the ground floor, and five bedrooms and a lounge on the first floor, accessed by a corridor lined with cupboards. The sink in the open-plan kitchen faces the sea, rendering certain chores less unattractive. Intermediate spaces extend the interior out to the exterior, such as a wooden terrace in front of the living room, and a free-running balcony in front of the bedrooms that runs the length of the south façade. The timber walkway that widens out at each end is linked to the garden by an exterior staircase. The house stretches east to west to capture sea views and solar gains. It is slightly angled in the south-east, closing the structure in on the garden. The north façade, which is positioned along a busy street, is made of concrete covered with a single layer of white plaster, as are the two end walls. These solid walls ensure privacy and block out noise, whilst providing thermal comfort. In summer, they store the cool night air, slowly releasing it during the day, whereas in winter they accumulate daytime warmth which is subsequently emitted at night. The other walls are made of a combined wood and metal structure. Louvered shutters – sliding on the first floor and concertina-folding on the ground floor – let in soft, filtered daylight. When the solar gains are not sufficient there is an earthenware wood-burning stove in the corner of the living room and billiard room, as well as an open fire in the lounge on the first floor.

The uniform design of the exterior cladding and shutters, which feature the same striated pattern, conceals the building's openings when the residence is closed up. Like the terrace and walkway, this outer skin is made of local pine from the Landes region.

The wood was "retified" – an effect achieved by pyrolysis at temperatures of around 200°C in a stable atmosphere, which makes the timber water-repellent and rot-proof, offering an ecological alternative to chemical preservation methods. The guard rails and pergola supports are made of stainless steel to withstand the sea air. Their unobtrusive design fades into the idyllic landscape featuring pine trees, a small sandy beach and yachts gliding on the water.

site: Le Canon, 33950 Lège-Cap Ferret, France — programme: holiday home; ground floor – living room/dining room, billiard room, kitchen, laundry room, boat shed; first floor – lounge, five bedrooms, bathroom, shower room and WC — client: private — architects: Marc Daufresne and Ivan Le Garrec, Paris — economists: Guiraud, Tallier et associés — surface areas: plot – 4,828 m²; house – 412 m² (gross), 294 m² (habitable) — schedule: design period – September 1998 to June 1999; construction period – September 1999 to August 2000 — construction cost: EUR 259,000 excl. VAT, or around EUR 1,050/m² incl. VAT — materials and construction system: ground-floor walls and entire north façade made of 20 cm concrete and 10 cm rockwool; combined timber/steel frame for the first floor, with the wall structure made of local pine from the Landes region, insulated by 10 cm of mineral wool; pine wood floor; interior finishings made of wood-based panels and painted plasterboard; terrace, exterior cladding and sliding shutters on the first floor made of retified pine from the Landes region — environmental measures: bioclimatic design concept (solid wall in the north, lightweight frame in the south), natural ventilation and horizontal and vertical solar protection devices to reduce heat in the summer; use of local wood without any chemical treatment (retified pine from the Landes region); earthenware wood-burning stove.

The house's positioning allies the objective of capturing views of the superb surroundings and the need to preserve a fragile ecosystem.

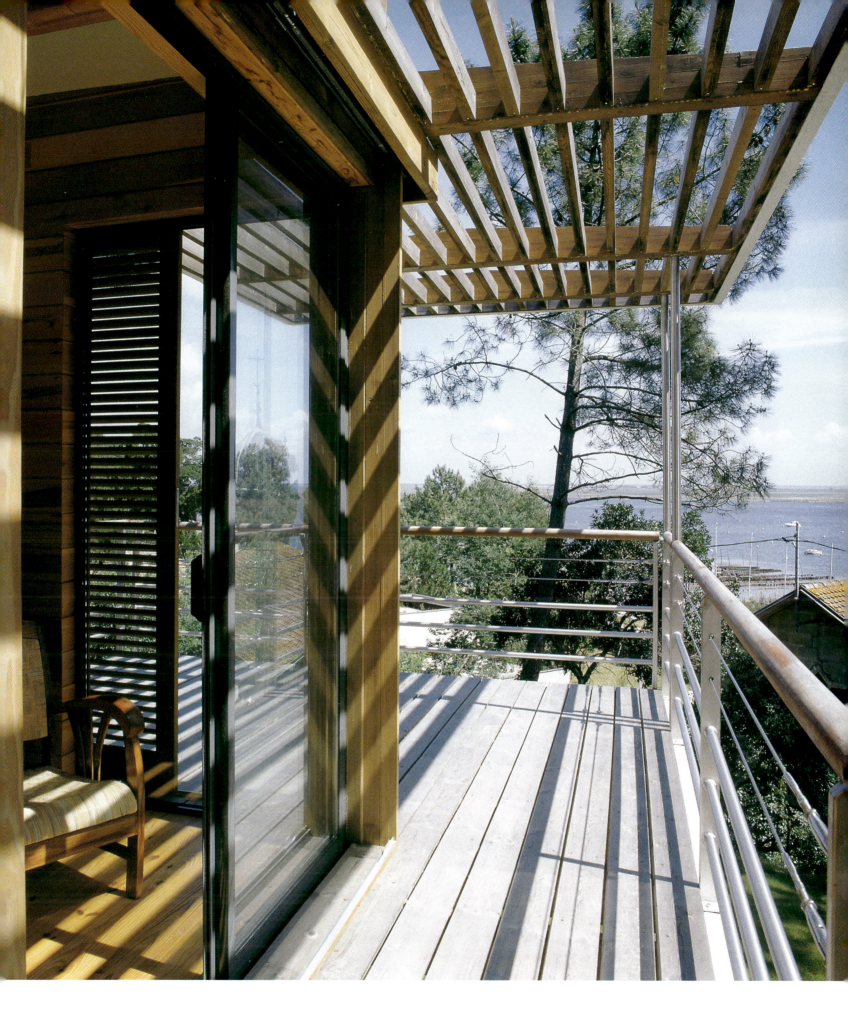

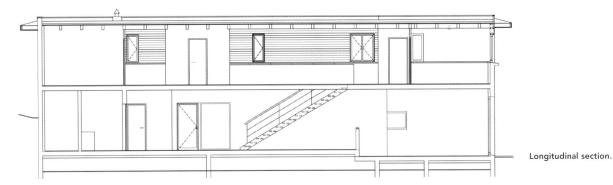

Longitudinal section.

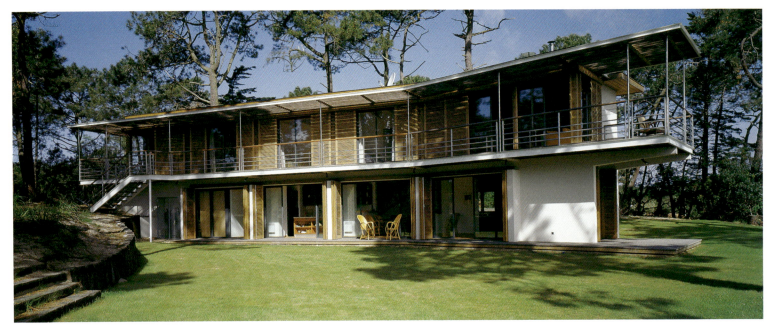

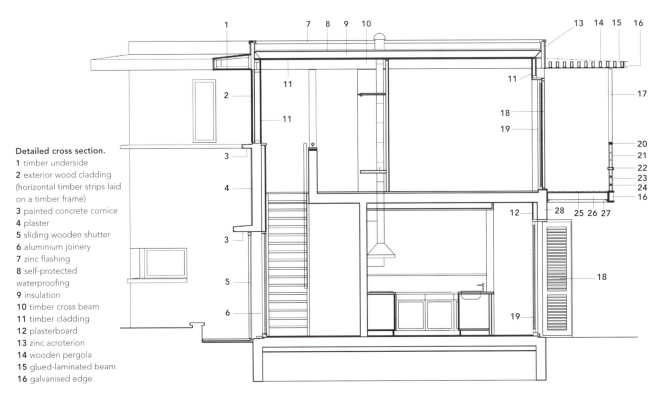

Detailed cross section.
1 timber underside
2 exterior wood cladding
(horizontal timber strips laid
on a timber frame)
3 painted concrete cornice
4 plaster
5 sliding wooden shutter
6 aluminium joinery
7 zinc flashing
8 self-protected
waterproofing
9 insulation
10 timber cross beam
11 timber cladding
12 plasterboard
13 zinc acroterion
14 wooden pergola
15 glued-laminated beam
16 galvanised edge

17 stainless steel tube
18 louvered wooden shutter
19 aluminium frame
20 timber handrail
21 stainless-steel cable
22 wooden rail
23 stainless-steel section
24 stainless-steel rail
25 timber deck
26 wooden joist
27 concrete beam
28 plastered concrete lintel

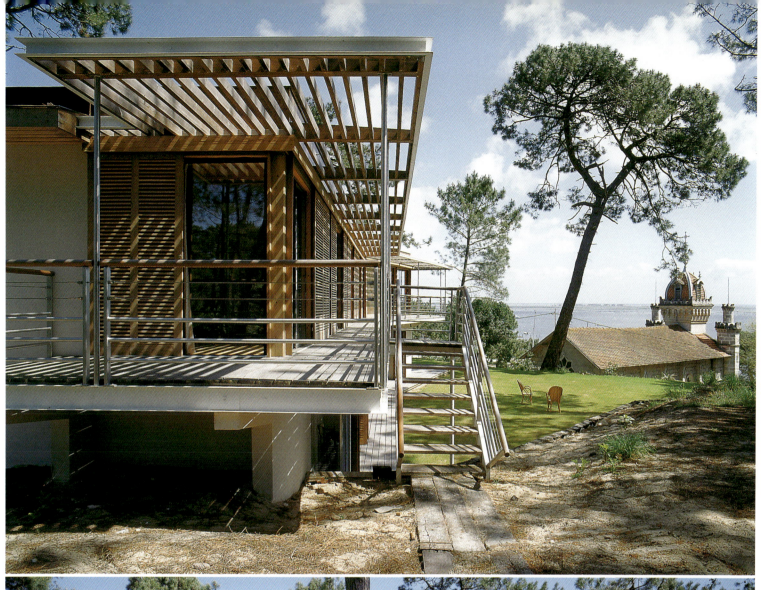

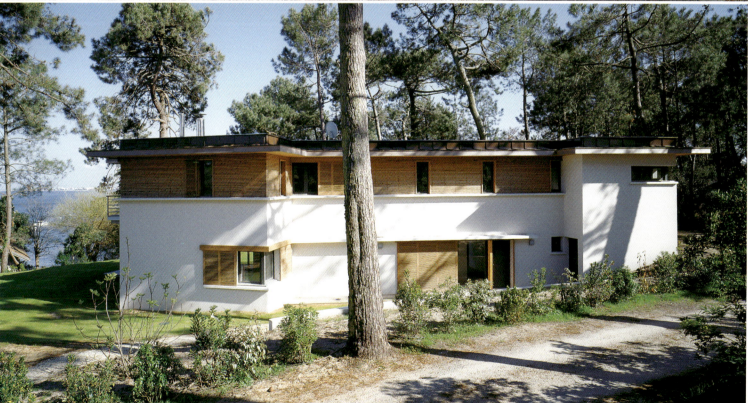

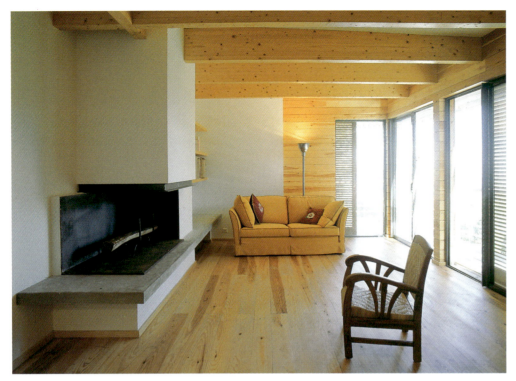

Lounge on the first floor.

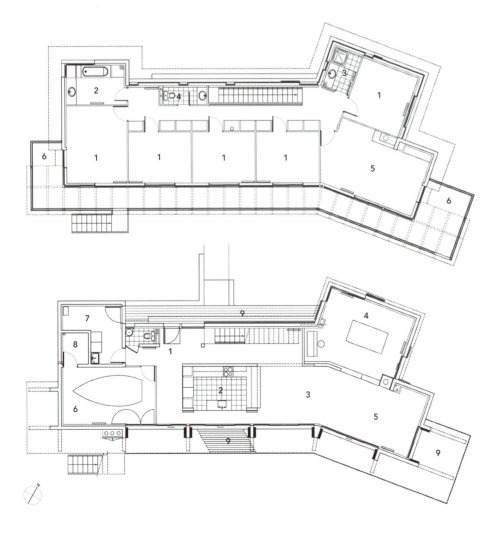

PASSIVE MEASURES TO REDUCE HEAT IN SUMMER
The design concept of this holiday home revolves around passive strategies to keep the house cool in the summer months. The maritime pine trees, which were carefully protected during the construction process, create an initial natural veil against the sun's rays. At the same time, the building's narrowness and north/south orientation help create natural cross ventilation. Sunscreen devices made of retified pine from the Landes have been incorporated into the building, reducing any glasshouse effect during a heatwave. The openings in the lounge are shielded from the sun by a balcony that runs along the first floor, and the bedroom windows are protected by a vertical-strip pergola.

First-floor plan.
1 bedroom
2 bathroom
3 shower room
4 WC
5 lounge
6 terrace

Ground-floor plan.
1 entrance
2 kitchen
3 living room
4 billiard room
5 small lounge
6 boat shed
7 bicycle shed
8 cellar
9 terrace

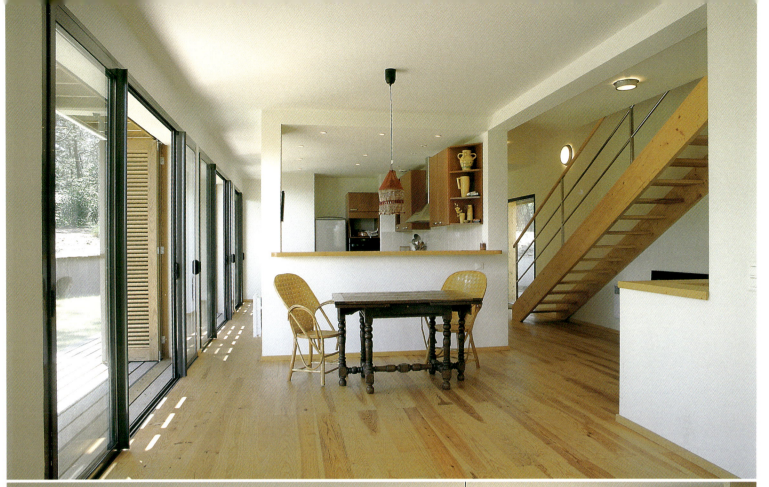

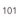

Self-sufficient house in Kangaroo Valley, Australia
Stutchbury & Pape

Australian residential architecture has won acclaim over the past several decades for its underpinning environmental design principles that offer innovative solutions attuned to the geographic context and local climate. The works of Glenn Murcutt and Richard Leplastrier – the craftsmen of intrinsically sustainable architecture – have strongly influenced a new generation of architects, of which Peter Stutchbury is one of the leaders. Bangalay is located on the south coast of New South Wales on a property that was once part of the Buderoo National Park, and owes its name to an Aboriginal term meaning eucalyptus growing on the land. Average temperatures range from 6°C in July to 32°C in January. The house stands on a hill overlooking Kangaroo Valley, in an area often swept by heavy winds and alternately submerged in fog or bathed in bright sunshine. The clients knew the place well, as they had spent many years camping there before having their house built. They wanted a place where they could sleep, eat, relax, and a study from which to run their olive plantation business. The result is an elegant shed of functional design and graceful structure.

A long corridor provides access to all the rooms, which stretches about 30 m from east to west. Washing and storage service areas line the length of the south façade, forming a narrow strip surrounded by concrete walls and acting as a thermal buffer. The heart of the north façade is a large sheltered courtyard, which separates the sleeping spaces from the living area, comprising a dining room, kitchen, living room and study.

A simple skillion roof rises towards the east, providing a greater sense of space to the living areas and allows the morning light to stream in. It lowers over the bedrooms to provide an atmosphere of containment and security, then rises up sharply over the terrace, unharnessing views out to the landscape. The overall result is a varying shape that makes the roof a striking feature of the structure. It rests on double portal columns made of recycled timber, measuring 6 m in width and featuring differing heights, set every 3.60 m along the east-west axis. A broad overhang casts a shadow on the north façade and end walls. The frame of the glazed bays juts out from the structure. There are sliding openings in the living room, which free up the width of two of the three grids, thereby eliminating all physical barriers between the house and its natural surroundings.

The ceilings, built-in furniture and wall facings are made of Hoop pine plywood. In this combination of solid wood and decorative wood cladding, the plastered concrete walls of the service zone offer a soothing effect by means of their plain, light-coloured surfaces, and contribute to thermal efficiency as a result of their high thermal mass. A small lake stretching in front of the north façade enhances the peacefulness of the place. This serves not only as a water feature and natural swimming pool, but in times of high fire risk becomes a vital fire fighting resource, feeding the sprinklers that are carefully positioned around the buildings. It also contributes to the natural air-conditioning system as it humidifies and cools the air propelled towards the house by the wind.

site: Upper Kangaroo Valley, New South Wales, Australia — programme: single-storey main residence for a couple, with combined work space; large living area with open-plan lounge, dining room and kitchen, together with an office, sheltered courtyard, two bedrooms, two bathrooms, storage space and storeroom; garage and technical equipment rooms grouped in an ancillary building — client: private — architects: Stutchbury & Pape/Peter Stutchbury and Phoebe Pape — surface areas: plot – 43 ha, including a 2 ha olive plantation and a 35 ha old-growth forest; habitable surface area: 200 m²; roofed terraces: 120 m² — schedule: design period – 2000; construction period – February 2002 to June 2003 — materials and construction system: combined timber and concrete structural frame, solid concrete walls in the south, portal frames made of karri (diversicolour Eucalyptus, Western Australia species); plywood interior facing made of Australian-grown Hoop pine (*Araucaria cunninghamii*); joinery made of merbau (*Intsia bijuga*) – an extremely hard, fire-resistant tropical wood – with Pilkington "Comfort Plus" single glazing; roof insulated against heat and sound, using reflector film (sisilation); house roofing made of 0.48 mm Stramit longspan® steel troughs with Colorbond® surfacing, cantilevered verandah roofing made of Lysaght Custom Orb® steel troughs with Colorbond® surfacing and 15 mm fibre-cement boards on the underside; concrete flooring except for the kitchen and bedrooms (*Eucalyptus tereticornis* wood floor), bathroom and laundry room (tiling), and terrace (ceramic slabs) — environmental measures: bioclimatic design concept with service areas set in the southern part, featuring solid walls to act as a thermal buffer, built-in solar protection, and natural cross ventilation; optimal-section frame made of wood recycled from a demolished warehouse in Newcastle; merbau joinery made from a sustainably managed forest in Papua-New-Guinea; photovoltaic cells (16 m²) to cover electricity needs; solar thermal collectors on the garage roof to heat domestic water; 100,000 l water tank near the garage.

The double-beam structure that supports the steel overhang roofing creates a 3.60-m cantilever on the eastern end wall.

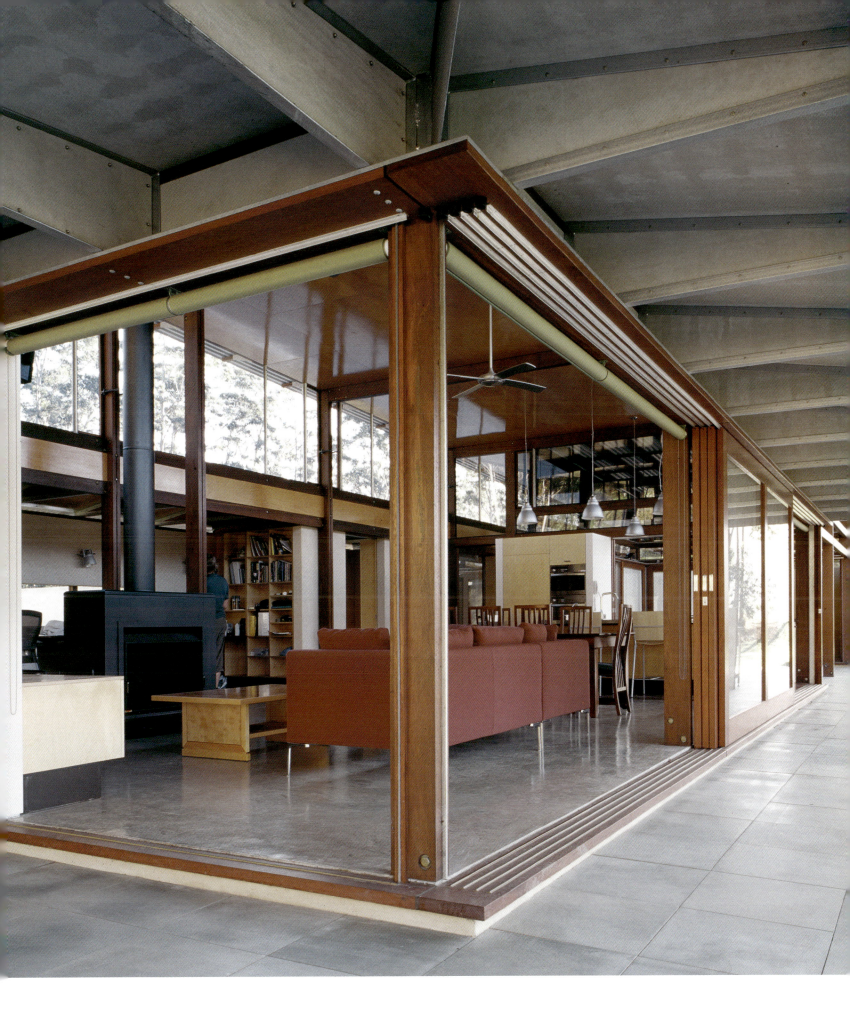

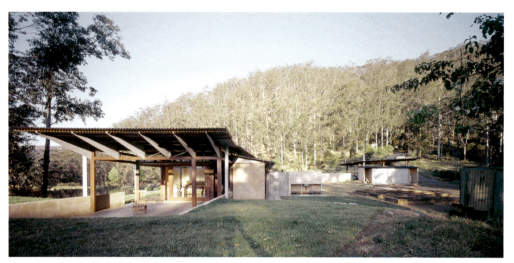

The garage and technical equipment rooms are grouped in an ancillary building south-east of the house.

The large sheltered courtyard separates the living and sleeping areas.

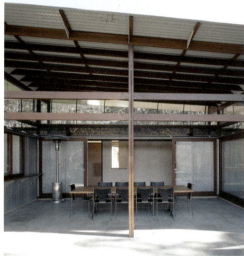

Ground-floor plan.
1 covered terrace
2 bedroom
3 bathroom
4 storage space
5 sheltered courtyard
6 kitchen
7 dining room
8 living room
9 storeroom
10 study
11 terrace

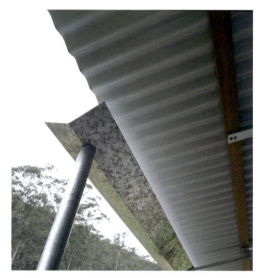

Longitudinal section.

Cross section.

Energy and water self-sufficient house

The low population density of the Australian outback makes it necessary to be self-sufficient in water and energy. The Bangalay house is totally self-sufficient – water is stored in a large dam at the top of the property and is fed by gravity to a water tank in the technical equipment room located near the garage south-east of the house. 32 solar photovoltaic panels of 80 W provide power for lighting and all electrical appliances. Fluorescent lighting fixtures were used wherever possible to ensure minimal power usage. The system has a power output of 10 to 12 kW in summer and 6 to 7 kW in winter. An inverter, supplied directly by the solar panels or by 24 gel batteries of 2V, converts the energy into alternative current; a diesel-run electrogen group is available if necessary. The air-conditioning system is based on a bioclimatic design concept, using cross ventilation for cooling and overhangs for protection from the sun. The ceiling-mounted fans are only used during heatwaves. Water from the dam is heated by a heat exchanger (powered by solar electricity), then pumped into the floor slab warming the house. A wood-burning wet back stove located in the technical equipment room provides a backup heating source should the stored power cells be low. Extra heating is also supplied by a cast-iron stove in the living room, which at the same time provides the comfort of a log fire.

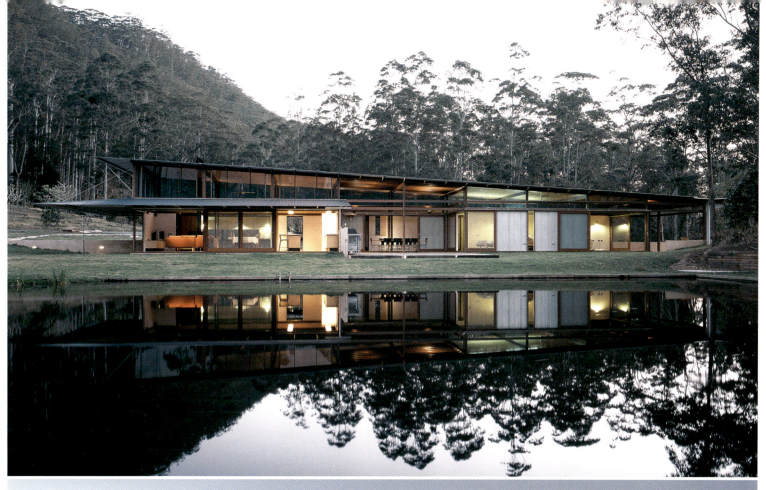

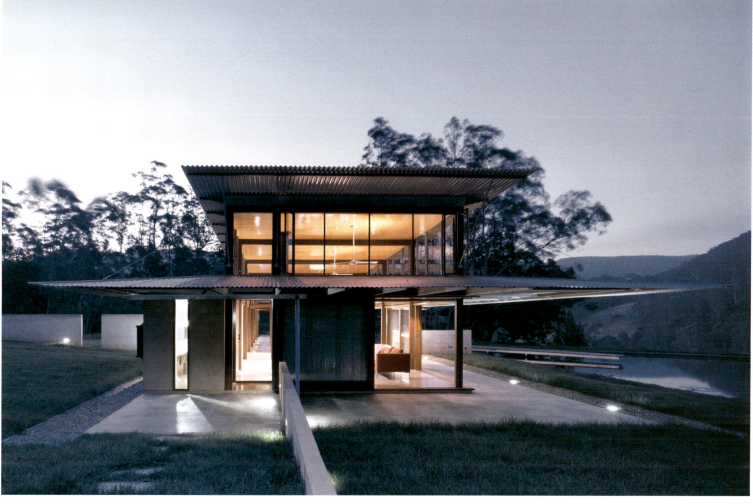

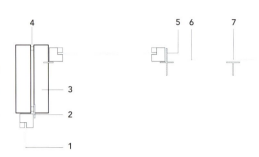

Openings positioned opposite one another, between the roof and the overhang, help create natural ventilation from the south to the north (remembering that the house is in the southern hemisphere).

Horizontal sections showing connections between the timber frame and fixed and mobile glazed components.
1 highlight casement window with merbau stile
2 aluminium flat bar (3/40 mm)
3 double portal column composed of two 4.5/20-cm eucalyptus posts
4 gap (10 mm)
5 aluminium crucifix glazing mullion (3 x 40 x 80 mm)
6 Pilkington "Comfort Plus" fixed glazing
7 silicone joint
8 galvanised steel plate (10 mm thick)
9 sliding glass door with merbau stile
10 edge of the door stile aligned with the edge of the column
11 timber batten fixed and sealed to the portal column (2/3 cm)
12 waterproof joint

Vertical section of the north façade.
1 fixed glazing panel – Pilkington "Comfort Plus"
2 aluminium T section glazing bar (3 x 40 x 40 mm)
3 aluminium flat bar (3 x 40 mm)
4 double beam comprising two 4/13.5-cm eucalyptus cross beams
5 steel fixing plate between beams (10 mm thick)
6 Lysaght Custom Orb® roofing for the overhang with Colorbond® surfacing
7 timber fixing battens (3.8/7 cm)
8 reflector film (sisilation)
9 T section galvanised steel gusset (6 x 50 x 50 cm)
10 hoop pine plywood inserts between beams to inside (10 mm shadowlines to junctions)
11 double beam comprising two 4/14-cm eucalyptus cross beams
12 Sikaflex joint
13 copper flashing
14 timber door head (5/25 cm)
15 sliding bay with merbau stile
16 timber beading
17 fly-screen mesh

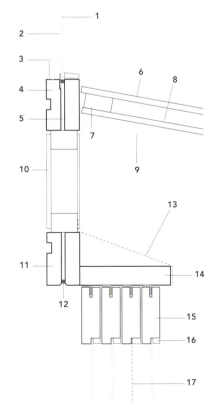

OPTIMISED CONSTRUCTION SYSTEM BASED ON RECYCLED SOLID WOOD
The Bangalay house represents the maturity of both structural design and aesthetic balance within Peter Stutchbury's continuing investigation of timber as a primary architectural element. Behind the house's apparent simplicity lies an extremely fine-tuned design, particularly concerning the connections between the double portal columns and the glazed building envelope, composed of fixed and mobile devices. The two 45 x 200 mm portal posts and the two 45 x 140 mm cross beams are separated by a 10 mm gap enabling the glazing infills, structural stiffening plates and assembly plates to be integrated. This cleating system also helped to increase the building's static properties and created a space through which the electricity cabling could be threaded.

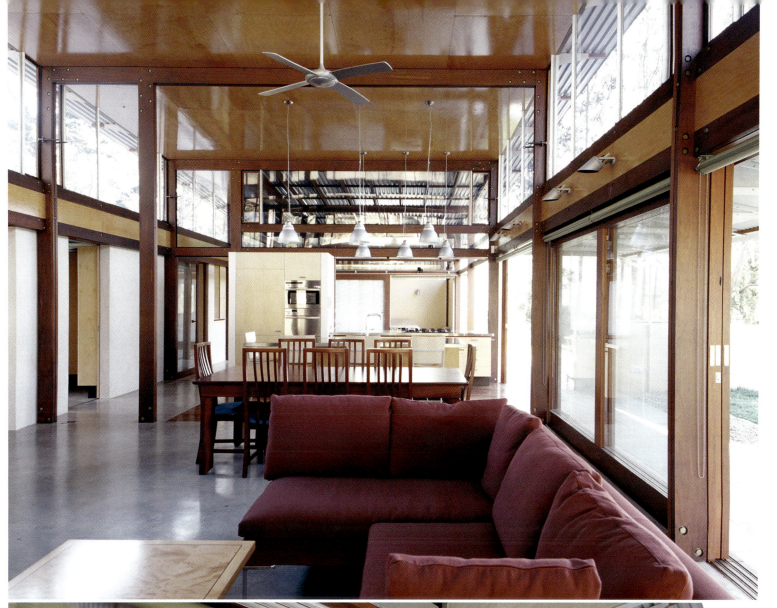

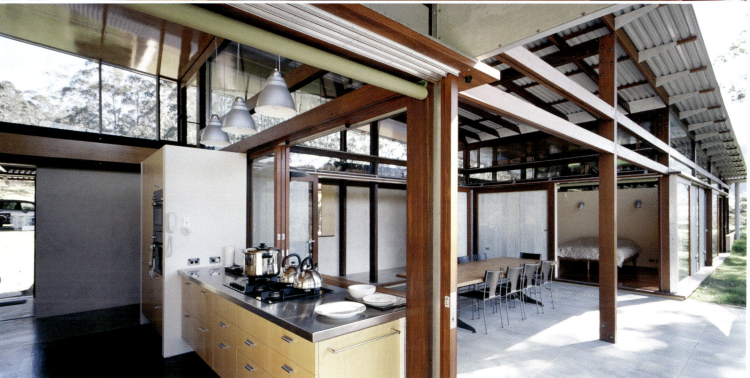

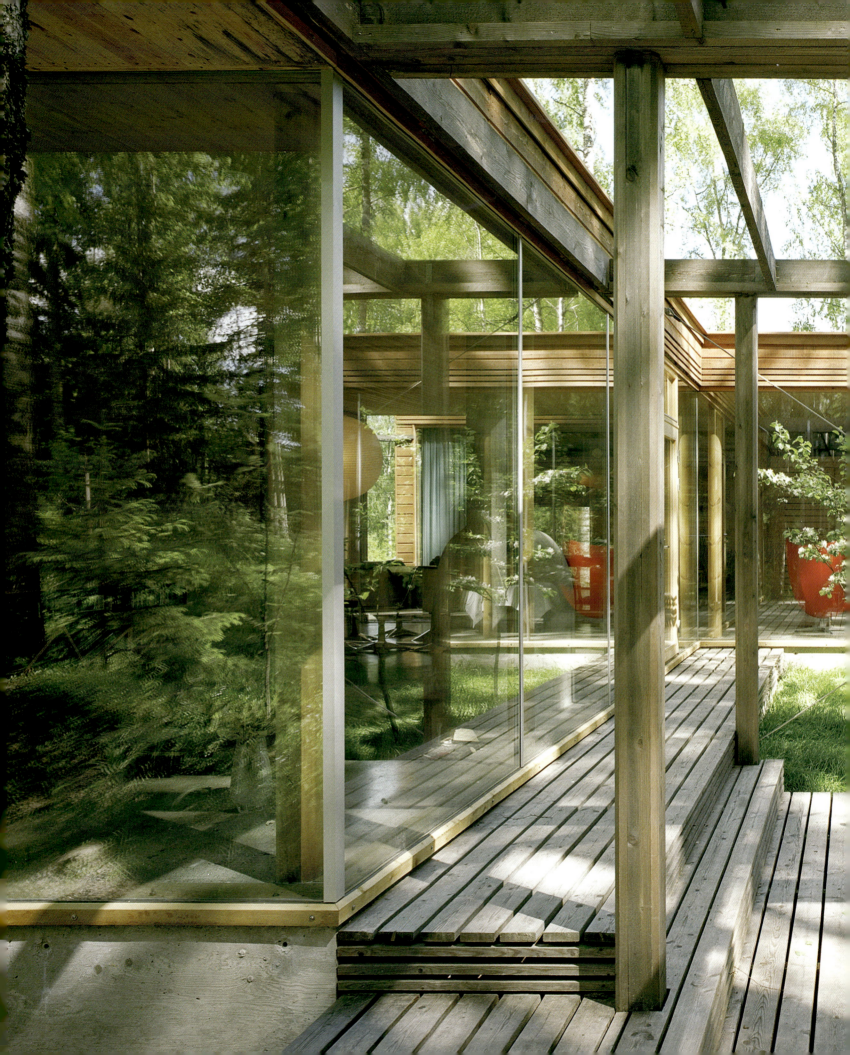

Villa and agency in Espoo, Finland

Olavi Koponen

The Finns, whose lifestyle is attuned to the natural wilderness and harsh climate of their country, often seek physical contact with materials, many of them dreaming of building with their own hands a timber holiday cottage with a sauna. This is particularly true of architects, who experiment with designs by building their own home. Examples range from Alvar Aalto's villa in Muuratsalo to Kristian Gullichsen's log cabin in the Hiittinen group of islands (see page 22).

Olavi Koponen is such an architect. Having spent several summers with friends building a waterfront holiday home, he has recently completed the construction of his own home and architectural practice in Espoo, in an eastern suburb of Helsinki. As is reflected in his architecture, Olavi Koponen goes straight to the point when describing his work. As soon as he has found his inspiration, he expresses his ideas in just a few words, and often checks during the design process that he is faithfully translating the original concept. The underlying idea that spawned the design of this structure where he lives and works was uncompromisingly turned into reality. "The house is composed of a single space where the exterior and interior are closely linked. The gardens mediate between the building and nature, separated only by glazed walls that stretch from floor to ceiling."

The house turns its back to the street and neighbours, and instead opens out to the west towards a grove of birch trees and spruces. The structure is hollowed out on three of its sides to make way for gardens. These generate the structural arrangement of five main spaces, whose borders are only marked out by furniture and delicate curtains. The service areas are grouped into two functional cores: kitchen, WC, storage space and boiler room grouped in the east, near the entrance, and sauna/bathroom in the south-west corner, near a more private space. The practice is set about 10 m away from the entrance and is connected to the south-east corner of the house by a footbridge.

The choice of wood for the structural frame and cladding was dictated by the site and the architect's desire for self-building. A carpenter helped to assemble the solid wood round posts, as well as the roof and pre-fabricated timber-framed boards, but Olavi Koponen mounted all the wall cladding on his own. The horizontal strips of tongue-and-groove larch cladding were coated in two layers of a transparent natural oil-based varnish. Inside, the sauna wall is clad in rustic-style large wood shakes, generating a pleasant contrast with the elegant, narrow-strip cladding of the walls and ceilings. Rough-sawn, untreated spruce was used, yielding a smell and surface that seems literally to breathe with life, inciting you to reach out and touch it.

site: Espoo, Finland — programme: ensemble comprising a main residence with 5 multi-functional spaces and 2 service cores, as well as an independent architectural practice connected to the house by a footbridge — client: Olavi Koponen — architect: Olavi Koponen, Espoo — surface areas: plot – 1,500 m²; house and practice — 220 m² (habitable) — schedule: design period – 2002; construction period – October 2002 to April 2004 (house), May 2004 to December 2004 (practice) — construction cost: EUR 220,000 — materials and construction system: round spruce posts set behind the glazed bays, pre-fabricated timber-framed walls and roof coffers; external cladding made of tongue-and-groove strips of Siberian larch measuring 25/145 mm (protective surface treatment by Osmo); ceiling and interior cladding composed of rough-sawn 15/95 mm strips of spruce laid in a tongue-and-groove pattern, except for the sauna wall which is clad in wood shakes; multi-layer weatherproofing for the roof — environmental measures: close proximity of work and home to reduce travel; set on stilts to preserve the natural ground and protect the trees during construction; mingling the building with greenery; use of a renewable natural resource (wood) for the structural frame and facings; highly insulated building envelope (15 cm of mineral wool for the walls, 26 cm in the roof); triple-glazed openings with low-emission and high-transmission properties, containing argon gas infill — technical equipment: dual-flow ventilation system with a heat exchanger that recovers a proportion of calories from the used air, fuel oil individual heating — heat transfer coefficient of the glazed bays – U = 0.8 W/m² K.

The glazed bays around the gardens place the occupants in the very heart of their natural surroundings.

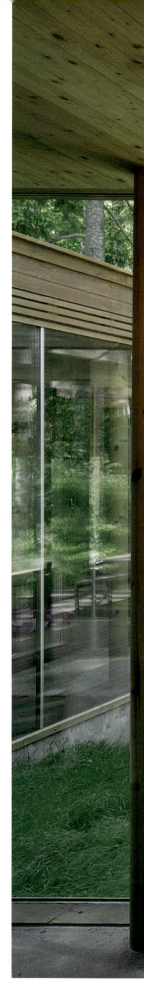

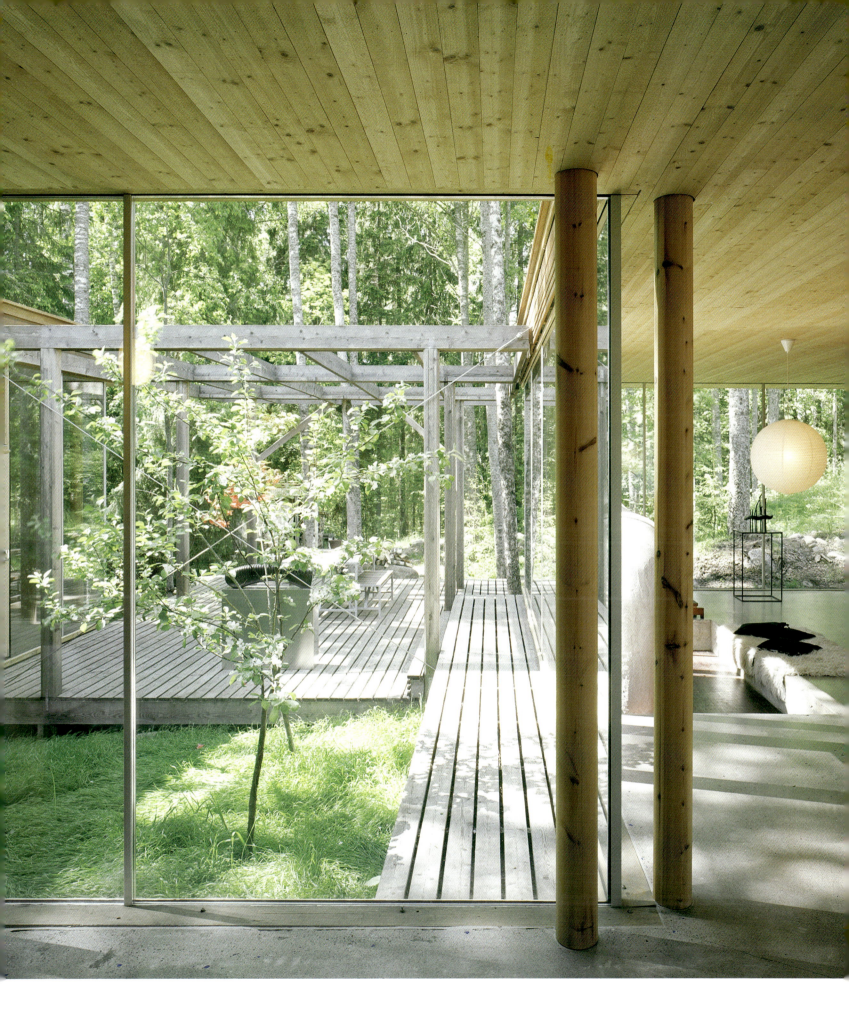

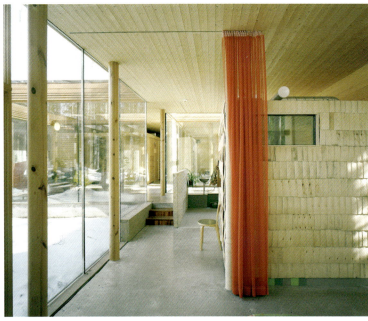

The shards of glass in the polished concrete floor come from iittala, the company that makes Alvar Aalto vases.

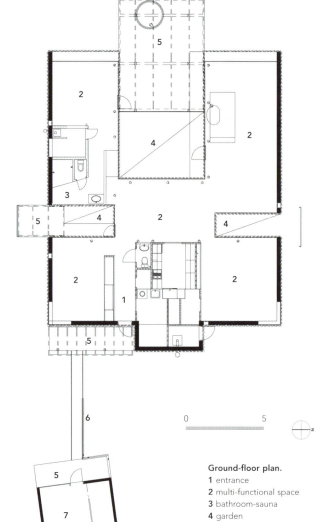

0 5

Ground-floor plan.
1 entrance
2 multi-functional space
3 bathroom-sauna
4 garden
5 terrace
6 footbridge
7 architectural practice

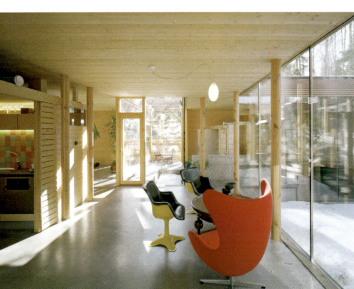

Larch, used for the outside, has a naturally hard-wearing core. It was covered with a transparent coat to protect it against bad weather and ultra-violet rays.

Cross section.

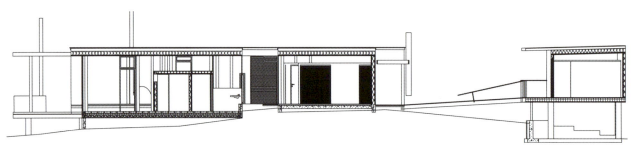

Longitudinal section of the house and practice.

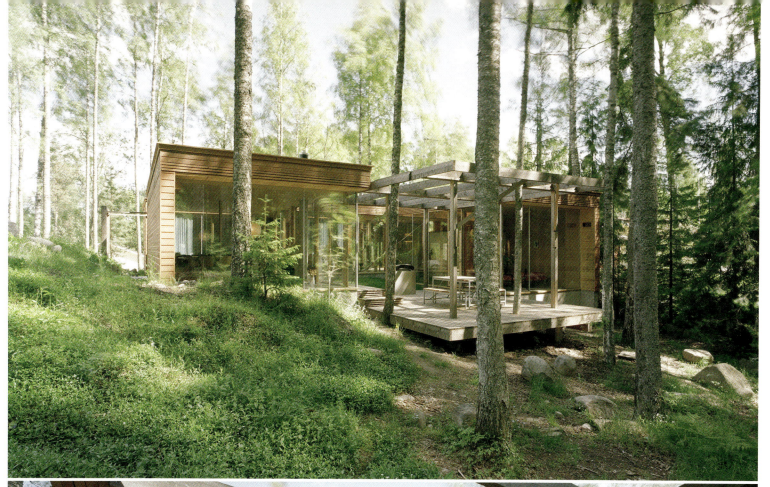

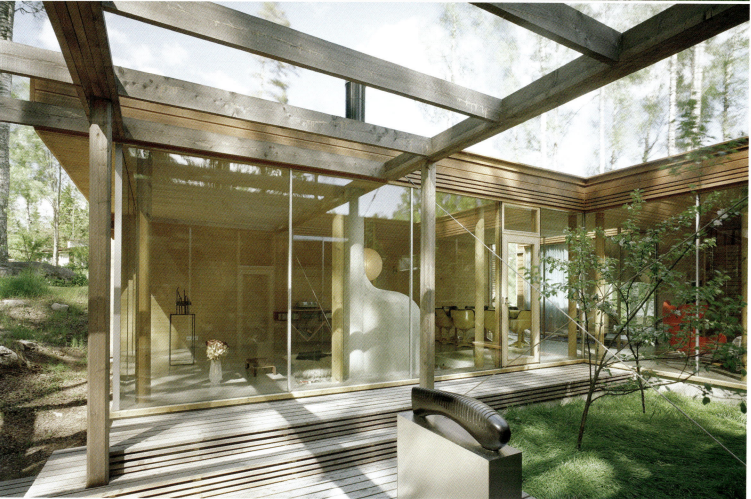

Stone house in Cannero, Italy

Pietro Carmine

The Milan-based architect Pietro Carmine took the opportunity when building his own home in his native village to deepen an environmental approach he had undertaken since 1985. Nestled at the foot of Mount Carza in a natural bay of Lake Maggiore, the medieval town of Cannero is a tourist resort with a Mediterranean climate whose buildings are set out in tiers between terraced gardens planted with vines and olive and lemon trees. The house, which was built against pre-existing dry stone walls, stands between the medieval path that runs alongside the shore and the 19th century road higher up. The main façade looks directly south over the lake and stretches along the footpath. The three ground-floor rooms are devoted to the architectural practice whilst the residential part takes up the two upper floors, characterised by overlapping volumes featuring numerous balconies and terraces. Two stone towers edge the timber-framed glass structure covering both the living room and the dining room on the mezzanine level of the top floor.

Pietro Carmine draws on what can be called a holistic approach, based on a rigorous analysis of multiple social, cultural, environmental and economic criteria. For this project, the focal point was the house's materials, chosen for three main reasons: first, they are the traditional materials used in the region; secondly, a low amount of energy is required to make them; and thirdly, they can fulfil several functions – for example, the balcony slabs made of local granite act both as cladding and a structural component.

The monolithic slabs making up the flat roof of the west tower are made of Luserna stone – a marble quarried in the north west of the Italian Alps. Laid on a purpose-made slope with a 2% gradient, they vary in thickness from 12 to 15 cm. To avoid condensation-related problems, a ventilated gap lies between the stone roof and the fibreboard ceiling for which magnesite was used as the bonding agent.

The lining walls that back onto the natural rock are made of cob (a mix of earth and straw) applied to willow tree branches plaited onto chestnut-tree posts. The kitchen wall on the side of the slope has straw and earth insulation inserted between the timber studs. The entrance of the house is topped by a recycled brick arch, and the archive room of the architectural practice by an arch made of *phyllostachys viridis mitis* – giant bamboo reaching 14 to 18 m high that grows in Cannero. The bamboo rods were treated according to Japanese tradition, whereby the lateral surface of the rods is heated with a flame until a resin appears which naturally polymerizes by creating a protective film. The top part of the arch, spanning 6 m, is strengthened by puzzolana concrete reinforced with bamboo netting. Apart from the foundations, the use of cement and steel was replaced by local natural materials whose manufacturing and transport require much less energy.

site: Cannero Riviera, Piemonte, Italy — programme: house and architectural practice; ground floor – entrance to the practice, office and archive space; first floor – entrance, living room with fireplace, bedroom, bathroom and two small terraces; second floor – kitchen, mezzanine dining room and large terrace — client: Pietro Carmine — architect: Pietro Carmine, Milan; other project team members: Carlo Mazzanobile and Mattia Lupo — surface areas: plot – 400 m²; house – 157 m² (habitable) — schedule: design period – 1987; construction period – 2000 — materials and construction system: local Serizzo granite walls in addition to the pre-existing dry-stone walls, lined with 8 cm hollow bricks; whitewash for the interior wall plastering in the kitchen and bathroom and clay-based plastering for the other rooms; granite slab lintels and balconies; fibrewood and sheep wool insulation; cob interior partitions; decks and roof supports made of local timber (pine for the decks, oak and chestnut for the structural frame); glued-laminated spruce arches for the glass structure, with larch cladding on the outside; recycled brick archway above the entrance to the house; bamboo arch spanning 6 m above the archive area; Luserna stone slabs (6 m long, 1 to 1.2 m wide and 12 to 15 cm thick) for the flat roof of the west tower, assembled based on a 7.5-cm mid-depth lap with a central 1 x 2.5 cm space, as in a bolt of lightening; ceiling (under the stone roof) made of Heraklit fibreboards with magnesite bonding agent (14 cm) — environmental measures: reusing dry stone walls; using local materials (stone, wood, bamboo) and recycled materials (most of the main beams are made of recycled wood); applying bioclimatic principles and passive use of solar energy (glass structure and earth and stone walls with high thermal mass); gas heating with radiating plates incorporated into the walls and a thermostatic regulator for each room — heat transfer coefficient of the exterior walls: U < 0.8 W/m² K — energy consumption: 50 kWh/m²/year.

Built of local granite using the age-old dry stone technique, the house sets off to advantage the paved medieval path alongside the shore of lake Maggiore.

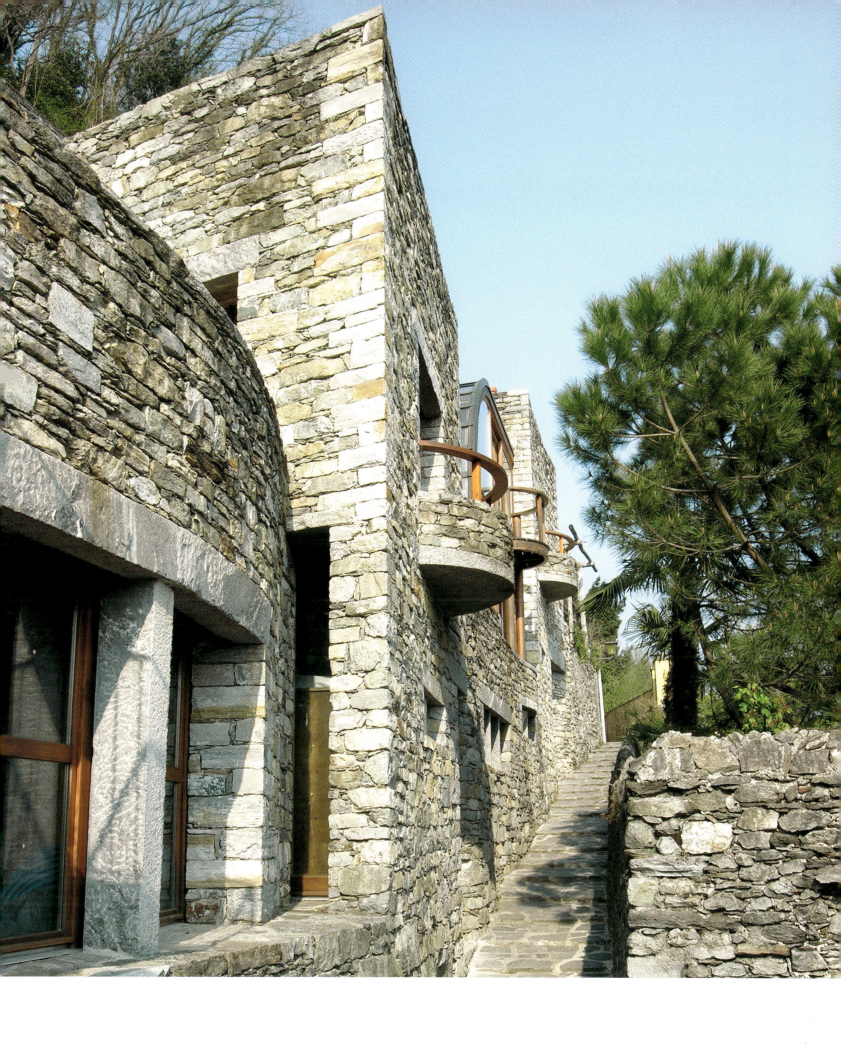

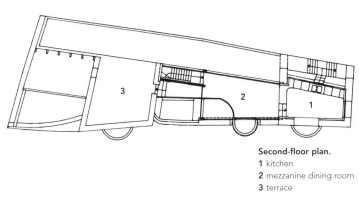

Second-floor plan.
1 kitchen
2 mezzanine dining room
3 terrace

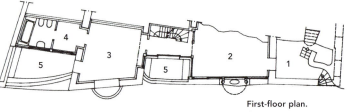

First-floor plan.
1 entrance
2 living room
3 bedroom
4 bathroom
5 terrace

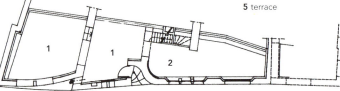

Ground-floor plan.
1 architectural practice
2 archive area

Priority was given to natural materials that could be obtained locally and which do not harbour any health hazards, such as wood, bamboo, stone and clay.

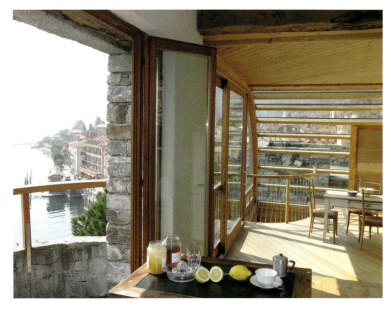

A DIFFERENT VIEW OF THE WORLD

Adopting a holistic approach involves analysing the context, as well as the related social, environmental and economic systems whilst taking into account any changes to these components and interactions between them. A study is subsequently carried out on their positive and negative impacts. The objective is to determine the advantages and drawbacks that the planned measures may have on a human, environmental and financial scale, in the short, medium and long term. This multi-criteria, integrative approach is applied not only in the building profession but also in medicine and agriculture.

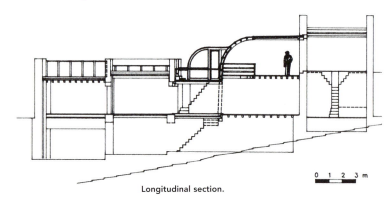

0 1 2 3 m

Longitudinal section.

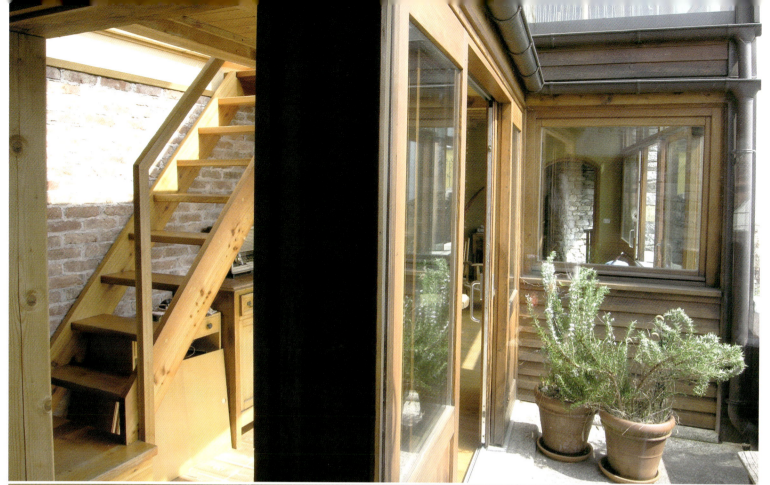

Straw-bale and sandbag house in London, UK

Sarah Wigglesworth and Jeremy Till

Sarah Wigglesworth designs ecological and energy-efficient buildings based on solid and low-cost materials that were often originally intended for another use, generating an unexpected form of architecture. The Straw House – a design for the architect's own home and associated architectural practice in North London – was an ideal opportunity to experiment with a structure composed of straw bales and sandbags located in a densely populated urban area. The project, designed in conjunction with Jeremy Till, offers an alternative solution in terms of both form and substance. It marks the beginning of a revitalisation process for a disadvantaged area that lies close to a railway track, and combines work and living space on one site. The scheme illustrates a different type of city life, with wild raspberries growing on the rooftop conceived as a meadow, and hens pecking in the garden around an eco-pond.

The approach adopted was unconventional yet extremely pragmatic and rigorous, resulting in a functional scheme based on a bioclimatic design concept and featuring precise construction details. The building is L-shaped and is positioned on a rectangular plot at the end of a cul-de-sac road lined with Victorian houses. The architectural practice faces north-east/south-west, parallel with the railway tracks. The structure's two storeys are set on gabion columns – wire casings filled with concrete blocks retrieved from nearby demolition sites. To reduce the noise of the trains, the wall located on the side of the tracks was lined with a pile of sacks filled with a mix of sand, cement and hydraulic lime. The other walls, which are timber-framed, are wrapped in a quilt-like "cloth" made of silicone-faced fibreglass with an insulating layer and as inner lining.

The architectural practice, which takes up the entire width of the plot, is positioned at a perpendicular angle to the dwelling, acting as an acoustic screen. The sleeping area is concentrated in the far north-western part, in a two-storey cube. The living section bridges the bedrooms and the practice. A partition, extended by the conic volume of the larder, marks out several niches in this large open-plan space, such as the kitchen, living room, study and library area, which rises up a five-storey tower. A dining room that can be converted into a meeting room serves as the hinge between the house and the practice. The bedrooms and north-east façade of the living room are insulated by straw bales set between wood lattice stanchions. These thick walls, pierced with several small openings, are rendered with lime plaster on the inside and are shielded from bad weather by a ventilated cladding made of corrugated metal and polycarbonate sheets. The south-west façade of the living room is turned towards the garden and is glazed in order to capture solar gains. The book-lined tower creates a chimney effect, helping to evacuate hot air. However, the living room is the coldest room – a fact of which the architects-clients were well aware from the outset. "We tolerate, even enjoy fluctuating temperature", they say.

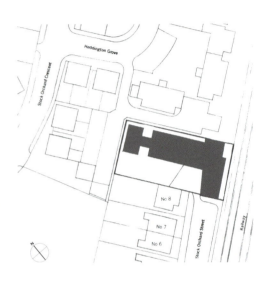

site: 9-10 Stock Orchard Street, Islington, London, United Kingdom — programme: two-storey house with a five-storey library tower and three-storey architectural practice. House: ground floor – entrance, two bedrooms, bathroom, utility room; first floor – bedroom with clothes hanging area and bathroom, living room with study area, library, kitchen and larder, dining room/meeting room. Practice: ground floor – entrance; first floor – hall, office, WCs; second floor – meeting rooms and storage space — clients: house – Sarah Wigglesworth and Jeremy Till; offices – Sarah Wigglesworth Architects — project manager: Sarah Wigglesworth Architects, London; architects – Sarah Wigglesworth and Jeremy Till; other project team members: Gillian Horn and Michael Richards — structural engineers: Price & Myers — prime contractor: Koya Construction; site supervisor: Martin Hughes — surface areas: plot – 800 m²; house – 274 m² (habitable); offices – 210 m² (useable) — schedule: design period – 1997; construction period – October 1998; start of use – December 2001 — construction cost: £ 550,000 (around EUR 810,000) — materials and construction system for the practice: gabion columns containing recycled concrete blocks; railway side – timber-framed wall lined with a wall of woven polypropylene sacks filled with sand, cement and lime (20 cm thick); other walls made of a timber frame with Warmcell cellulose insulation and 25 mm quilt-like padding with an outer fibreglass membrane soaked in silicone — materials and construction system for the house: north-east façade and bedrooms – straw-bale insulation (105 x 49 x 37 cm) inserted between the timber studs, interior rendered with lime plaster, and ventilated cladding composed of corrugated galvanised steel and polycarbonate sheeting; western red cedar structural frame — environmental measures: bioclimatic design concept (highly insulated walls in the north and glazed façade in the south-west, natural ventilation via a chimney effect in the tower and larder); airtightness; high-performing double glazing; recycled materials (straw bales, concrete, railway sleepers, cellulose made from old newspapers) and materials whose manufacturing requires little energy, such as wood and sandbags; flat roof designed as a meadow on a 15 cm substrate — specific equipment: gas-condensing boiler and water heater, linked up to solar thermal collectors (90.4% efficiency, Sedbuk grid class A); composting toilets for the house, and low-flush toilets for the practice; rainwater collected in two 3,000 l tanks (one for providing water for the washing machine and office toilets, and the other for irrigating the roof meadow and garden) — energy consumption for heating the house and office: 38.64 kWh/m²/year (value calculated based on consumption) — water consumption: 138 m³/year (for 15 people in the practice and two in the house).

Several transparent polycarbonate sheets reveal the straw bales beneath the house's galvanised steel cladding.

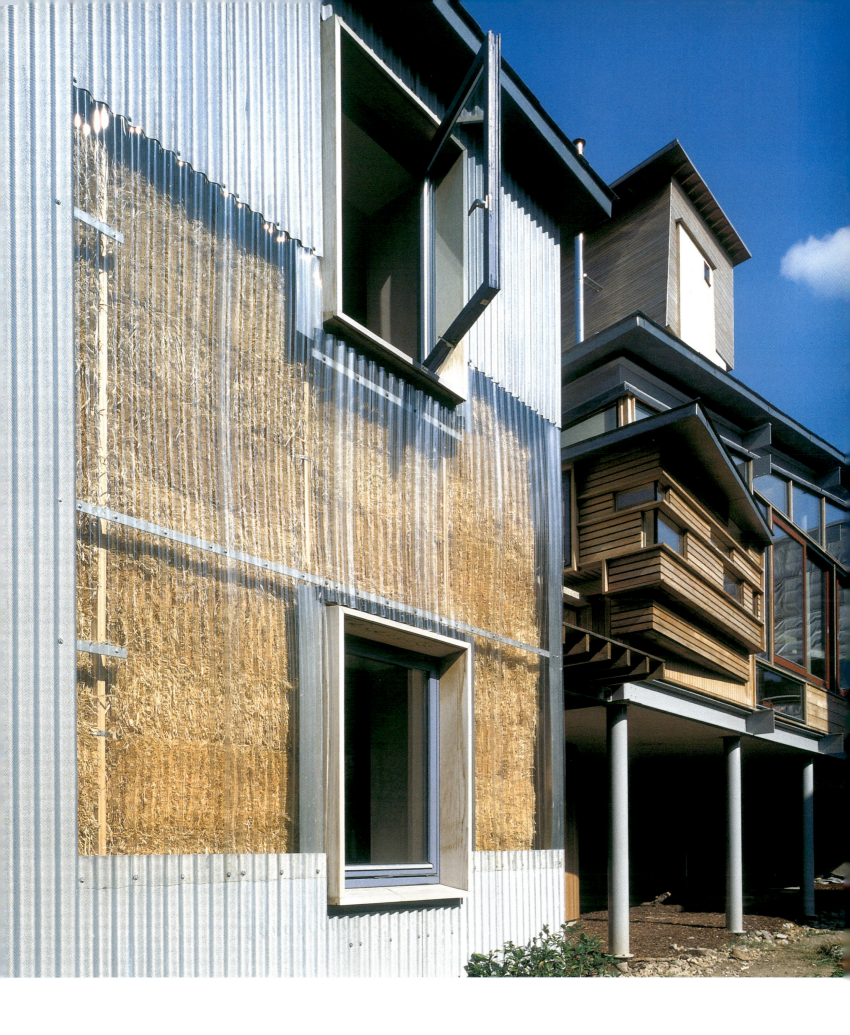

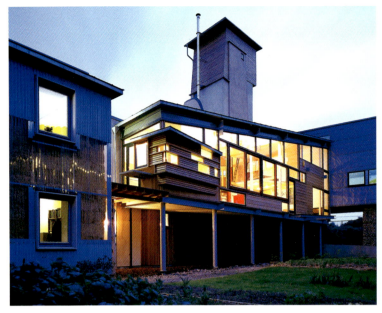

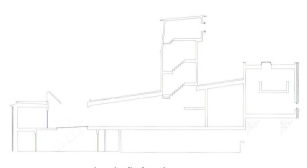

Longitudinal section.

ADOPTING AN APPROACH THAT IS PART INTUITIVE AND PART BASED ON A MULTI-CRITERIA ANALYSIS

There are several ways of designing ecological architecture. One is more or less intuitive, rooted in the study of vernacular buildings. Another is based on multi-criteria analysis grids, often combined with an environmental management method that draws on the ISO 14001 procedure. The Stock Orchard Street project was deliberately designed in empirical fashion, without using analysis grids or complex calculations. The materials were selected not for their innovative features, but because they are environmentally friendly in terms of their lack of toxicity, low energy cost over the entire life cycle, ability to be recycled, and so forth. The use of an inexpensive outer cladding that can be easily changed symbolises an approach based on breaking down the building into separate functions: structure, cladding and service areas. It contrasts with the holistic approach which favours components that can fulfil several functions (see house in Cannero, page 114). The experimental design of this project has already been used in other works by Sarah Wigglesworth and can be viewed on the architectural practice's website (www.swarch.co.uk).

120

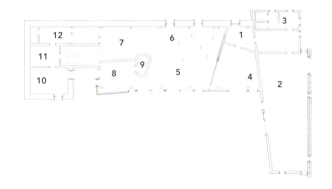

First-floor plan.
1 hall
2 office
3 WCs
4 dining room/meeting room
5 living room
6 library tower
7 study area
8 kitchen
9 larder
10 bedroom
11 clothes hanging area
12 bathroom

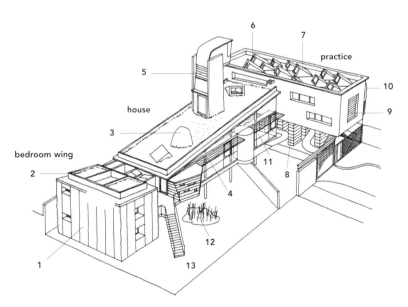

Diagram showing the building's ecological features (some of which have yet to be realised).
1 straw-bale wall
2 planted roof
3 ventilation stack above the larder
4 horizontal wooden sunscreen (project)
5 natural ventilation by means of a chimney effect in the library tower
6 glazed light projectors in the north
7 photovoltaic panels
8 gabion columns containing recycled concrete blocks
9 louvre boards that let cool air into the practice
10 sandbag walls to reduce the noise of the trains
11 high-performing double glazing on the south façade
12 eco-pond for treating domestic wastewater
13 vegetable garden

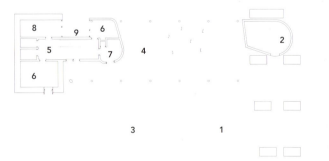

Ground-floor plan.
1 courtyard
2 entrance to the practice
3 garden
4 covered courtyard
5 entrance
6 bedroom
7 bathroom
8 utility room
9 patio

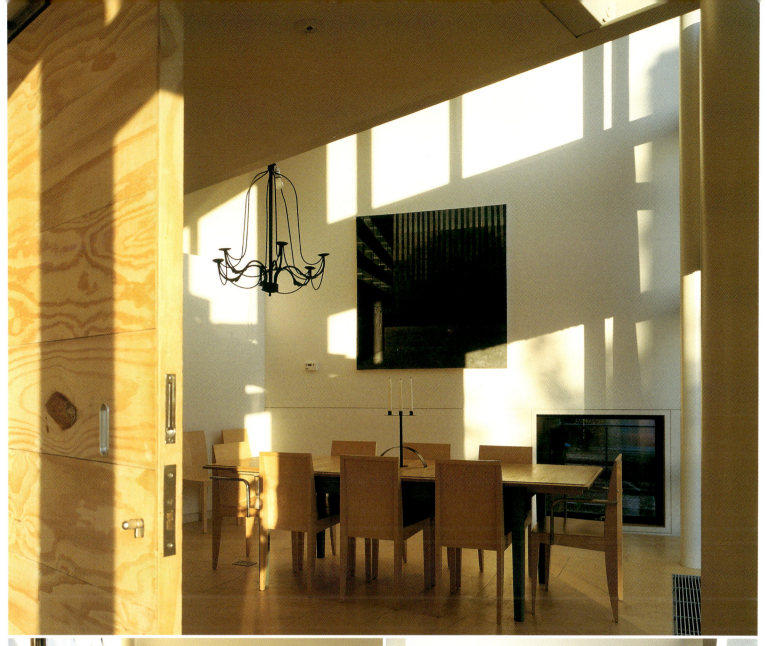

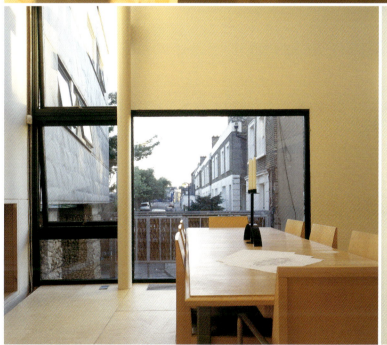

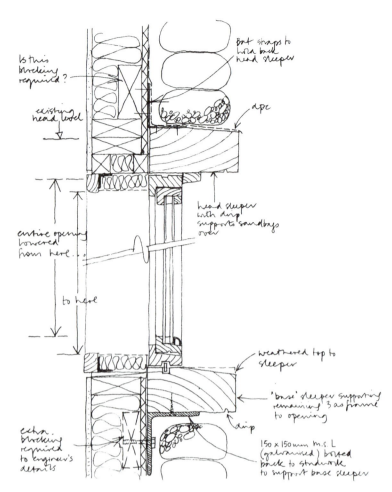

Section of the sandbag wall
of the architectural practice.

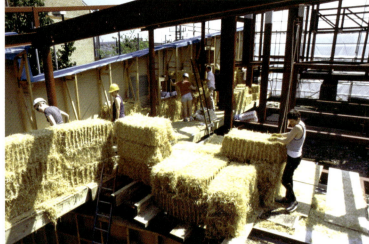

Building the straw-bale wall
of the house: the bales are
set between wood lattice
stanchions.

Section of the straw-bale
wall.
1 planted roof
(15 cm substrate)
2 cladding comprising
corrugated polycarbonate
and galvanised steel sheets
3 straw bale
(37 x 49 x 105 cm)

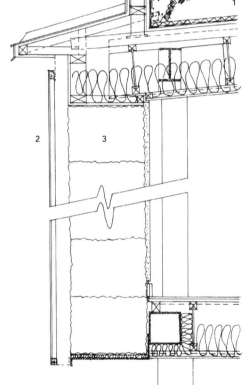

Building the wall of the
practice on the railway side:
bags filled with sand,
cement and lime line the
timber-framed wall.

Straw-bale construction

Straw is an agricultural raw material that enables structures to be swiftly and inexpensively self-built, or built without requiring specific skills. It is a renewable and recyclable material that has a low impact on the environment, and has effective thermal and acoustic properties. Its thickness helps to regulate changes in temperature, especially between day and night. Straw-bale construction began in Nebraska, about a century ago, but has only been used in other continents over the past 15 years or so. It is based on the historic technique of stacking bales as if they were large construction blocks, so that they serve both as the structural frame and as insulation. They are then rendered with lime plaster inside and out, but the surface area of the openings is limited to ensure the building's stability. This extremely rustic process might seem little suited to our industrialised society. However, as a result of combining the bales with a timber load-bearing frame, straw-bale construction is currently gaining rapid momentum. This project by Sarah Wigglesworth Architects in London is one of the first straw-bale structures to have been built in an urban area.

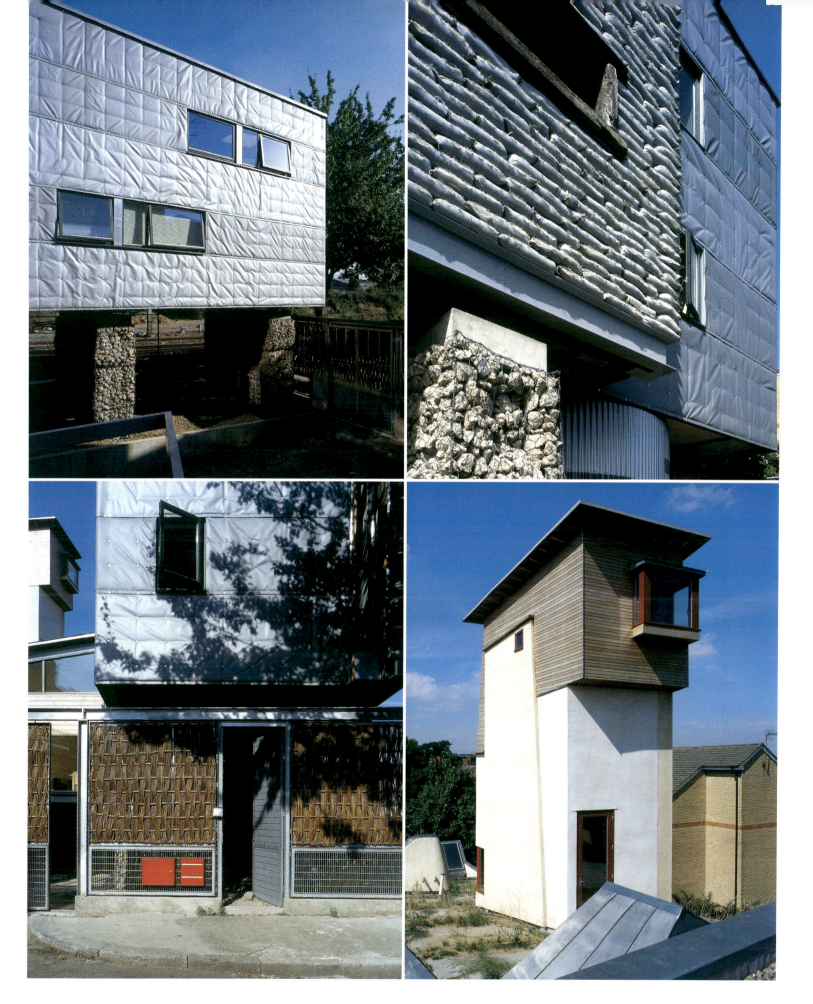

Stacked-beam home in Tyrol, Austria

Antonius Lanzinger

Austria is famed both for its traditional picturesque chalets and for its modern timber architecture that is over-insulated in order to save energy. The house built by Antonius Lanzinger for his family turns its back on both of these clichés. In his design, this carpenter-trained architect aimed to build "a contemporary stacked-beam home that is not dressed in Tyrol-style leather breeches".

The structure sits on top of a cliff, on the outskirts of Brixlegg, a small market town. The land was inexpensive but harboured several disadvantages, including a north-west slope with a 35° gradient, the rocky surface of the outcrop and the fact that trees in the neighbouring forest mask the sun in winter. These major constraints dictated the shape of the house, resulting in it taking up just a 6 m by 8 m footprint to reduce the foundations, and in building it high in search of the sun and views.

The reinforced concrete base stretches out to form a basement containing a bathroom/sauna and a log store. Above, the tower-like house is built entirely of stacked beams. Each functional area stands one on top of the other, starting from public to private spaces. One enters the house via the ground-floor, arriving in the *gute Stube* – the warm and welcoming Austrian living room, and subsequently goes up to the kitchen, then up to the children's area and to the parents' space, before finally reaching the terrace.

The rooms are set on either side of a central concrete core that groups the pipe systems, bathroom facilities and heating equipment. Their height varies depending on the room in question – 5 m for the living room, 3.80 m for the kitchen, 2.20 m for the area shared by the four daughters, and 3.50 m for the parents' room. Despite a limited 48 m² floor area, the spaces flow into one another with virtually no doors – a layout that the parents intended as a pedagogical exercise, to encourage living within a community and to foster exchange of ideas and opinions. Time will tell whether they were right. Piercing openings into a stacked-beam structure poses both technical and aesthetic problems. There are therefore only a rare few windows in the house, framing a specific element of the landscape, although daylight is also let in through top openings. On the flat rooftop however, there is a sweeping vista of the Inn valley and Tyrolean Alps.

The house is heated by earthenware stoves on the ground and second floors, connected to the conduit of the central core. Between these two floors there is an open fire in the kitchen, although this is mainly decorative. 15 m³ of wood suffice to achieve a comfortable temperature in winter. The Lanzingers did therefore not use insulating wood panelling for the interior as was originally planned. The structural fir envelope is visible on both sides, providing the dwelling's occupants with the qualities of a living and breathing "pure timber" wall that smells superb.

site: Mariahilfberg 20, 6230 Brixlegg, Tyrol, Austria — programme: four-storey main residence for a couple with four children; living room on the ground floor, kitchen with dining room on a split level overlooking the living room; children's area on the first floor, parents' space on the second floor, and a terrace — client: Lanzinger family — architect: Antonius Lanzinger, Wörgl — structural engineer: Konrad Merz, Merz Kaufmann Partner, Dornbirn — surface areas: plot – 777 m²; house – 145 m² (habitable) — schedule: design period – 2001; construction period – November 2001 to September 2002 — construction cost: EUR 255,000 incl. VAT but excluding architect's fees, representing around EUR 1,760 incl. VAT per habitable m² — materials and construction system: reinforced concrete basement; body of the building made of stacked beams, halved into one another at the corners — environmental measures: minimum footprint; showcasing a traditional technique; use of local, untreated timber; wood heating.

The fir used for the stacked beams in this tower-house comes from Achental, a nearby valley.

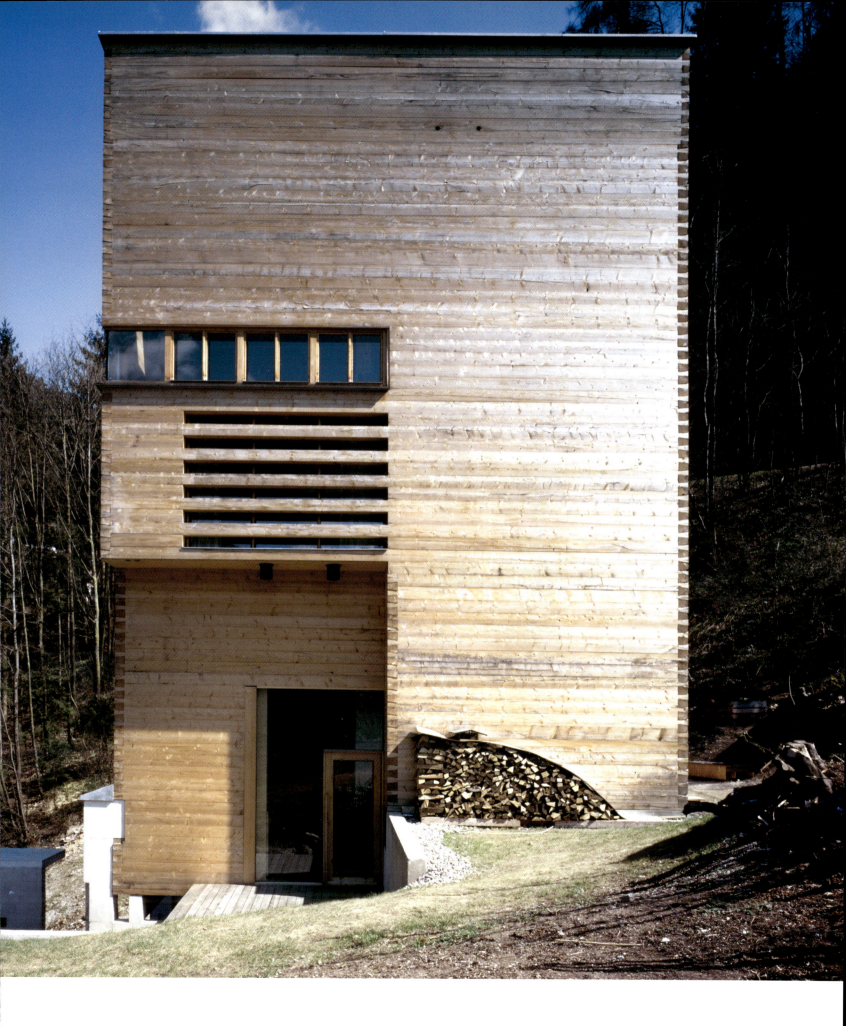

126

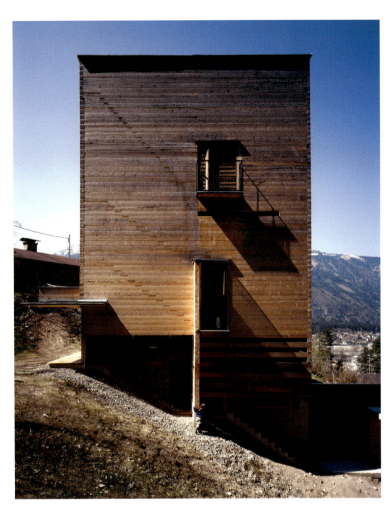

The four storeys are
connected by solid oak
cantilevered steps, set into
the beamed walls.

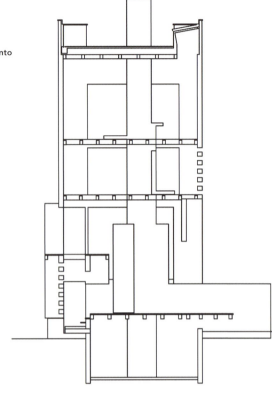

Cross section.

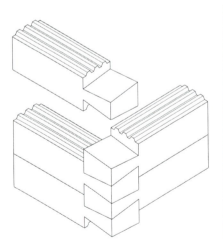

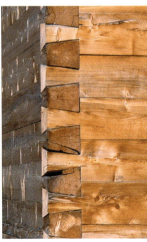

Detail of the "Tyrolean
lock" – a triple tongue-
and-groove linking system
that ensures stability and
waterproofing.

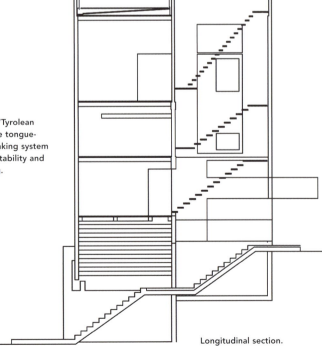

Longitudinal section.

A MODERNISED VERSION OF A HISTORIC CONSTRUCTION SYSTEM

The structure rises above the reinforced concrete basement, stretching 12.50 m high, made of
beams with a 16 x 18 cm section, plus 2 cm for the tongues. The local fir was artificially dried,
planed on the two visible sides and machined on the upper and lower sides to create a triple
tongue-and-groove assembly that acts as a mechanical linking system and as a waterproofing
device. The beams are halved into one another at the corners, and are bolted in the shape of a
dovetail, which the Austrians call a "Tyrolean lock". This type of connection, which is cleverly
symmetric, facilitated standardised production of the components, which were pre-fabricated
and subsequently assembled on site in the space of six weeks by three carpenters. The decks
are composed of 3.5 cm triple pleated boards fixed onto 12 x 18 cm joists. This assembly makes
up a plate that resists pull and compression and helps to windbrace the structure. Five metal
tie-rods that cross the entire height of the walls anchor the house to the concrete slab.

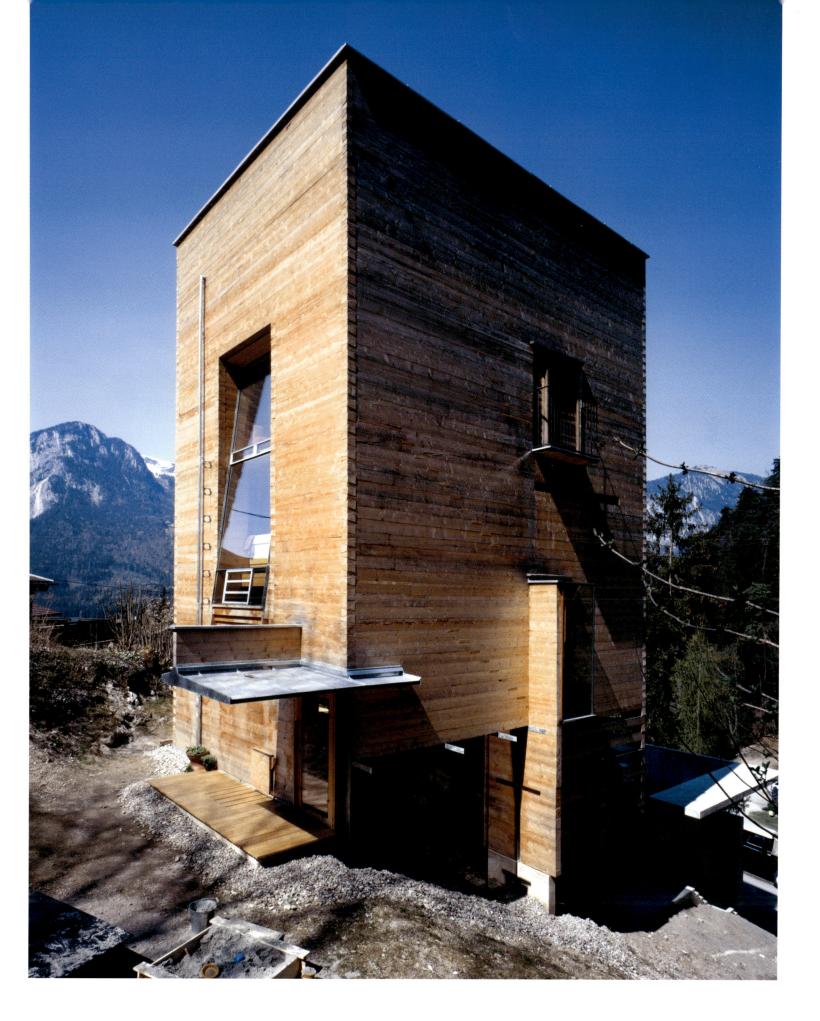

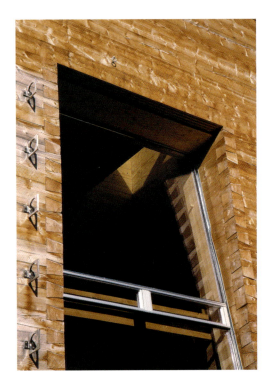

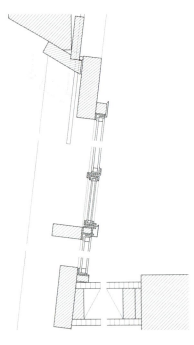

Detail of the sloping window.

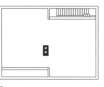

Plans of the six levels.
1 parents' area
2 children's area
3 void over the living room
4 kitchen-dining room
5 mezzanine
6 living room (*Stube*)
7 cellar
8 WC
9 bathroom
10 log store

Terrace.

Second floor.

First floor.

Mezzanine.

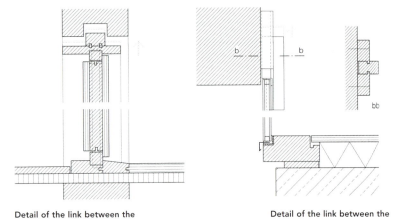

Detail of the link between the structural frame and the door (space at the top to allow for the give of wood).

Detail of the link between the structural frame and the window (space at the top to allow for the give of wood).

ANTICIPATING THE GIVE OF WOOD

Antonius Lanzinger's experimental design, rooted in modernising a traditional technique, was facilitated by incisive solutions proposed by the engineer Konrad Merz. The fact that wood moves was one of the main problems facing the designers. It was by no means a negligible problem in the case of this four-storey building, which subsided 15 cm the first year. In order to deal with the issue before it arose meant separating from the beam structure the joinery and core containing the building's pipe systems and networks. The doors and windows are therefore self load-bearing, being suspended or fixed laterally with a large clearance.

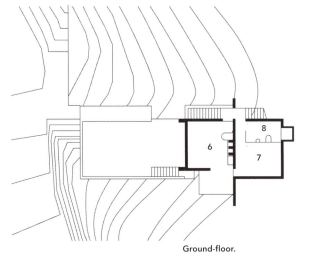

Ground-floor.

Basement.

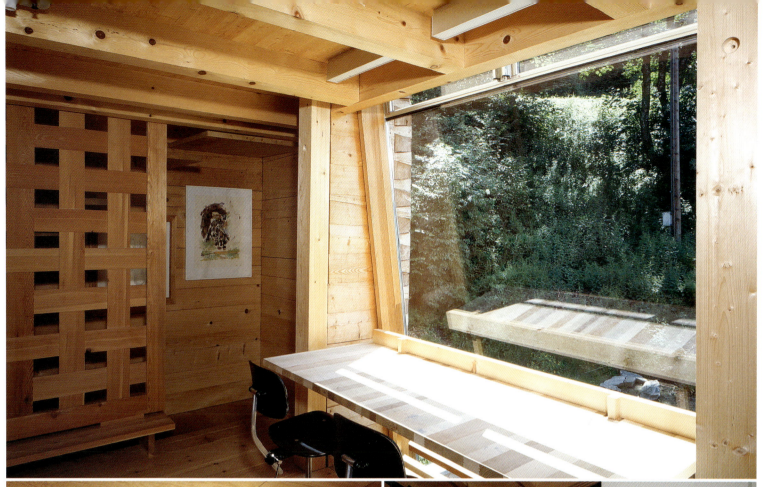

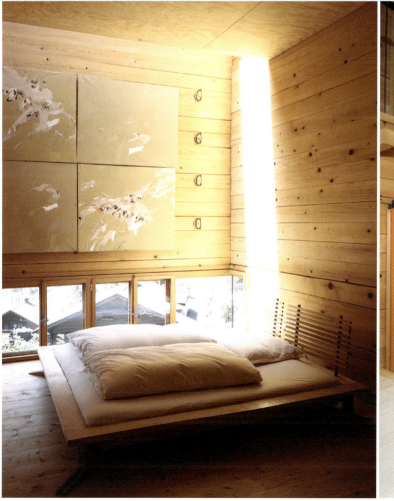

Residence on Mount Macedon, Australia

Inarc architects

Mount Macedon, located approximately 70 km north-west of Melbourne, culminates at 1,000 metres' altitude in a bucolic region where the Australian bush rubs shoulders with cultivated pastures and where night temperatures drop to as low as -4°C during the long cool season. It was on a twelve-hectare family holding that the landowners decided to build a holiday home for three generations, and which may become their permanent residence in the future. Access paths were blended into the landscape, and excavation work was kept to a minimum to protect tree roots and top soil.

The building's low long lines are reminiscent of American Modernist houses, but the combination of this type of minimalist architecture with local rustic materials reveals a contemporary Australian variant. The structure is single-storey so as to merge with the surrounding vegetation. Laid on steel stilts it is raised up from the natural ground level, which also allows easy access for white-ant inspections. A converted pre-existing building houses the gas cylinders and six rainwater tanks used for watering the greenery and fire-fighting.

The entrance on the south-west façade features several steps, a stone wall and a wall made of Corton steel, freed from the jutting roof by a glazed impost. The swing door opens in the middle of a corridor leading to the house's three compartmentalised zones. Upon entering through this front door, one's eye travels towards a distant view of the landscape beyond an interior courtyard, which separates the living room from the owners' private suite. An independent annex for family and guests is positioned at the north-west end of the corridor, near the vast terrace. Sliding partitions enable the three zones to be acoustically and thermally separated from each other – an astute solution that makes the house easily adaptable to the requirements of its users and reduces to a bare minimum both maintenance and energy consumption.

Double glazing was used in order to reduce heat loss, and the building envelope was insulated with two layers of mineral wool, each of which is 8 cm thick, separated by a 9-cm strip of air. In addition, energy costs have been reduced by some 65%, thanks to a geothermal heating system that utilises the median temperature of the earth via 500 m of underground pipes. These pipes were drilled vertically into the earth, running as deep as 80 m, and filled with water. The median earth temperature stabilises the water temperature to around 13°C, which is then used in winter for heating and in summer for cooling.

The materials were chosen based on an analysis of the energy required to manufacture and transport them. They include eucalyptus retrieved from demolition sites and local basalt quarried from nearby Kyneton, used for walls constructed by a local stonemason based on a traditional technique. Steel, basalt and eucalyptus are all fine materials whose high cost is offset over the long term by lower maintenance outlay and by their resistance to white ants and cockatoos – a local pest.

site: Mount Macedon, State of Victoria, Australia — programme: holiday home divided into three compartmentalised zones: family area with living room, dining room and kitchen; private suite with bedroom and lounge; three bedrooms with bathrooms and independent lounge — client: private — architects: Inarc architects/Reno Rizzo and Christopher Hansson, Melbourne; landscape architect: Robert Boyle Landscape Design — structural engineer: BHS Consultants — prime contractor: Cooper Morrison — surface areas: plot – 12.15 ha; house – 457 m² (habitable) — schedule: design period – 2001; construction period – January 2002 to March 2003 — materials and construction system: combined metal/wood/stone structural frame (primary steel frame, basalt central core, and eucalyptus interior and exterior cladding), anodised aluminium joinery, Corten steel cladding on the south-west façade — environmental measures: structure set on steel stilts to minimise the building's impact on the natural terrain; use of local basalt in mortar-less walls based on a traditional technique; use of wholly recycled eucalyptus for the exterior and interior cladding, wood floor and furnishings; highly insulated building envelope (double glazing and double padding of mineral wool); geothermal heating and cooling; recovery of rainwater.

The building is positioned in the centre of the plot near a eucalyptus grove, offering far-reaching views of the landscape between the trees.

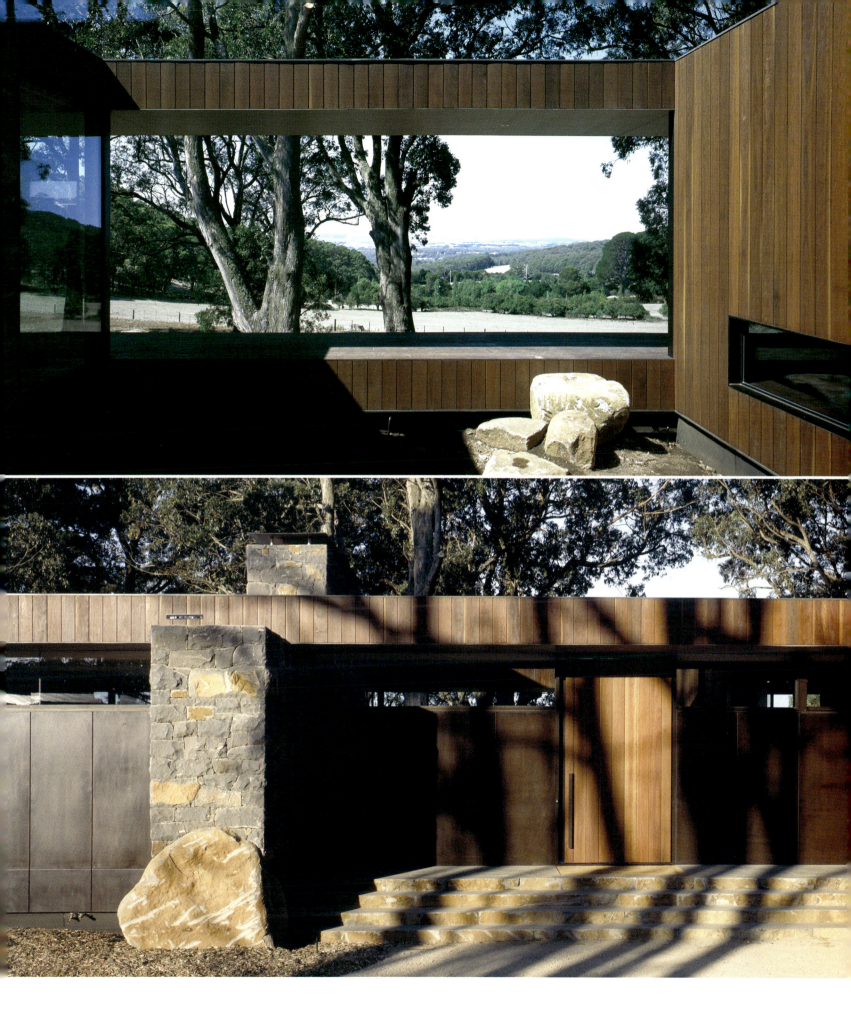

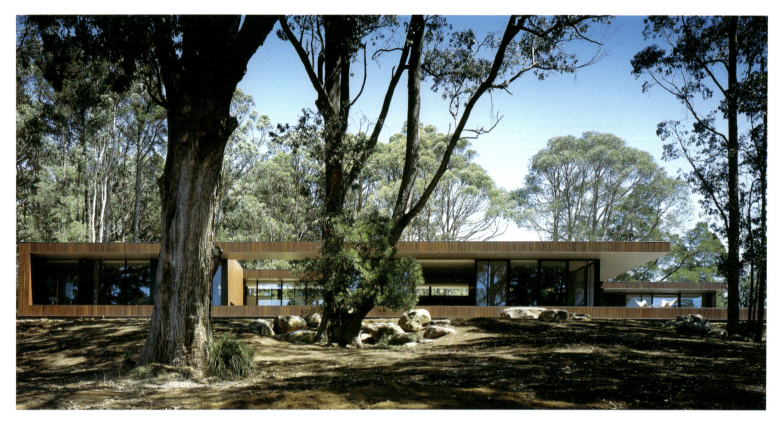

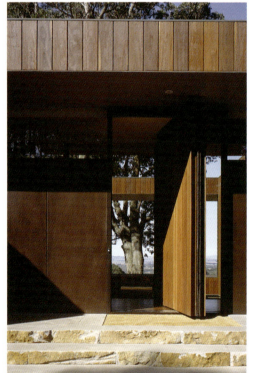

As the swing door opens, glimpses of the landscape around the foot of Mount Macedon are unveiled.

WHOLLY RECYCLED WOOD

Of the 600 recorded varieties of eucalyptus trees, not all can be used for building. However, the Australian Grey Ironbark (*Eucalyptus paniculata*) is a thick, hard wood that is naturally resistant to white ants and other biological hazards. It is used here for the exterior and interior cladding, wood floor and furnishings came from demolished warehouses and piers. Ironbark has a long lifespan (hundreds of years in some cases), is completely dry and very resilient. Sold by Australian Architectural Hardwoods (www.aahardwoods.com.au), it is used a great deal by Australian architects.

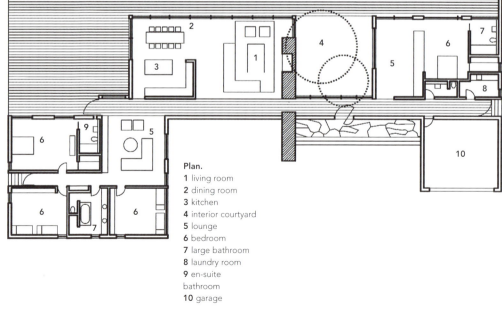

Plan.
1 living room
2 dining room
3 kitchen
4 interior courtyard
5 lounge
6 bedroom
7 large bathroom
8 laundry room
9 en-suite
bathroom
10 garage

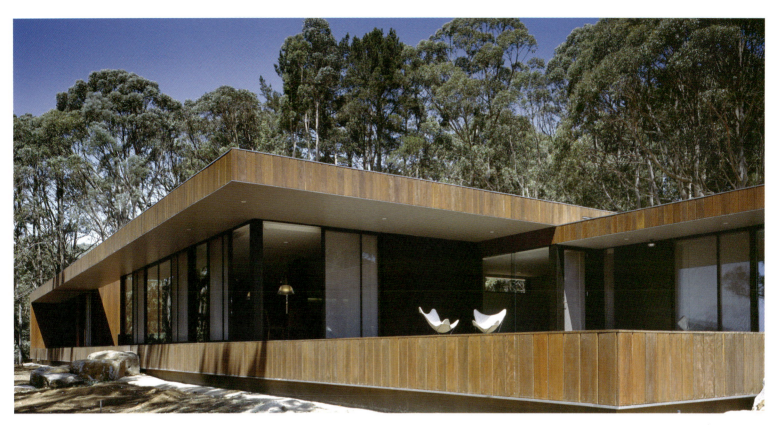

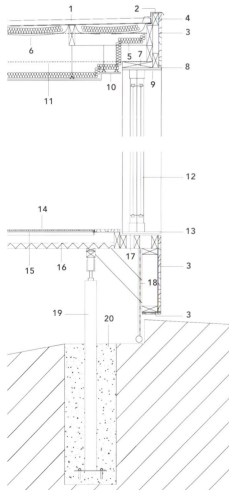

Vertical section of a bedroom.

1 steel roof decking
2 steel flashing
3 timber panelling (20 x 200 mm)
4 timber truss
5 mineral wool insulation
6 building paper sisilation
7 timber lintel
8 aluminium flashing
9 aluminium box section
10 suspended ceiling system
11 steel beam
12 window in aluminium frame
13 aluminium box channel
14 wood floor

15 sub flooring
16 insulation
17 waterproofing membrane
18 steel mesh
19 metal post
20 concrete footing

The stones, of irregular shape and size, were assembled using hardly any mortar.

Stone villa near Valencia, Spain

Ramón Esteve

Ramón Esteve, who lives and works on the south-east coast of Spain, draws his inspiration from vernacular structures and their pragmatic aspects, focusing on interaction between function and use and the logical utilisation of each material. Whether they be brick, stone, or whitewashed concrete (see page 46), his houses are rooted in the principles applied to traditional residential architecture with a view to ensuring that occupants are comfortable in the summer months, which are often burningly hot. Ramón Esteve's transposition of the Mediterranean design type derives from a highly contemporary minimalist method.

Visitors approaching the north façade of this house located in a small town south of Valencia see an austere set of blind walls that seem impenetrable. Once over the threshold, however, this hermetic image is transformed into a sequence of fluent spaces oriented south towards the garden. The communal rooms are grouped in the far western part of the building. The four bedrooms are set in a line in the east wing off an interior corridor and can be accessed from the garden via a walkway sheltered by an overhang. Three roofed terraces regulate the sunshine, eliminating the need for sunshades. The larger of these terraces is positioned in the south, in front of the living room and along the same axis as the swimming pool; another is placed south-west, in front of the dining room, and the third is situated in the west, in front of the kitchen. In summer, all of the interior spaces are bathed in natural light, but the sun's rays cannot penetrate into the house, and the shade created by the overhangs cools the air. The walls are positioned so as to protect the residence from northerly and westerly winds whilst letting in breezes from the east.

There is a clear contrast between heaviness and weightlessness, generated by the construction solutions used. The limestone-block walls are 60 cm thick, and ensure a wide range of functions: they are load-bearing, house the technical equipment and fulfil acoustic and thermal needs. They block out heat in summer whilst in cool periods store the warmth generated by the open fire, meaning that the radiators only need to be turned on as a back-up solution. The cavities between the solid wall sections are glazed from floor to ceiling, covering more than 4 m in the family rooms and nearly 3 m in the bedrooms. Such proportions are common in Mediterranean countries, where the focus is more on creating draughts during the summer rather than retaining heat in winter.

The floor is clad in polished, slightly shiny stone slabs, lending a refined air to the rugged limestone surface. The dark wooden furniture designed by Ramón Esteve sports stark lines, acting as a counterpoint to the rustic masonry. The exterior fittings bear a similar hallmark of sophisticated simplicity, as illustrated by the indirect lighting fitted into the thick walls and the pine terrace decking that frames the rectangular swimming pool.

site: La Solana, Ontinyent, Province of Valencia, Spain — programme: holiday home; ground floor – core containing daily living areas, with entrance, lounge, dining room, kitchen and storeroom, three roofed terraces and a wing with four bedrooms and two bathrooms; partial basement with water tank and ancillary rooms — client: private — architect and interior designer: Ramón Esteve, Valencia; other project team members: Angels Quiralte and Juan Ferrero — structural engineer: Ramón Sanchis — prime contractor: Inrem — surface areas: plot – 9,000 m²; ground floor – 190 m² (habitable); terraces – 110 m² — schedule: design period – 1998; construction period – 2000 — materials and construction system: 60 cm-thick limestone-block walls; hollow block decks; white concrete overhangs; galvanised steel frames for the openings; sliding bedroom shutters made of cellulose-based panels soaked in phenolic resin (Prodema), set on a galvanised steel frame; limestone floor slabs used both for the interior and exterior; MDF (Medium Density Fibreboard) for the doors and built-in furniture with wenge facing (*Millettia laurentii*), an African broad-leaved tree whose wood is thick and naturally sustainable; swimming pool terrace decking made of pine treated with copper salts — environmental measures: design concept adapted to the weather conditions (based on the angle of the sun's rays in the different seasons and direction of the main winds); very thick walls and floors to keep the house cool; solid walls built of local limestone using a traditional technique; recovery of rainwater on the roof and storage in a 70,000 l tank to supply the swimming pool and water the garden; Mediterranean plants and foliage (cypress trees and oleander bushes).

Indirect lighting is incorporated into the slits at the base of the solid limestone walls.

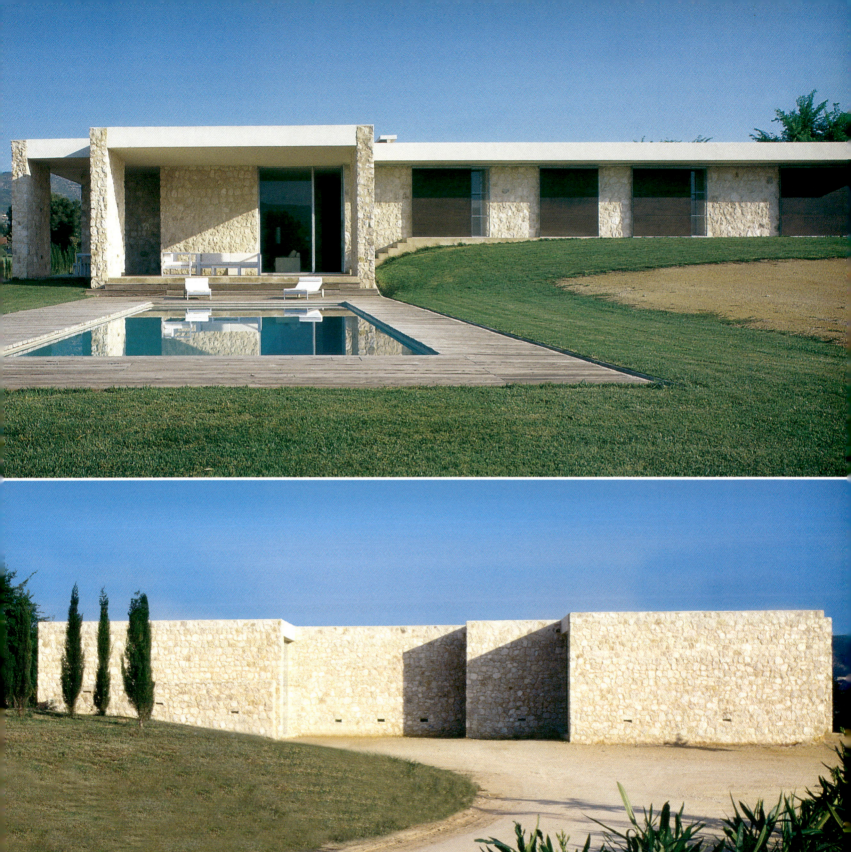

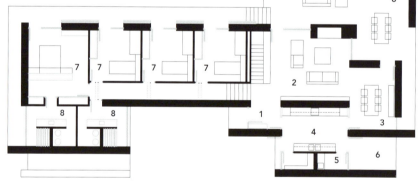

Ground-floor plan.

1 entrance
2 living room
3 dining room
4 kitchen
5 storeroom
6 roofed terrace
7 bedroom
8 bathroom
9 swimming pool

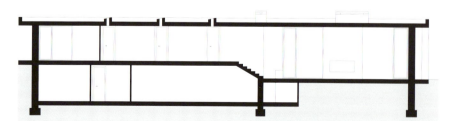

Longitudinal section.

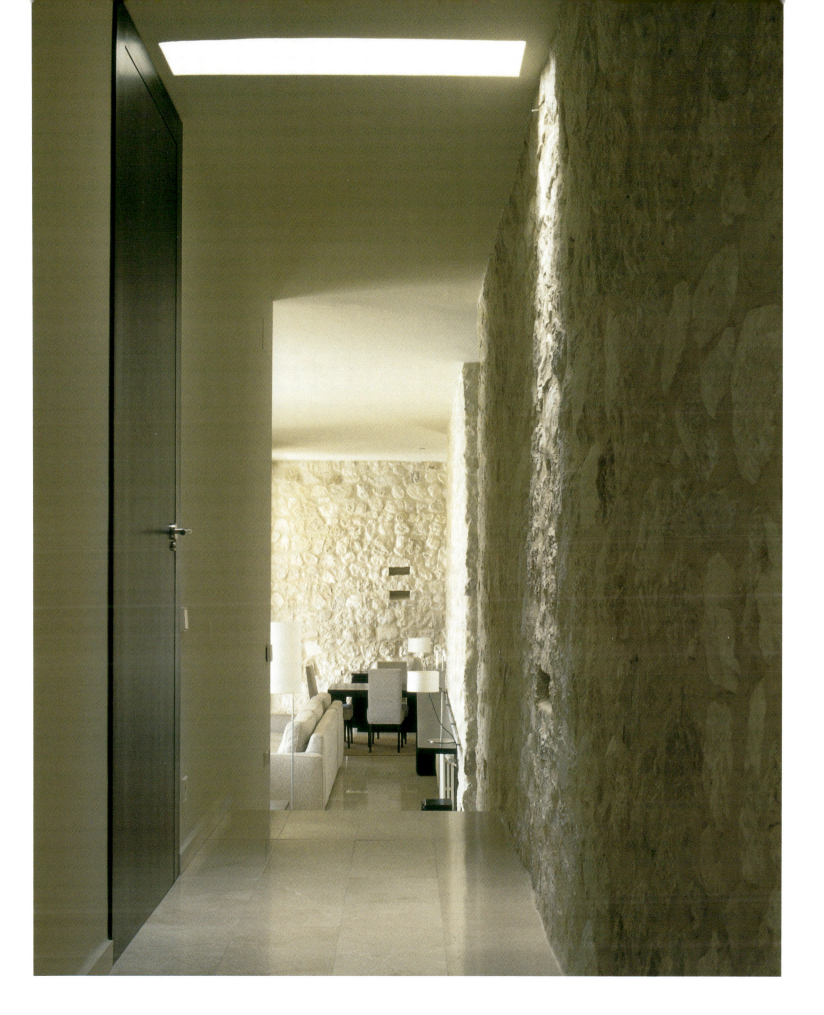

Timber residence near São Paulo, Brazil

Mauro Munhoz

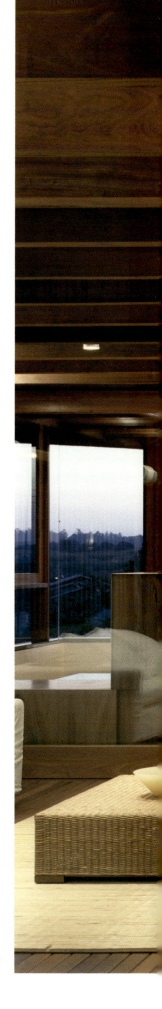

The revival of building with wood and adopting an ecological approach to construction often go hand in hand. In Brazil, this twin process was initiated in the 1980s by the architect Marcos Acayaba and the engineer Helio Olga. As the head of a structural engineering firm and construction company, Helio Olga has participated in several hundred projects that have roused young architects' interest in constructing timber structures using a local material. The buildings designed by Mauro Munhoz are representative of such types of ecologically-correct timber architecture.

The countryside house that Mauro Munhoz has recently built 100 km north of São Paulo is due to shortly become the main residence of a young couple with two children, who currently live in the city centre. The programme was split into two independent wings forming a north-facing L-shape (due to this being the southern hemisphere), around the swimming pool and garden. The body of the main building sits perpendicular to the street and is an independent unit whose functions are clearly defined by storey: service areas on the ground floor, social life and nursery on the garden level, and parents' space located on a split level at the far south-east end. The guest wing, which will later become the children's wing, is set perpendicular to the main building, on an intermediate storey between the garden level and the first floor.

The original – fairly uneven – shape of the land was a key component of the scheme. It offered the possibility of combining sweeping exterior views with a sensation of privacy. Using a bioclimatic design concept based on a precise analysis of the site, a passive energy system ensures thermal comfort in summer, provided by natural ventilation, overhanging roofs, horizontal sun screens and fixed and mobile openwork vertical components. The spacious living room topped by a timber shell roof is glazed on all sides to allow views of the landscape, but is shielded from the afternoon heat by horizontal protections. The outdoor living area is like a verandah – the lack of walls exposes it to the tropical climate from which it is protected merely by the flat roof sections.

The retaining walls as well as the chimney are built of goiás, a white stone quarried about 200 km from the site and laid in irregular, several centimetre-thick beds based on a traditional technique called *canjiquinha*. Above, everything is in solid wood. The structural frame, cladding, solar protections, terraces, sliding shutters, wood floors, ceilings and guard rails with built-in benches are made of cumarú, a very thick tropical tree that can be used for the exterior without being chemically treated. The structure's precise detailing reveals a perfect knowledge of the qualities and weaknesses of wood.

site: Itu, São Paulo, Brazil — programme: large home for a couple and their two children; ground floor – garage, workshop, laundry room, storage area, staff quarters; garden level: living room, exterior living room, dining room, kitchen, play room and children's bedroom; split level – four guest rooms with en-suite bathroom; first-floor: master bedroom with bathroom and terrace — client: private — project manager: Mauro Munhoz Arquitetura, São Paulo; architect: Mauro Munhoz; other project team members: Eduardo Lopes and Fabiana Tanuri; site supervisor: Fernando Alvarenga — engineer and manufacturer of the timber structural frame: Helio Olga, Ita Construtora, São Paulo — surface areas: plot – 6,472 m²; roofed spaces (enclosed and open) – 626 m² — schedule: design period – 2002; construction period – September 2002 to March 2003 — cost: construction – US$ 720/m²; total cost – approximately US$ 1,000/m² (including furniture, exterior fittings and fees) — materials and construction system: post-and-beam structure made of cumarú set on a reinforced concrete base with stone facing — environmental measures: respecting the landform, adopting a passive energy strategy to keep the house cool in summer, using local construction techniques and timber from a sustainably managed forest.

The exterior living room, set between the lounge and the dining room, opens out to the garden but is covered by a jutting roof.

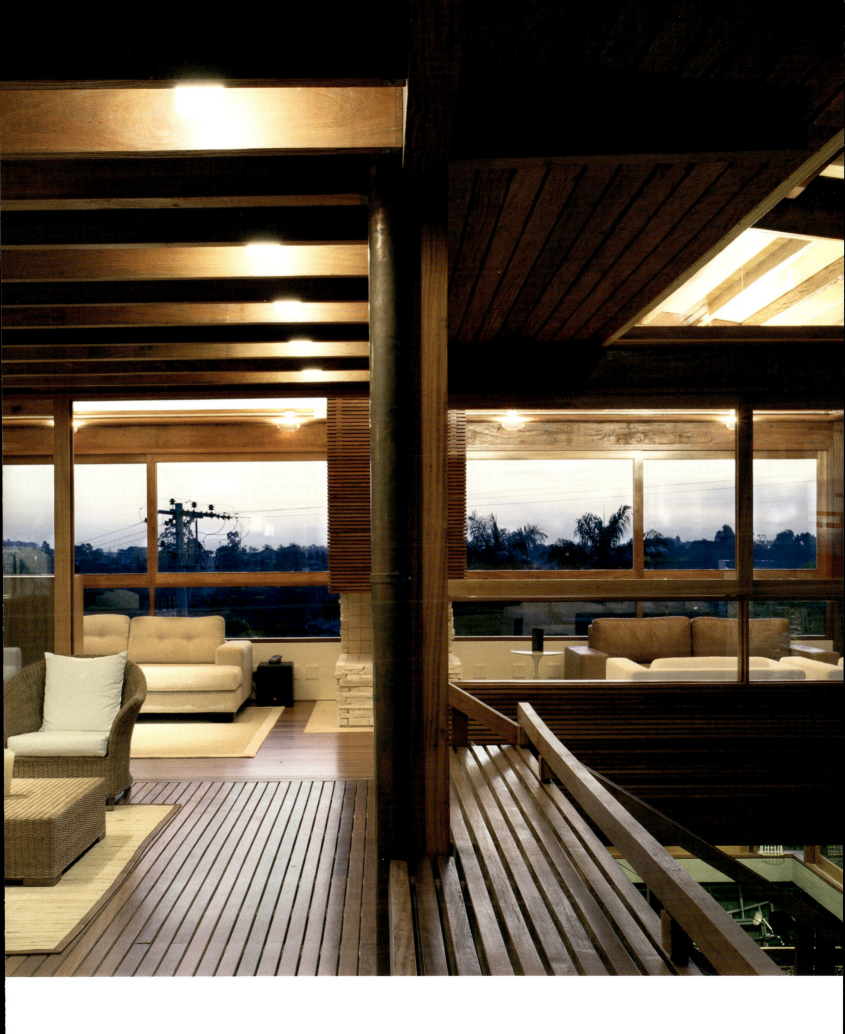

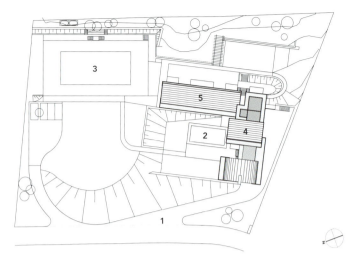

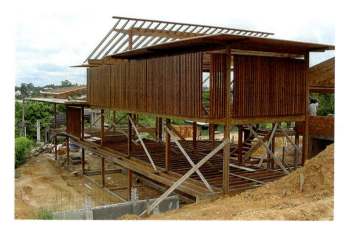

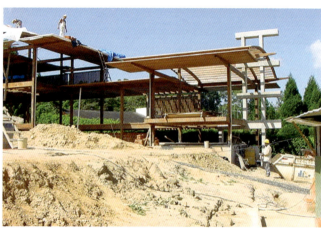

Block plan.
1 vehicle access
2 swimming pool
3 tennis court
4 main building
5 guest wing

BUILDING WITH WOOD TO STORE CARBONIC GAS

The cumarú used here came from one of Brazil's few sustainably managed plantations (sustainable management is practised in less than 5% of the Amazonian forest). Only the oldest trees are cut, creating a clearing through which the sun's rays can reach the young, growing trees. During their growth phase the trees absorb CO_2, which helps reduce the greenhouse effect. When old trees rot in the forest they emit the equivalent of the CO_2 they have absorbed over their life cycle. If the wood is used for construction purposes, the CO_2 is stored for several decades, or even centuries, during which time it is to be hoped that the human race will have taken the necessary measures to protect nature and its own survival.

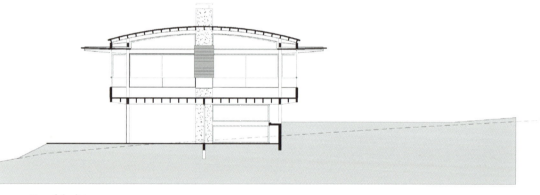

Cross section of the living room.

The house includes a main building designed for the privacy of family life, and a wing that can currently accommodate a large number of guests and which will serve as an independent area for the children when they become teenagers.

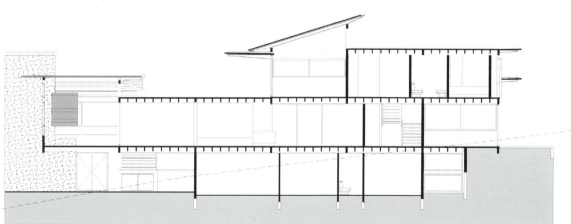

Longitudinal section.

Facing page:
Main building viewed from the guest wing (top).

North-west end wall (bottom left).

South-east façade of the guest wing (bottom right).

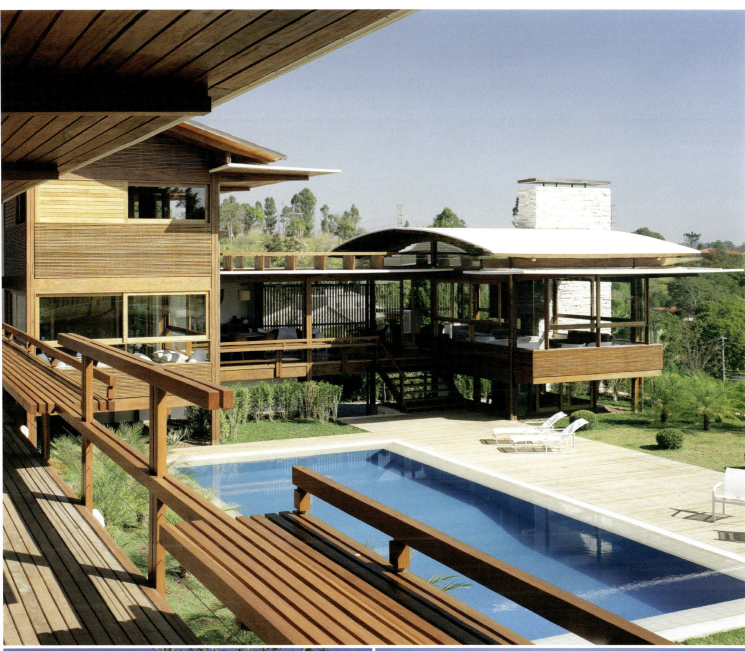

141

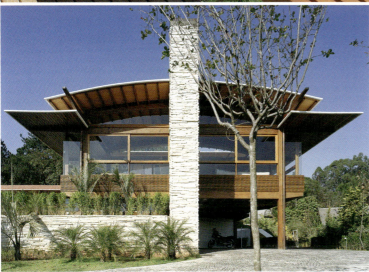

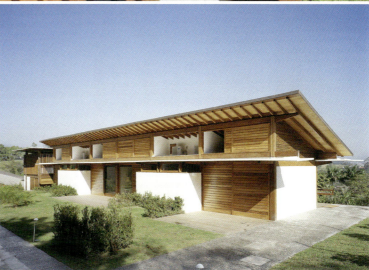

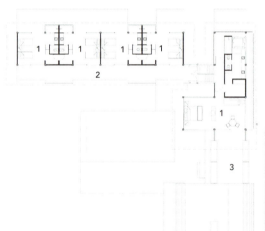

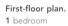

First-floor plan.
1 bedroom
2 gallery
3 terrace

Garden-level plan.
1 exterior living room
(verandah)
2 lounge
3 play room
4 kitchen and dining room
5 bedroom
6 sauna
7 swimming pool

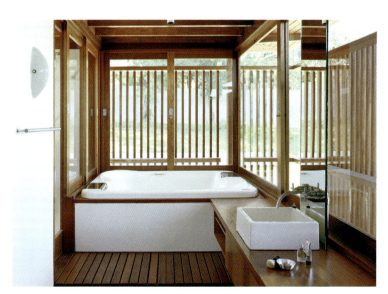

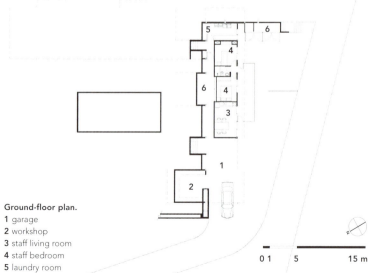

Ground-floor plan.
1 garage
2 workshop
3 staff living room
4 staff bedroom
5 laundry room
6 storage area

0 1 5 15 m

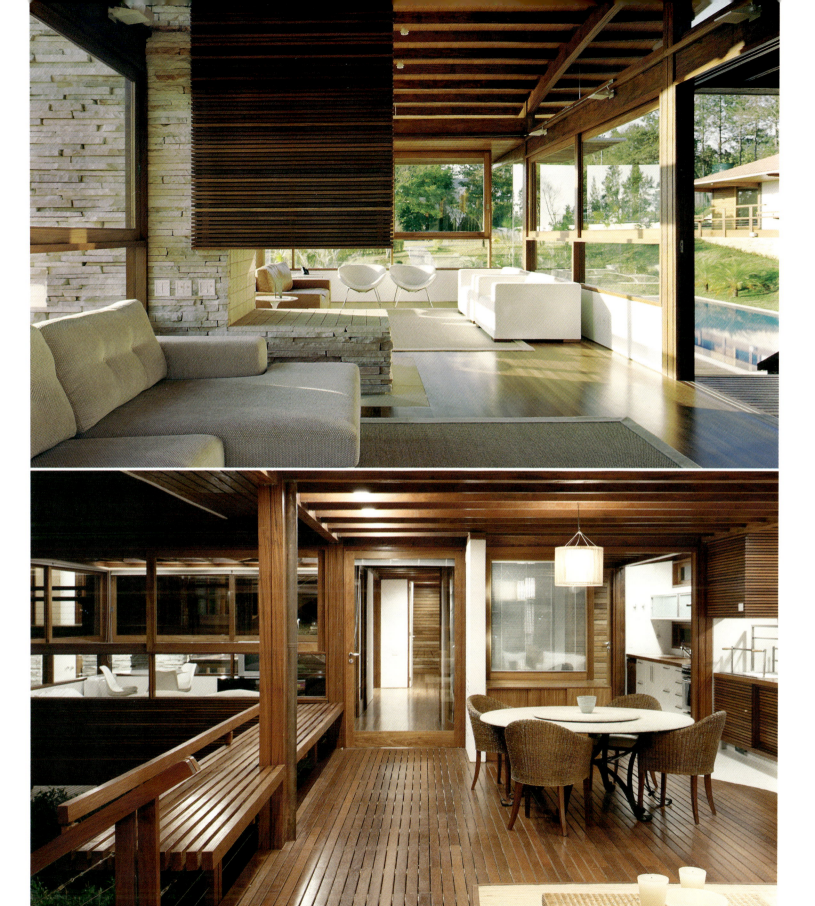

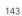

Earth-brick house and studio in Bangalore, India

Chitra Vishwanath

Bangalore is a university and scientific hub specialised in information technology, and yet the infrastructure of this city with a population count of six million is problematic. Since setting up her architectural practice 15 years ago, Chitra Vishwanath has worked on resolving construction-related problems concerning pollution, waste and systems. Her objective is to minimise the imprint of buildings on the environment during and after the construction process. The approach she has adopted is rigorous and covers all aspects of sustainable development, such as in her choice of materials, use of solar energy and rainwater, and treatment and recycling of domestic wastewater. The social aspect of this approach, which is rooted in the teachings of Mahatma Gandhi, aims at creating a team spirit, with each player taking responsibility.

The design of this house arose from the encounter between two women committed to enhancing their region's natural, cultural and community heritage. Jenny Pinto creates paper lamps embedded with plants and foliage, and whose fabrication requires a great deal of water – a rare commodity in Bangalore which is located at 920 m altitude on a plateau where temperatures range between 15°C and 35°C. It was whilst she was finding out information on how to recycle rainwater that Jenny met Chitra, whose earth house and associated architectural practice so appealed to her that she selected her to design her own work and living space.

The three ground-floor rooms that face south are devoted to papermaking. The studio takes up the west wing and has a taller floor-to-ceiling height than the other rooms, whilst the kitchen, living room and a bedroom are grouped together in the north-east corner. On the upper floor, accessed by an exterior staircase, the bedroom is fronted by a large verandah with views over a nearby lake. The positioning and size of the openings were calculated to prevent the sun's rays from penetrating deeply into the main rooms, without blocking out daylight altogether. The resistance of earth to changes in temperature means that in summer the walls warm up only very slowly during the day, and the heat calories are released at night, with the fired-clay floor and small arches retaining the coolness. An opening in the living room ceiling creates a cool draught, generating natural ventilation. Recycled rainwater is used for domestic purposes. It is heated by solar thermal collectors and by a stove that burns waste from the vegetation used in the papermaking process. Domestic wastewater from the house and studio is filtered through an eco-pond and used for watering the garden. Energy for the studio lamps is provided by photovoltaic modules with integrated batteries. Thanks to these simple economical measures, the Pinto house is almost entirely water and energy self-sufficient. That said, Bangalore's lifestyle is less influenced by the "socially fabricated" needs typical of industrialised countries, albeit that this situation is currently changing in India.

site: Bangalore, State of Karnataka, India — programme: two-storey building with combined living and work space; ground floor – set around an interior courtyard, kitchen, dining room, bedroom, ancillary areas and rooms for the paper lamp studio; first floor – bedroom, loggia and verandah — client: Jenny Pinto — architect: Chitra Vishwanath, Bangalore — surface areas: plot – 1,475 m²; useable surface area – around 300 m² (studio, house, patio, verandah and terraces) — schedule: design period – 2002; construction period – April 2002 to January 2003 — construction cost: US$ 35,000, representing approximately EUR 28,530 — materials and construction system: compressed earth bricks, stabilised with 5% cement (10 x 17.5 x 23 cm blocks); local granite slabs for the exterior steps, wall ties and lintels of the openings; support for the floor structure and flat roof made of small arches pre-fabricated on site using 12.5 x 25 cm fired-clay bricks, borne by steel truss beams; infill above the arches made up of pieces of tiles from a nearby construction site and debris from a granite quarry; aluminium troughs for the sloping sections of the roof — environmental measures: adaptation to the climate and opportunities offered by the site; choice of local materials whose manufacture requires little energy; house made of bricks crafted on site out of earth extracted from beneath the house; debris used for the infill; recovery of rainwater for domestic use — specific equipment: photovoltaic modules to supply lighting in the studio, with batteries that last for at least four-hours; solar cooker for making meals; solar thermal collectors for heating domestic water; underground 10,000 l water tank for the rainwater that supplies an elevated reservoir by pump from which water is conducted by gravity, with excess water flowing into a sunken well to refill the groundwater table; cleaning domestic waste water by means of an eco-pond (horizontal gravel filter, reeds and ultraviolet rays).

The walls of the Pinto house are blocks of compressed earth, and the roof arches are made of fired-clay bricks.

DECIDING ON CONSTRUCTION MATERIALS

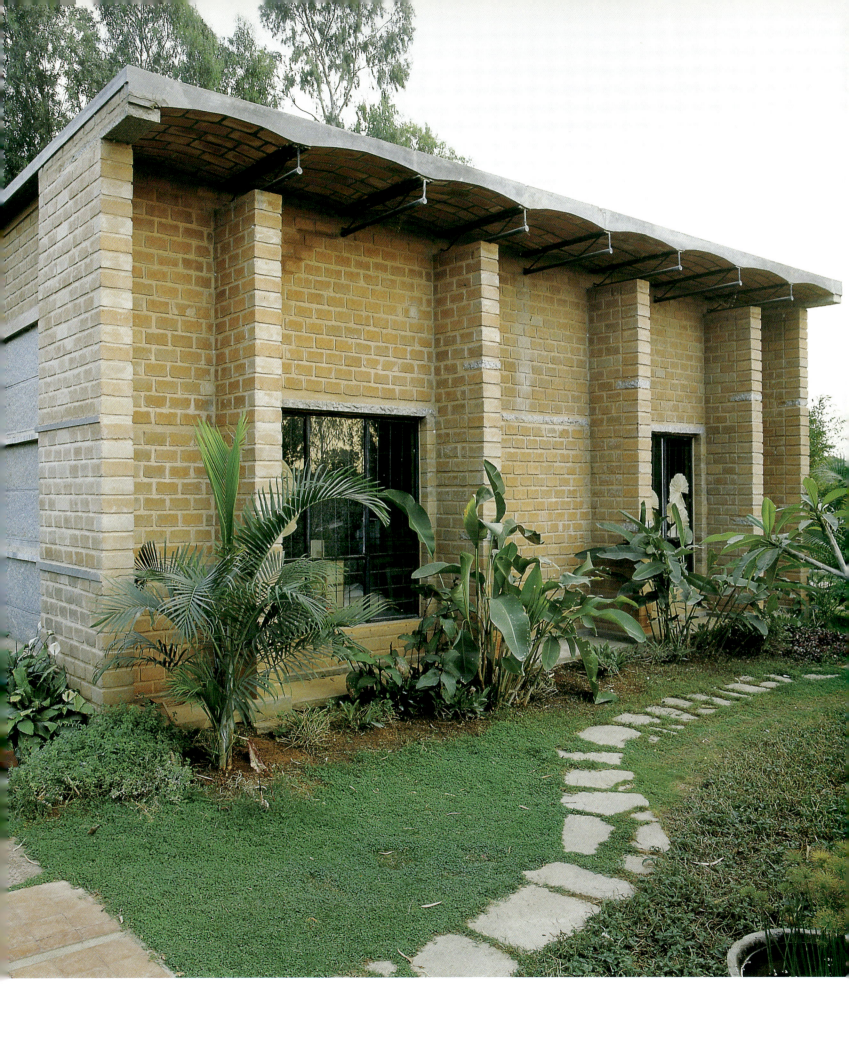

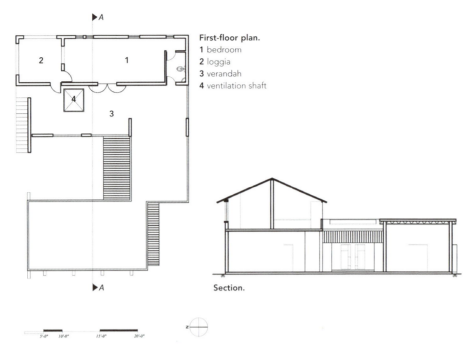

First-floor plan.
1 bedroom
2 loggia
3 verandah
4 ventilation shaft

Section.

The solar cooker directly uses the sun's rays.

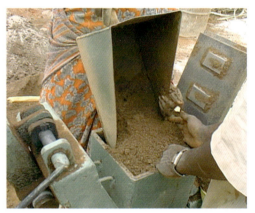

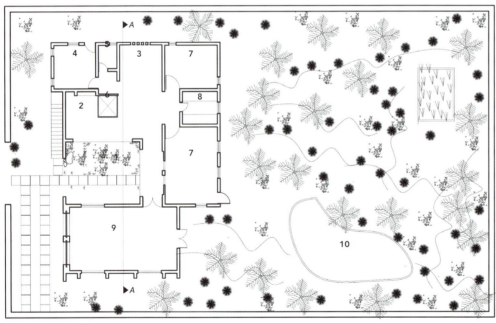

Ground-floor plan.
1 interior courtyard
2 living room and dining room
3 kitchen
4 bedroom
5 bathroom
6 ventilation shaft
7 paper-making room
8 stock room
9 studio
10 eco-pond

EARTH-BRICK CONSTRUCTION

Building with earth bricks offers multiple ecological, economic and social advantages. As the raw material is available locally, transport between the production site and the construction site is generally negligible. In the case of the Pinto house there was no transport whatsoever, as the earth was extracted in situ. Earth was mixed with the granite dust from nearby quarries, and was then stabilised by adding cement representing approximately 5%. This had the benefit of replacing sand, which would have had to have been transported from over 50 km away and would have increased both the cost and the environmental footprint. No energy was consumed during the manufacturing process: the mix was compacted in a manual press and the bricks dried in the sun for around ten days, whilst being slightly sprayed with water, and were then ready for use. The blocks were made with mortar composed of the same mix. In addition to there being hardly any debris or negative impacts on the environment, the effect on local society was extremely positive, generating local jobs and drawing on the know-how of traditional techniques. The Pinto house bricks were produced and laid by two teams of six workers. Chitra checked that everyone was treated with consideration, that they were fairly paid and had access to medical care. She also ensured that health and safety conditions on the work site were respected.

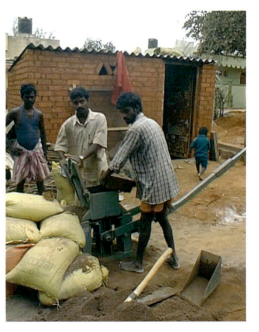

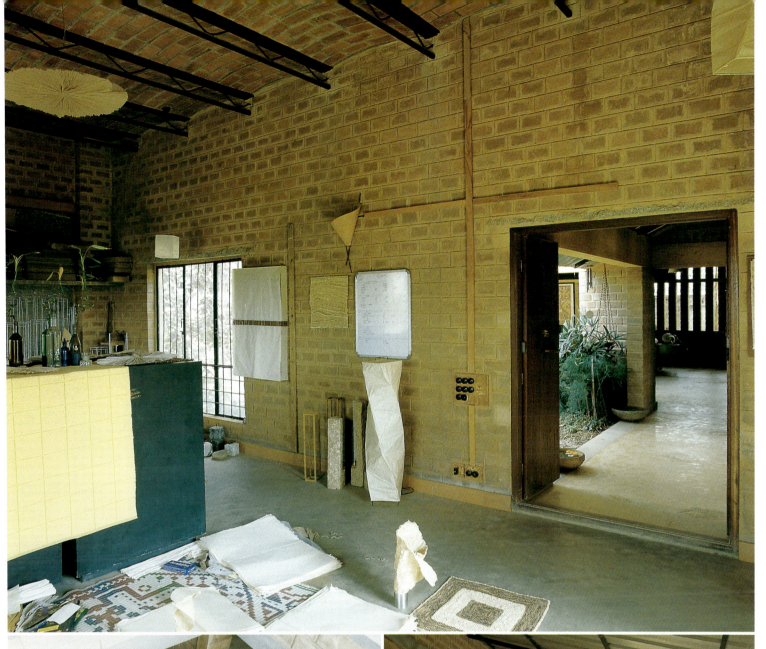

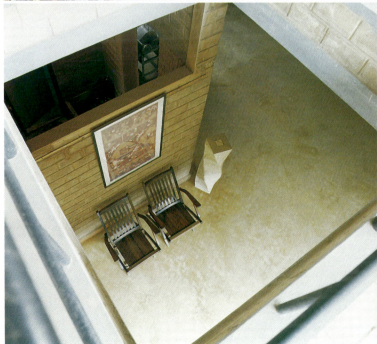

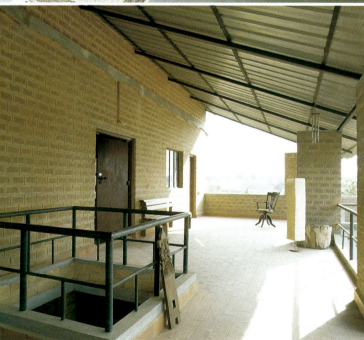

House of earth and light in Phoenix, USA
Marwan Al-Sayed

Having spent years as a child living in Morocco and later travelling extensively through other North African countries, the Iraq-born architect Marwan Al-Sayed is fascinated by the intense luminosity and mineral landscape of the Sahara. His "house of earth and light" draws inspiration from North African vernacular architecture but is set in another desert, on another continent. The structure resembles a modern, elegant tent, pegged to its earth base, and reflects the taut relationship between heaviness and weightlessness, between solidity and a sense of floating. It is located just outside the centre of Phoenix, in Alta Vista Park – a small residential enclave dotted with architecturally distinctive modern houses, including several residences by Frank Lloyd Wright, who chose Arizona for the location of his winter studio (Taliesin West). Phoenix's urban sprawl stretches along a desert region set at around 300 m altitude in a geographic basin surrounded by mountains. The climate is hot and dry, with average temperatures ranging from 12°C in January to 34°C in July. The flat site offers close views to the north of the nearby Squaw Peak Mountains and distant eastward views to Camelback Mountain. An *arroyo* – a shallow and often dry stream bed – crosses the plot, fostering growth of native vegetation such as desert ironwood (*Olneya tesota*), creosote bushes (*Larrea tridentata*), bayondas (*Cercidium praecox*) and barrel cacti (*Ferocactus*). This strangely beautiful, rocky site is arid and austere. To make the residence comfortable for its occupants, the architect protected the interior spaces from the blistering sun by applying the bioclimatic design principles of Saharan housing. Facing south-east/north-west, with a 15° variance between the east and west axis, the house is sheltered from the end-of-day heat transmitted by the gently sloping rays of the sun. The house dedicated to accommodating guests, oriented north-east/south-west in front of the western end wall, also protects the main building. In addition, the fabric roof juts out by 1.80 m in front of the south façade.

The house is designed to bridge over the *arroyo*. Two monolithic volumes pierced with the occasional opening frame the living room's lightweight structure. These volumes consist of thick rammed earth walls, like the enclosing wall that runs alongside the water feature fed by a spring. The volume near the car port incorporates the entry, study, kitchen and a sunken sitting area accessed by steps. The second one contains the more private spaces of the bedrooms and bathroom. The large living room/dining room is situated between these two volumes, directly above the stream bed. It is double-glazed (with insulation) on both sides, with pivoting vertical apertures to facilitate natural cross ventilation. The presence of shade and water attracts a rich and varied fauna, such as insects, birds and even jackrabbits – large hares that can be found in the United States. The house's occupants can therefore enjoy both the cool breeze and the buzzing life that occupies this desert oasis.

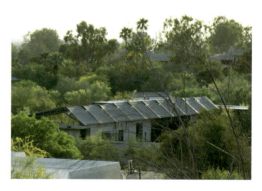

site: Alta Vista Park, Phoenix, Arizona, United States — programme: single-storey main residence with entrance, study, kitchen, lounge, living room/dining room, two bedrooms, one large bathroom and one smaller bathroom; detached atelier converted into a house for guests during the second construction phase — client: private — architect: Marwan Al-Sayed Architects Ltd, Phoenix — structural engineers: Douglas Snow and Associates, Phoenix (structural frame); Mike Ishler, Ishler Design and Engineering, Santa Monica (fabric roof) — surface areas: plot – 3,870 m²; main house – 252 m² (habitable); guest house – 126 m² — schedule: design period – 1997; construction period: first phase (main house and atelier) – 1998-2000, second phase (construction of a water feature and conversion of the atelier into a house for guests) – 2003-2004 — construction cost: first phase (partially self-built) – around US$ 350,000, representing approximately EUR 290,000; second phase – US$ 150,000, representing around EUR 125,000 — materials and construction system of the main house: lightweight steel frame for the living room; 46 cm-thick rammed earth walls (95% earth and 5% Portland cement); insulating double glazing; coloured concrete floor cladding; triple-layered translucent fabric roof, stretched over triangulated steel trusses — environmental measures: respecting the specific features of the site (building designed to bridge over an arroyo); steps taken to preserve a fragile ecosystem; bioclimatic design principles applied to ensure thermal comfort in summer (e.g. capitalising on earth's thermal mass and on natural ventilation); showcasing a historic technique (rammed earth construction); water feature fed by a spring to cool the air via evaporation.

The steel roof frame, built-in furnishings and several pieces of the furniture were designed by Marwan Al-Sayed.

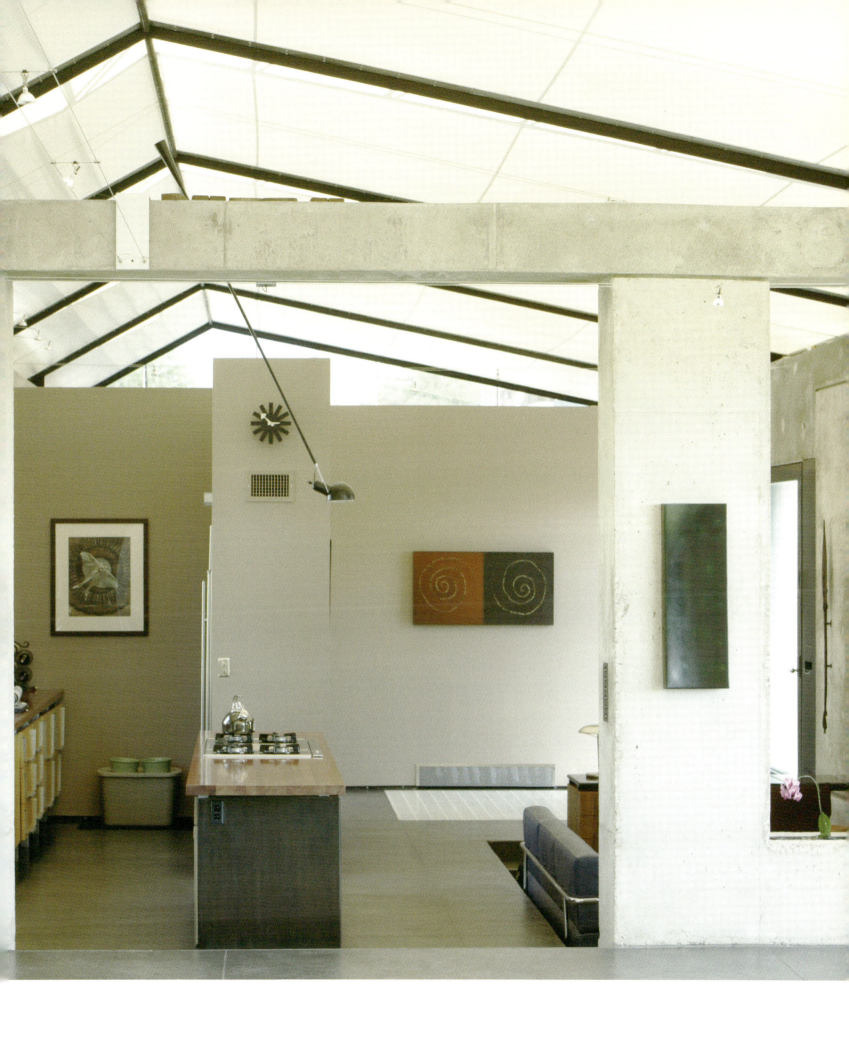

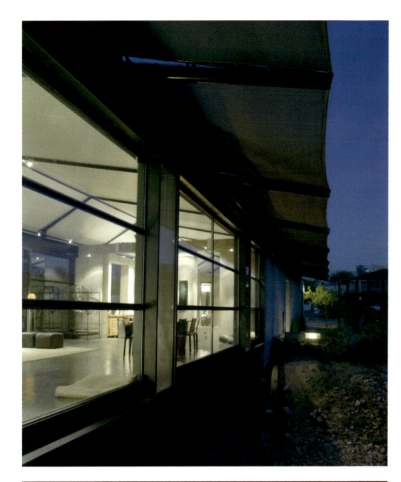

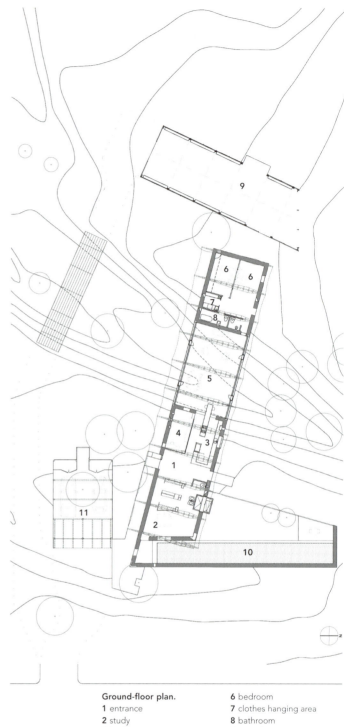

Ground-floor plan.

1 entrance
2 study
3 kitchen
4 sunken sitting area
5 living room/dining room
6 bedroom
7 clothes hanging area
8 bathroom
9 guest house
10 water feature
11 car port

RAMMED EARTH CONSTRUCTION

Rammed earth construction enables earth structures to be built without adding fibres and without requiring the support of timber or steel frames. The earth is packed down with a rammer between formwork, with the building going up layer by layer, over several storeys. The beaten, compacted earth binds together, thickens, and forms an even mass. One cubic metre of compacted earth weighs around 2 t. The rammed earth walls, which are about 50 cm thick, have high thermal mass and act as an effective insulator, protecting the structure against heat in the summer and cold in the winter. In this house set in the Arizona desert, the walls are 46 cm thick and the earth was mixed with Portland cement (5%) – an innovative composition that was necessary in order to comply with building code requirements.

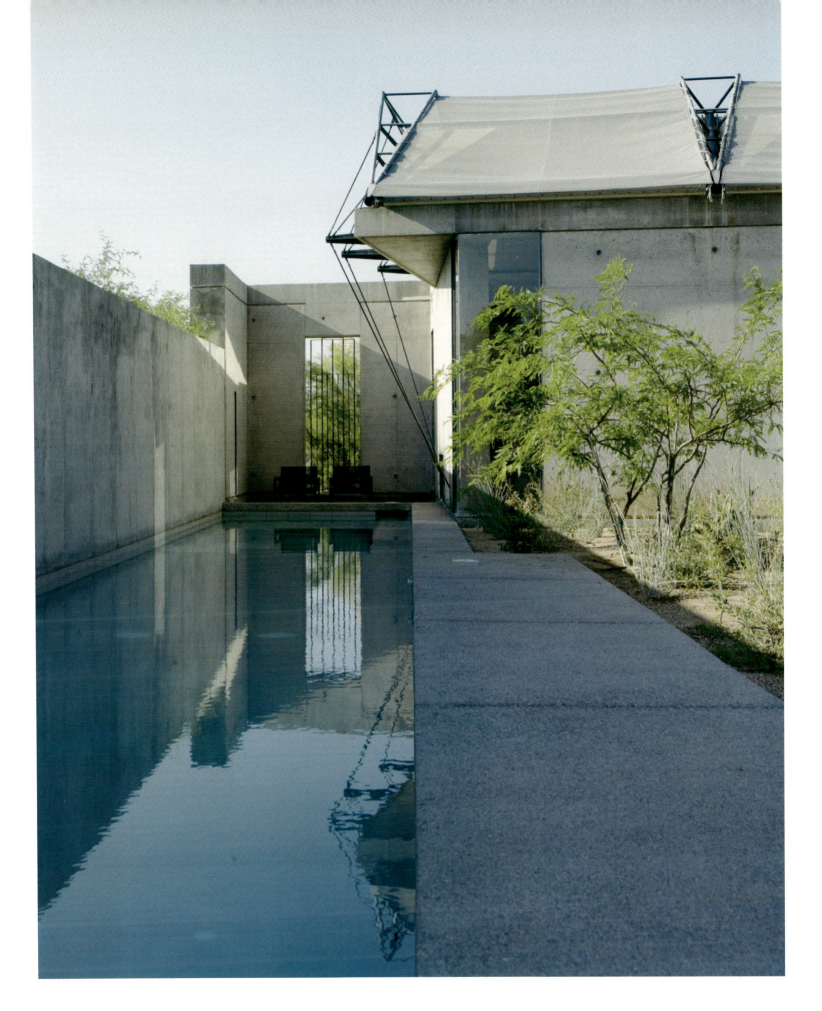

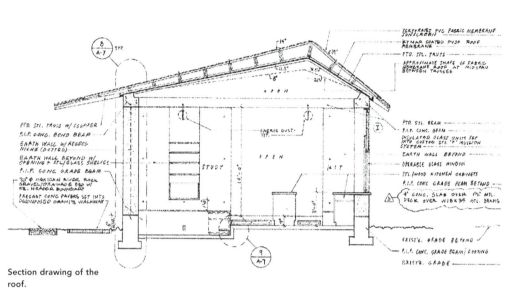

Section drawing of the roof.

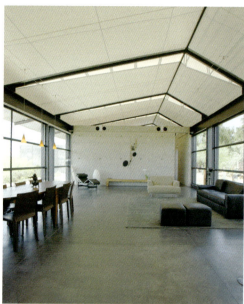

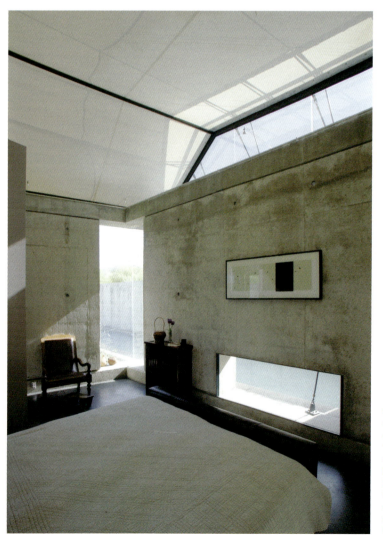

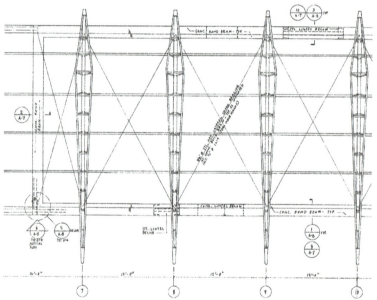

Detailed plan of the textile roof.

STRETCHED TEXTILE ROOF: A TECHNOLOGICAL INNOVATION

One of the strong points of this project is the combination of secular know-how (rammed earth construction) with state-of-the-art technology (a triple layered fabric roof). Acting as the house's "fifth façade", this light, translucent roof is stretched over triangulated steel trusses. The top skin is PVC coated perforated fabric (by Ferrari, France) which extends 1.80 m over the south façade and constantly casts a shadow on the following membrane that it protects. This impermeable median layer lets light through. It is a Kynar coated PVDF (polyvinylidene fluoride) fabric that is resistant to ultraviolet rays, ageing, dirt and solvents. The final interior layer, originally developed for the aerospace industry, is translucent yet serves as a barrier against the sun's rays. A 15 cm air gap between these two layers acts as a thermal buffer. (The third layer had not been made at the time the photos were taken.)

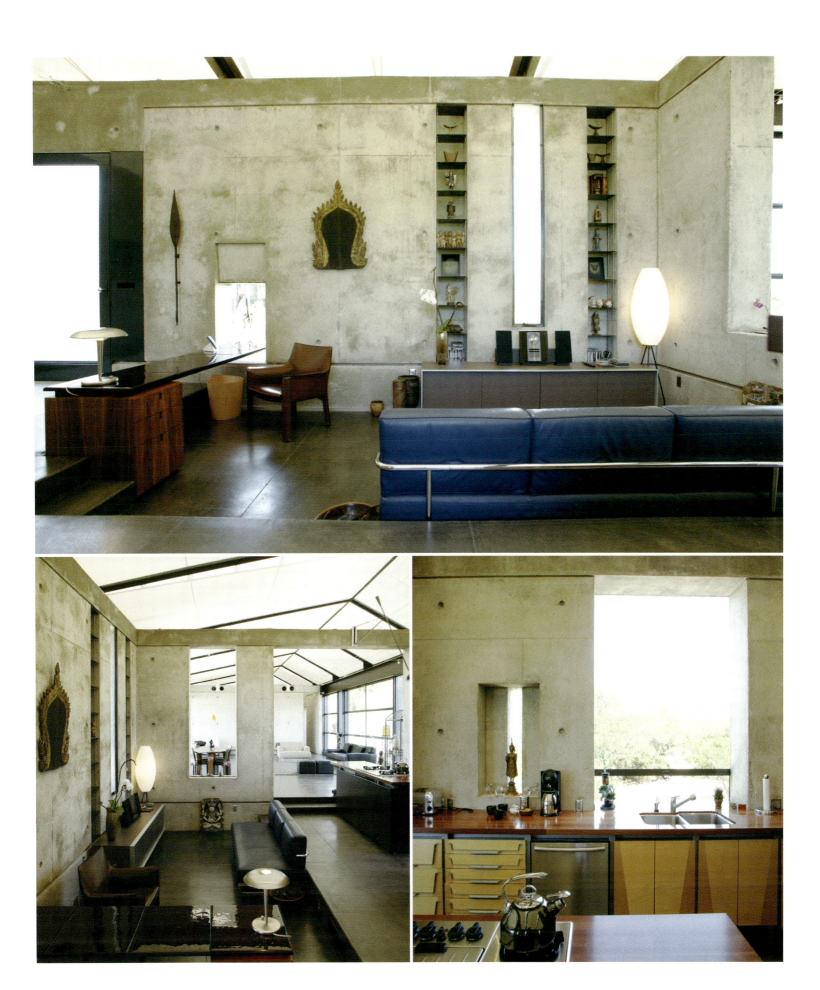

Biographies of the architects

G. Murcutt

M. BLouin

R. Esteve

K. Gullichsen

J.-L. Rames, L. Gouwy, and A. Grima

Yung Ho Chang

Kristian Gullichsen (1932) – FINLAND
Kristian Gullichsen graduated from the University of Technology in Helsinki, where he also taught for a long period of time. Having worked for several years on Alvar Aalto's team, he opened his own practice in 1961. He set up in partnership with Erkki Kairamo and Timo Vormala in 1973, with whom he has carried out numerous large-scale projects both in Finland and abroad. As Alvar Aalto's spiritual heir, Kristian Gullichsen's work is guided by a focus on the human dimension of architecture as well as on seeking relevant responses to the local context and on connecting deeply with his Finnish roots.

Glenn Murcutt (1936) – AUSTRALIA
Born in London to Australian parents, Glenn Murcutt subsequently spent the first years of his life in New Guinea. His family then settled in Sydney Bay – the same area as his current home that he renovated in 2004. He graduated in architecture from Sydney Technical College, following which he worked in London and embarked on the first in a long series of study trips. On founding his practice in 1969 he set out on an atypical and solo career dedicated to single-family housing, crowned by his winning of the Pritzker Prize in 2002. Glenn Murcutt teaches throughout the world and directs an international master class every July at Newcastle University (Australia).

Laurent Gouwy (1953), Alain Grima (1955),
Jean-Luc Rames (1952) – FRANCE
Laurent Gouwy, Alain Grima and Jean-Luc Rames all studied at the Toulouse school of architecture, from where they graduated in 1978 before going on to win the *Albums de la jeune architecture* prize in 1988. They head up a practice of some ten people in Toulouse, where they concentrate on team work, contextual dialogue with the site, and a functional approach rooted in the rational values of vernacular architecture.

Marc Blouin (1956) – CANADA – www.scheme.qc.ca
Since the beginning of his career in 1980, Marc Blouin has taken a keen interest in urban residential architecture and has actively participated in the move back to building single-family housing within the town centre – a course of action that began several years ago in Montreal. Scheme, which he founded in 1990 in association with the landscape designer François Courville, was one of the first architectural practices in Quebec to bring together professionals from a range of disciplines. Marc Blouin views sustainable development as the driving factor of an architectural project and the guarantee of its longevity.

Yung Ho Chang (1956) – CHINA – www.fcjz.com
Born in Beijing, Yung Ho Chang began his career in the United States after obtaining a Master's in architecture from the University of California at Berkeley in 1984. He later returned to live in China, to set up the Atelier Feichang Jianzhu in 1993, where he is the principal architect. He is head of the Graduate Center of Architecture at Beijing University and also lectures at many other universities in Asia, as well as in Europe and the United States. In 2000 he was awarded the Unesco Prize for the Promotion of the Arts.

Ramón Esteve (1964) – SPAIN – www.ramonesteve.com
After graduating in architecture from the technical college in Madrid in 1990, Ramón Esteve set up his own practice in Valencia, where he works on an ever-widening range of projects, including interior design, exhibition stands, furniture design, office design, collective housing and public facilities. Basing his villas on Mediterranean design principles but with minimalist furnishings, he fine-tunes each detail in the same way as an aesthete.

H. Dietrich and M. Untertrifaller

J. Cutler B. Anderson

W. Sobek

W. Ritsch

B. Weber and B. Oertli

M. J. Mayer

Helmut Dietrich (1957) and Much Untertrifaller (1959) –

AUSTRIA – www.dietrich.untertrifaller.com

Helmut Dietrich and Much Untertrifaller studied at the Technical University in Vienna and worked on several projects together before setting up a practice in Bregenz in 1994. Although their work now takes them beyond the borders of the Vorarlberg region, they have remained faithful to the underlying philosophy of the *Baukünstler*. "We are not interested in formal experimentation or sensational architecture", they say. "Our solutions are simple and pragmatic. The variety of our schemes and our refusal to specialise in one type of programme keeps us attentive."

James Cutler (1949) and Bruce Anderson (1959) – USA –

www.cutler-anderson.com

Having earned two Masters in architecture (one from the University of Pennsylvania in 1971 and the other from the Louis I. Kahn Studio Program in 1974), James Cutler went on to set up his own practice in 1977. Bruce Anderson, who obtained a Master's degree in architecture from the University of Washington in 1988, has formed part of this practice of some ten people since 1982 and became a partner in 2001. Both architects divide their time between working at the practice and teaching. Their architecture is characterised by a highly original way of handling wood, reflecting their respect for raw nature and the landscape of each site.

Werner Sobek (1953) – GERMANY – www.wernersobek.com

Having completed a double graduate programme in architecture and structural engineering between 1974 and 1980, Werner Sobek went on to obtain a PhD from Stuttgart University. He then worked at Schlaich, Bergemann & Partner. He set up a structural engineering firm in Stuttgart in 1992, and together with subsidiaries in Frankfurt am Main and New York, contributes to the design of internationally renowned structures, including bridges and airports. In 1999, the firm saw the addition of a design agency specialised in exhibition stands and urban furniture. Since 1994 Werner Sobek has chaired the department previously headed by Frei Otto at Stuttgart University.

Wolfgang Ritsch (1956) – AUSTRIA

As there is no architecture school in his native Vorarlberg, Wolfgang Ritsch studied at Stuttgart's academy of fine arts, graduating in 1982. During the 1980s he was one of the leaders of the *Baukünstler* movement, for which the Vorarlberg is famed. He has designed a great number of large-scale projects, both alone and with local colleagues, including the Dornbirn fire station (1995) and the Rieden-Vorkloster sports hall in Bregenz (2004). He chaired the Vorarlberg Institute of Architecture from 1997 to 2005.

Barbara Weber (1966) and Bruno Oertli (1958) – SWITZERLAND
– www.weber-oertli.ch

Barbara Weber graduated in architecture from the technical college in Zurich and from the SVIT school, whose syllabus is specialised in building assessment. Having trained as a building draughtsman, Bruno Oertli studied architecture at Winterthur Technikum and subsequently earned a post-graduate degree in "The Ecology of Buildings". They went into partnership in 1997, setting up the Weber-Oertli practice. Their objectives are militant: "We seek modernity but not what is in fashion. We strive to provide responses that are appropriately suited to the site and users' needs. What we design is simple but not banal."

Markus Julian Mayer (1961) – GERMANY –

www.index-studio.com

The work of Markus Julian Mayer, who studied at Technical University in Munich between 1980 and 1987, hovers between art, architecture and sociology. By switching between theory and practice he endeavours to attain a new understanding of space through a variety of channels, including houses which he calls "hybrid", as well as public facilities, and exhibitions for the Bavarian Society of Architects, of which he is an active member.

P. and L. Nitsche

C. Peters

P. Stutchbury

P. Carmine

A. Lubenow

I. Le Garrec and M. Daufresne

O. Koponen

Lua Nitsche (1972) and Pedro Nitsche (1975) – BRAZIL

Lua Nitsche and her brother Pedro studied at the faculty of architecture and urban planning at São Paulo University. They first worked with teams preparing national competitions and then set up in practice together in 2002. Urban living is their focal point, as illustrated in their work on social housing schemes in São Paulo. Their vision of sustainable development is very idealistic: "In nature, ecology ensures the free existence of animals, without their being held in captivity, and the development of vegetation without forests being laid to waste or rivers being straightened out. In ecological architecture, generous flowing spaces built with the bare minimum ensure the freedom of mankind. Ecological architecture equals architecture of freedom!"

Anke Lubenow (1967) and Carsten Peters (1963) – GERMANY – www.bau-energie.de

Since 2000 Anke Lubenow has been a partner of Planungsgruppe Bau + Energie founded in 1997 by Carsten Peters. Their "integrated design" method is based on the exchange of ideas across a broad range of disciplines, as well as on the participation of users and close collaboration with specialised engineers. Their projects include building new energy-saving structures as well as renovating and restructuring existing buildings (which are sometimes listed) by improving their energy efficiency.

Marc Daufresne (1952) and Ivan Le Garrec (1955) – FRANCE

Ivan Le Garrec is a graduate of Paris-La Villette school of architecture, and Marc Daufresne of Paris-La Seine school of architecture, where he taught between 1985 and 1992. In 1990 they co-founded Daufresne, Le Garrec & associés and they are members of the *Association des architectes français à l'export* (Afex). For them, the starting point of any project is to "seek, be attuned to, and decode what the site has to recount – the history that it exudes and the past's silent request to renew its existence via future projects. Designing architecture is not about placing a foreign object in a certain place, but about building a new episode in a pre-existing environment, extending mankind's effort to create a welcoming world."

Peter Stutchbury (1954) – AUSTRALIA

Having graduated from Newcastle University (Australia) in 1978, Peter Stutchbury set up an architectural practice in 1981, which he heads with his wife Phoebe Pape. "Stutch" introduces his country's natural surroundings into his buildings, factoring in the climate and respecting the landscape. He is the spiritual heir of Glenn Murcutt and Richard Leplastrier, with whom he has taught the international master class at Newcastle University since 2001, and is one of the leaders of Australia's new generation of ecologist-architects.

Olavi Koponen (1951) – FINLAND

Olavi Koponen, who was born in the east of Finland, was an active communist in the 1970s before studying political science in Moscow. Having returned to his native land he gave up his communist activities once he joined the Tampere school of architecture, from which he graduated in 1993. "Olli" opened an architectural practice in Helsinki in 1990, but following a cardiac problem decided to shift the course of his life. Since then he designs, implements and finances all of his own works. His house with combined practice is the first of four ecological housing projects.

Pietro Carmine (1934-2005) – ITALY

After graduating from the Venice IUAV school of architecture in 1965, Pietro Carmine set up his own architectural and urban design practice in Milan in 1972. From 1985 onwards his work was geared to careful and considerate development based on a process that he called " culture of sustainability", and which he presented in many conferences and lectures. His house in Cannero is a tangible example of this "holistic" approach.

S. Wigglesworth

C. Hansson and R. Rizzo

C. Vishwanath

A. Lanzinger

M. Munhoz

M. Al-Sayed

Sarah Wigglesworth (1957) – UNITED KINGDOM –
www.swarch.co.uk
Sarah Wigglesworth worked for a variety of architectural firms in both the United Kingdom and United States before founding Sarah Wigglesworth Architects in 1994. Jeremy Till is her partner in daily life, in the architectural practice and at Sheffield University, where they both teach. Their approach is rooted in theoretical research and numerous militant publications. As they say, "We believe in listening, in research, in collaboration, in innovation. We aim to produce architecture which exceeds our clients' expectations and to take time and budget seriously. We prefer the everyday to the iconic, the rough and the smooth to the smooth alone, [and] too many ideas to no ideas at all."

Antonius Lanzinger (1962) – AUSTRIA
Antonius Lanzinger trained as a carpenter before studying architecture at the technical university in Innsbruck. After working with several fellow architects he set up his own practice in 1996. The principles of this craftsman-architect are to "analyse traditional construction methods. Reflect on ways of providing a new interpretation of these simple, economic and intelligent techniques. Take a step back from the ideology of passive housing design and its accompanying technology."

Reno Rizzo (1958) and Christopher Hansson (1954) –
AUSTRALIA – www.inarc.com.au
Inarc is an architectural and interior design practice based in Melbourne. The two principal directors are Reno Rizzo, Architect and Christopher Hansson, Interior Designer. The practice has been in existence for ten years, and is known for its high level of interdisciplinary design skills. Building types covered by Inarc include single-residential, medium-density residential, interiors, commercial and exhibition design. The practice's style has been described as "contemporary but with a strong human warmth."

Mauro Munhoz (1959) – BRAZIL
Mauro Munhoz graduated from the faculty of architecture and urban planning at São Paulo University, where he also followed a Master's programme in environmental urban structures. Whilst single-family housing is a major theme of the architectural practice he set up in 1986, urban planning is also addressed. For example, his restructuring of the public spaces of Parati, a seaside resort, won several awards for its underpinning environmental approach. "We aim to understand the specific features of each project – the site's physical characteristics, the technical repertoire of each craftsman, as well as the particular lifestyle and cultural references of the users. The architect's poetic potential is not limited by such a precise reading of the context; on the contrary, it is enhanced."

Chitra Vishwanath (1962) – INDIA – www.inika.com/chitra
Since 1998, the architectural practice founded by Chitra Vishwanath in Bangalore in 1990 has steadily expanded, and she now employs some ten people, including several foreign trainees. The ecological measures applied by Chitra to the 400 houses and public buildings that she has constructed over the past 15 years are ever-innovative. She sensitively selects techniques and materials to reduce the building's environmental imprint and strikes up friendly relations with both her clients and workers.

Marwan Al-Sayed (1962) – USA – www.masastudio.com
Having emigrated to the United States during his adolescent years, the Iraqi architect Marwan Al-Sayed studied architecture and art history at Vassar College, and in 1986 earned a Master's degree in architecture from the University of Columbia. He practiced for twelve years in New York before setting up a small practice geared to design in association with his wife, Mies Grybaitis. Marwan's design solutions are drawn from his numerous travels. In his view, "light is central to the design process; it is a language that an artist can comprehend and that a child can feel."

Documentary and bibliographic sources

Websites

Ecological buildings

www.assohqe.org
Website of the HQE ® association
www.batirecologique.com
www.batirsain.free.fr
www.biohabitat.free.fr
Explanations on alternative construction
techniques.
www.ecobuildingnetwork.org
www.ecoconcept.org
www.eco-logis.com
Information on materials and finishings, amongst
other things.
www.greenbuilder.com
www.ideesmaison.com
www.inti.be/ecotopie
Information on sustainable building and urban
planning.
www.qem.fr
On the environmental quality of materials.
www.sustainableabc.com

Earth architecture

www.adobebuilder.com
On self-building with adobe.
www.craterre.archi.fr
Website of the international earth architecture
centre of the Grenoble architectural school.
www.eartharchitecture.org
Website on earth architecture
www.earthbuilding.com

Building with straw

www.lamaisonenpaille.com
www.strawbalefutures.org.uk
A technical guide to building with straw can be
downloaded from this site.
www.strawbuilding.org
The California Straw Building Association

Building with wood

www.apawood.org
The Engineered Wood Association
www.bois-foret.info.com
Website of the French timber industry.
www.bois-habitat.com
Website of the Belgian association
Bois et habitat.
www.cwc.ca
Canadian Wood Council

www.dataholz.com
Website of ProHolz, Austrian centre for the
promotion of timber.
www.woodfocus.fi
Finnish Wood Council

Housing and health

www.air-interieur.org
Website of the French watchdog for the quality
of interior air.
www.euro.who.int/Housing
WHO website on housing and health
www.housingandhealth.ca
www.inies.fr
French database on the environmental and
health aspects of construction products.
www.medieco.info
Website of Doctors Suzanne and Pierre Déoux.

Renewable energies and energy savings

www.edf.fr
Technical data sheets relating to renewable
energy.
www.futureenergies.com
www.negawatt.org
www.nrel.gov
American renewable energy laboratory
Website of the negawatts association.
www.outilssolaires.com
Useful glossary both for solar energy and other
areas.
www.pac.ch
On heat pumps.
www.renewable-energy-source.info
www.renewables.ca
www.50-solarsiedlungen.de
Description of 50 solar buildings (with drawings
and photos) that can be downloaded in pdf
format.

"Passive" and "Minergie" housing

www.ajena.org
Website of *Energie et environnement*, an
association in the Franche-Comté region
(France).
www.casaclima.it
Italian website on passive energy housing.
www.cepheus.de
Website in German and English on the European
programme for passive energy housing.
www.minergie.ch

Swiss website in several languages on the
"Minergie" label.
www.passiv.de
Website of the *Passivhaus Institut*.
www.passivehouse.at
Austrian website on passive housing.

Vorarlberg
www.energieinstitut.at
Website of the Vorarlberg institute of energy.
www.v-a-i.at
Website of the Vorarlberg institute of
architecture.

Books

On ecological architecture

Daniel D. Chiras, *The Natural House. A
Complete Guide to Healthy, Energy-efficient,
Natural Homes*, Green Publication, Chelsea,
2000.

Klaus Daniels, *The Technology of Ecological
Building. Basic Principles and Measures,
Examples and Ideas*, Birkhäuser, Basel, Boston,
Berlin, 1997.

Suzanne and Pierre Déoux, *Le Guide de l'habitat
sain. Habitat, qualité, santé, pour bâtir une santé
durable*, Medieco, Andorra, 2nd print run, 2004.

Brian Edwards, *Towards a Sustainable
Architecture. European Directives and Building
Design*, Architectural Press, Oxford, 1996,1999.

Marc Emery, *Appropriate Sustainabilities. New
Ways in French Architecture*, Birkhäuser, Basel,
Boston, Berlin, 2002

Dominique Gauzin-Müller, *Sustainable
Architecture and Urbanism. Concepts,
Technologies, Examples*, Birkhäuser, Basel,
Berlin, Boston, 2002.

Amerigo Marras, *Eco-tec. Architecture of the In-
between*, Princeton Architectural Press, New
York, 1999.

Sue Roaf, Manuel Fuentes, Stephanie Thomas,
Ecohouse. A Design Guide, Architectural Press,
Oxford et al., 2001.

James Wines, *Green Architecture*, Taschen, Cologne, New York, 2000.

On energy-saving houses and solar housing design
Sophia and Stefan Behling, *Sol Power. The Evolution of Sustainable Architecture*, Prestel, Munich, London, New York, 2000.

G. Z. Brown and Mark DeKay, *Sun, Wind and Light. Architectural Design Strategies*, John Wiley & Sons, New York, 2001.

Thomas Herzog, *Solar Energy in Architecture and Urban Planning*. Prestel, Munich, London, New York, 1996, 1998.

Jean-Pierre Oliva, *L'isolation écologique. Conception, matériaux, mise en œuvre*, Terre vivante, Mens, 2001.

Thierry Salomon and Claude Aubert, *Fraîcheur sans clim'. Le guide des alternatives écologiques*, Terre vivante, Mens, 2004.

Christian Schittich (Ed.), *Solar Architecture. Strategies, Visions, Concepts*, Birkhäuser, Basel, Boston, Berlin, 2003.

On building with natural materials (wood, earth, and straw)
Dominique Gauzin-Müller, *Construire avec le bois*, Le Moniteur, Paris, 1999.

Dominique Gauzin-Müller, *Wood Houses. Spaces for Contemporary Living and Working*, Birkhäuser, Basel, Berlin, Boston, 2004.

Thomas Herzog, Julius Natterer, Roland Schweitzer, Michael Volz and Wolfgang Winter, *Construire en bois*, Presses polytechniques et universitaires romandes, Lausanne, 2005.

Otto Kapfinger, *Martin Rauch – Rammed Earth / Lehm und Architektur / Terra cruda*, Birkhäuser, Basel, Boston, Berlin, 2001.

Gernot Minke, *Building with Earth. Design and Technology of a Sustainable Architecture*, Birkhäuser, Basel, Berlin, Boston, 2006.

Gernot Minke, Friedemann Mahlke, *Building with Straw*, Birkhäuser, Basel, Berlin, Boston, 2005.

André Ravéreau, *L'Atelier du désert*, Parenthèses, Marseille, 2003.

Monographs of architects whose works are published in this book
Philip Drew, *Peter Stutchbury*, Pesaro Publishing, Sydney, 2000.

Françoise Fromonot, *Glenn Murcutt*, Gallimard, Paris, 2003.

Sheri Olson, *Cutler Anderson Architects*, Rockport, Gloucester, 2004.

Walter Zschokke, *Helmut Dietrich/Much Untertrifaller*, Springer, Vienna, 2001.

Photographic credits

159